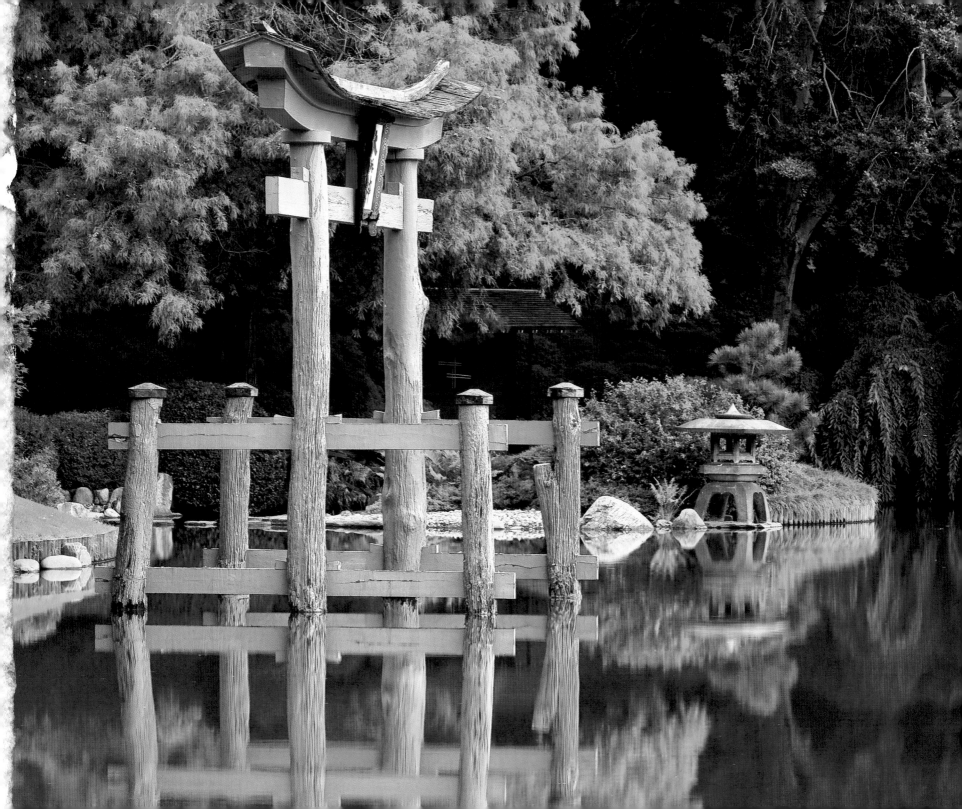

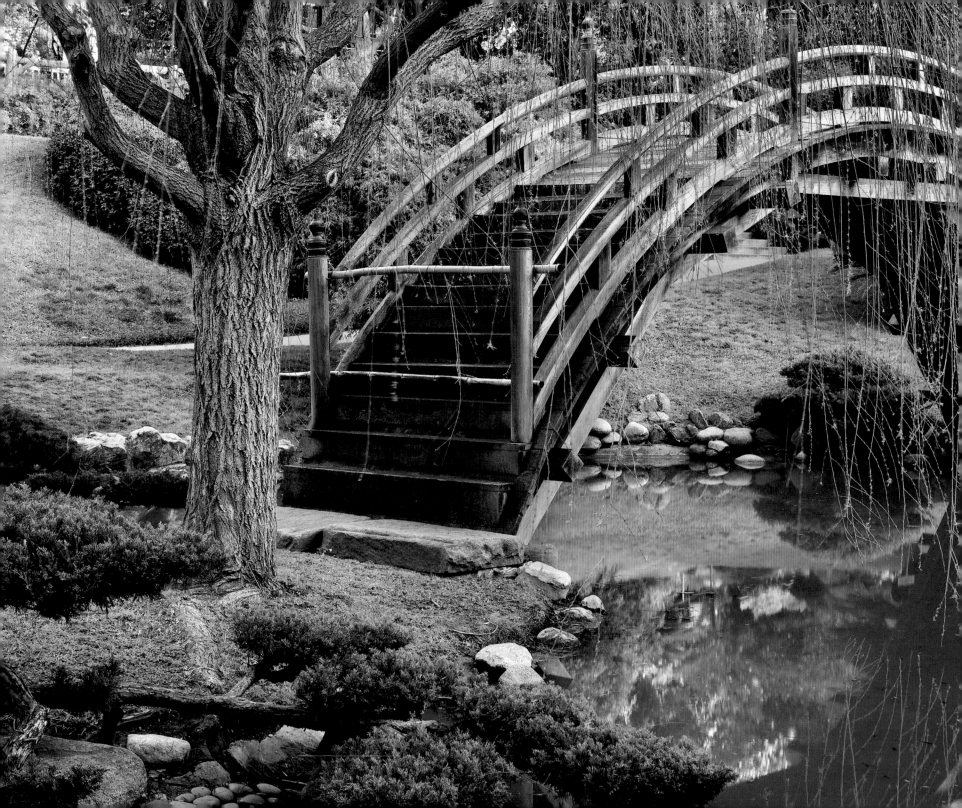

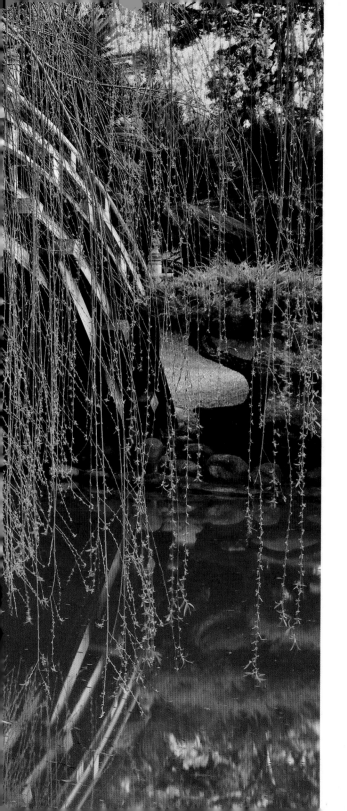

Quiet Beauty

The Japanese Gardens of North America

Kendall H. Brown

Photographs by David M. Cobb

TUTTLE Publishing

Tokyo | Rutland, Vermont | Singapore

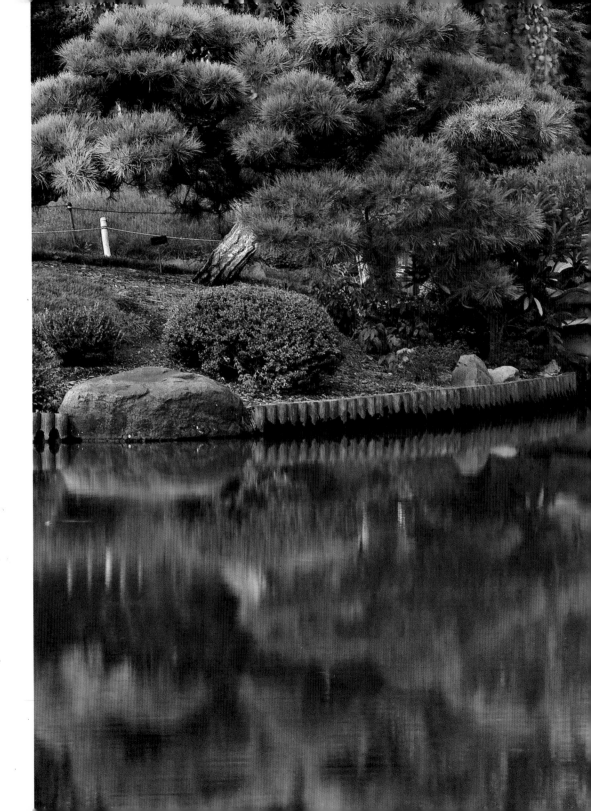

Published by Tuttle Publishing, an imprint of Periplus Editions (HK) Ltd

www.tuttlepublishing.com

Text © 2013 Kendall H. Brown
Photographs © 2013 David M. Cobb
(except page 8: photo © Mark Schwartz Photography)

Library of Congress Cataloging-in-Publication Data

Brown, Kendall H.
 Quiet beauty : Japanese gardens of North America / Kendall H. Brown ; photographs by
David M. Cobb.
 p. cm.
 Japanese gardens of North America
 Includes bibliographical references.
 ISBN 978-4-8053-1195-0 (hardcover)
 1. Gardens, Japanese--North America. 2. Gardens, Japanese—North America—Pictorial
works. I. Cobb, David M. II. Title. III. Title: Japanese gardens of North America.
 SB458.B76 2013
 712.097--dc23
 2012036548

ISBN: 978-4-8053-1195-0

Distributed by

North America, Latin America & Europe
Tuttle Publishing
364 Innovation Drive, North Clarendon, VT 05759-9436 U.S.A.
Tel: 1 (802) 773-8930; Fax: 1 (802) 773-6993
info@tuttlepublishing.com; www.tuttlepublishing.com

Japan
Tuttle Publishing
Yaekari Building, 3rd Floor; 5-4-12 Osaki, Shinagawa-ku, Tokyo 141-0032
Tel: (81) 3 5437-0171; Fax: (81) 3 5437-0755
sales@tuttle.co.jp; www.tuttle.co.jp

Asia Pacific
Berkeley Books Pte. Ltd.
61 Tai Seng Avenue, #02-12, Singapore 534167
Tel: (65) 6280-1330; Fax: (65) 6280-6290
inquiries@periplus.com.sg; www.periplus.com

15 14 13 10 9 8 7 6 5 4 3 2 1

Printed in Singapore 1301TW

Front and back endpapers A Japanese maple lights up the sky at the Portland Japanese Garden.

Page 1 A brilliant *torii* set in the pond garden at the Brooklyn Botanic Garden, New York.

Pages 2–3 The moon bridge at the Huntington Botanic Garden, San Marino, California.

Pages 4–5 A bridge and *yukimi*-style lantern mark a transition at the Brooklyn Botanic
Garden, New York.

Page 7 A viewing pavilion in the pond garden at the Brooklyn Botanic Garden.

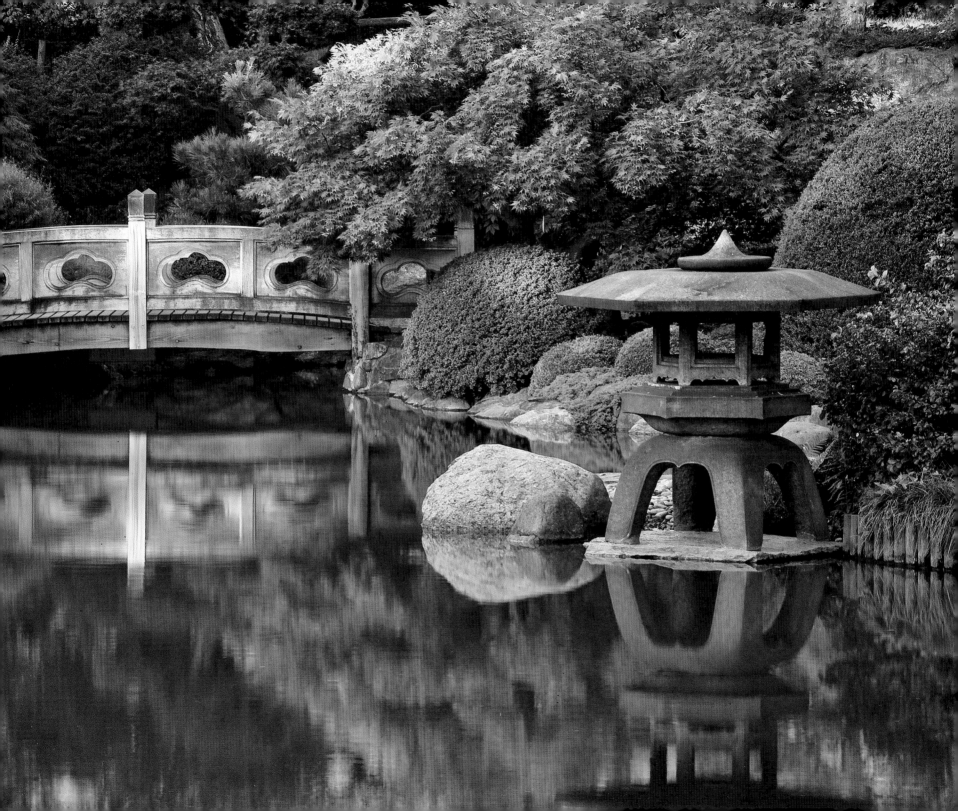

contents

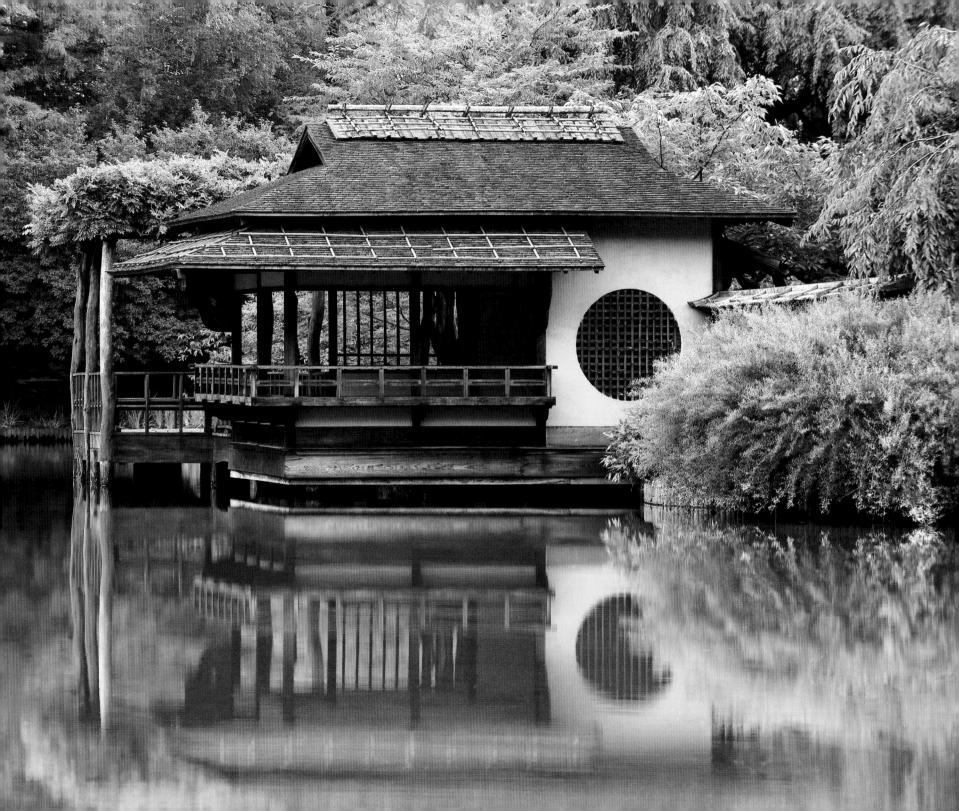

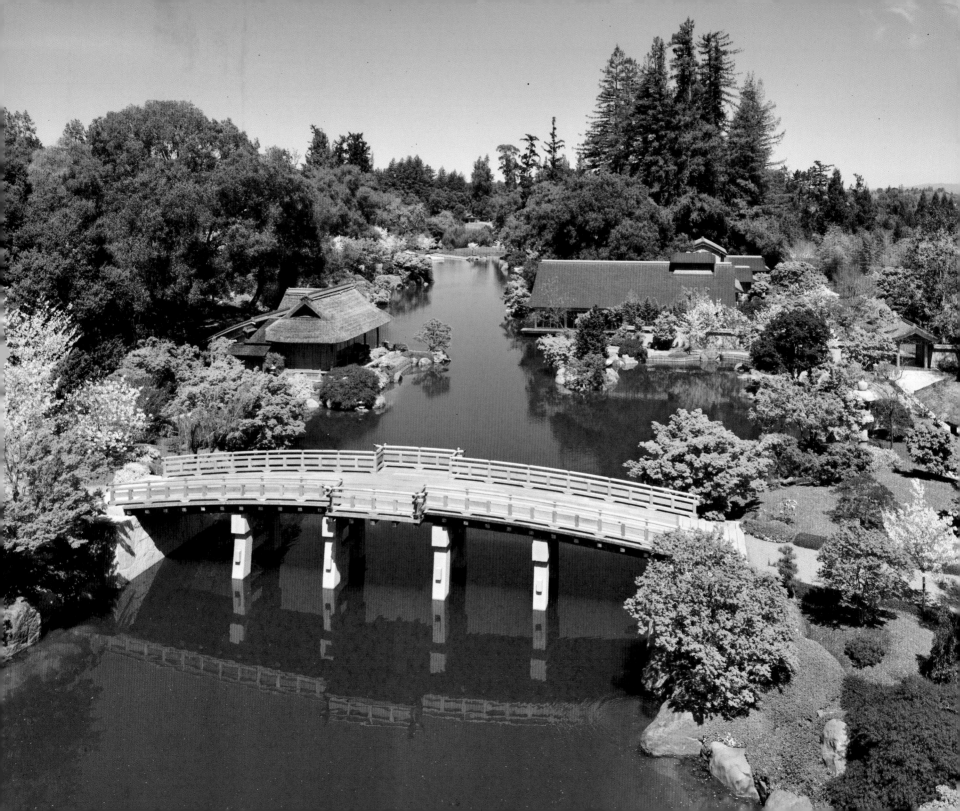

PLACES TO DREAM
NORTH AMERICAN JAPANESE GARDENS AS HISTORY

Japanese gardens or, more accurately, Japanese-style gardens, in North America offer distinct pleasures. In contrast to the cacophony of cities, the anonymity of suburbs, and even the anxiety of deserts or forests, these gardens can provide beautifully controlled environments. In artful landscapes we lose ourselves in a path woven around a pond and a harmonious stone arrangement; we delight in the variegated colors of graceful *koi* and the bright hues of blossoming plums; and we are calmed by a stream's gentle murmur and the dappled greens of moss. Another kind of pleasure is contextual and social rather than sensory and psychological. Japanese gardens in North America are often found where we least expect them, and in places unknown in pre-modern Japan. Thus, we feel a special delight in discovering a "dry garden" of stones and sand at a museum, a lush pond garden on a college campus, or a waterfall-fed stream garden in a hospital. Those familiar with gardens in Japan may also enjoy Japanese-style gardens intellectually, noting creative native plant substitutions or thoughtful ways of interpreting Japanese design principles within distinctly North American spaces.

For all their pleasures, Japanese gardens outside Japan also face distinct pressures that can make them slightly uncomfortable places. Because many gardens take on the responsibility of representing Japan, they can become self-conscious. At worst, this results in clichéd collections of superficial "Japanesey" elements. These flaws are magnified in gardens that were designed with insufficient knowledge and poorly constructed, or are improperly maintained.

Whatever we might think of their charms and their foibles, North American Japanese gardens have a distinct history that sets them apart from the pre-modern gardens in Japan on which they are often based in part, and to which they have been compared reflexively. This book presents Japanese gardens outside Japan as possessing their own distinct beauty and singular history. Its fundamental premise is that Japanese gardens in the United States and Canada are North American gardens in Japanese styles. As such, they first reveal how North Americans have interpreted and created Japanese gardens to serve a variety of functions and meanings. Further, many of these cultural landscapes also suggest how Japanese government officials have deployed gardens to project an image of Japan and to build ties of friendship. Finally, these gardens frequently are key sites for Japanese-Americans and Japanese-Canadians, for whom they are statements of goodwill, identity, and social belonging in the wake of bitter treatment before and during World War II.

As horticulture and human culture, Japanese-style gardens can effectively educate about Japan. They also have the power to nurture the spirit and stimulate creativity, serving as spaces for solitary retreat and social gathering. Most broadly, Japanese gardens in North America are key agents in a "trans-Pacific imagination." In form and function, they participate in a hybrid culture based on layers of transmission and appropriation in which Japanese prototypes are modified, then those refracted forms reflected back to Japan. As a result, there are now Japanese "Japanese gardens" (*Nihon teien*) that resemble their North American brethren.

Fig. 1 Private Estate, California. Photo © Mark Schwartz Photography.

PROLOGUE
METHODS AND GOALS

This book presents 26 gardens that demonstrate the complex history of Japanese gardens in North America. This history explores variations in style and meaning, accounting for them among larger shifts in trans-Pacific political relations, evolving North American social values, and changes in taste. These gardens trace five eras in the historical evolution of Japanese-style gardens from the late nineteenth century to the early twenty-first century. Discussed in detail below, these provisional periods are intended to stimulate study of why North American Japanese gardens have changed and how gardens from the same era can be compared usefully. Each garden is presented as a case study that elucidates characteristics of its historic epoch as well as it its own distinct circumstances.

Describing 26 North American gardens in detail, then briefly noting another 75 in Appendix 2, is to present a critical mass of notable Japanese-style gardens. Writers and garden administrators have long discussed modern North American Japanese gardens in relation to pre-modern gardens in Japan. Because it disconnects them from their immediate history as well as their diverse functions and meanings, this authenticity paradigm, though intended to understand and aggrandize these gardens, has had the unintended consequence of diminishing their significance. Yet, by isolating one group of gardens for extended study and another for brief mention, this book runs the opposite risk of creating a canon—an exclusive list of Japanese-style gardens that privileges a few, marginalizes some, and ignores others. Hence, some caveats are in order. The numbers 26 and 75 are arbitrary, creating the appealing but subjective total of 101 gardens. There are gardens in Appendix 2 that the author prefers to some in the main section. Moreover, there are gardens not listed here that give pleasure and are part of the history of Japanese gardens in North America. Finally, for practical reasons this book omits private gardens (Fig. 1), and thus disregards a number of spectacular residential gardens and the people who created them.

The 26 featured gardens were chosen based on four criteria. First, they are public gardens, accessible without a reservation. Second, they are historically significant within the rubric delineated below, representing key features of a period, stylistic type, or stage in the career of a noted garden builder. Third, they are compelling physical spaces, sufficient in their scale (or as part of a larger garden complex) to constitute a "destination" for tourists. Fourth, they were chosen with an eye to geographic coverage, demonstrating the appeal and adaptability of Japanese garden styles across North America. Finally, while not a basis of inclusion because it cannot be guaranteed, these 26 gardens have exhibited at least a modicum of maintenance. As living art forms, gardens are never finished. Maintenance is thus a key part of any garden's status and history. In this regard, maintenance and function—in terms of education, social events, and ways of raising funds—are discussed when critical to the garden's story.

This history of North American Japanese-style gardens situates them among the people, places, and eras that produced them. It examines larger historical themes, geographic factors and, most of all, the human agents whose will and skill were the ultimately determinative factors. In this last regard, most of the following chapters highlight the roles of garden designers, placing them within the larger context of the era and design ideology. These garden creators include Japanese who relocated to North America in order to make gardens, Japanese who traveled abroad to do so, and Euro-Americans making gardens in their homeland. In the pre-war era, we encounter little studied immigrants like Takeo Shiota who created numerous gardens. In the post-war period, we again confront the contributions of Japanese immigrants like Nagao Sakurai in the 1950s and 1960s, Kōichi Kawana in the 1970s and 1980s, and Hōichi Kurisu in the 1980s.

Among the "lost histories" that this study seeks to identify are the intentions of Japanese designers who created gardens during brief working trips in North America. These men—including Takuma Tono, Jūki Iida, Kannosuke Mori, Tadashi Kubo, Kinsaku Nakane, and Ken Nakajima—comprise a who's who of modern garden builders. It is important to place their North American gardens within their larger careers, and, if their gardens are to be properly maintained, to understand their design ideals. Even as those Japanese designers were "exporting" their ideas to North America, Euro-American garden builders like David Engel and David Slawson were adapting concepts gleaned from study in Japan into their native landscape.

Designers constitute only the most obvious point of entry into the rich human history of Japanese-style gardens. The contributions of garden administrators, curators, and maintenance gardeners are also important—and noted in some of the following chapters. Similarly, in shifting the study of gardens from abstract ideals to the contributions of real persons, we need to pay attention to the people whose efforts led to the creation of gardens. Often, amid the complex stories of multiple hands, there is a single driving force, and the following chapters introduce such figures as Edward Tatsukawa, a Japanese American businessman whose determination led to a fine garden in Spokane,

and Frances de Vos, a botanical garden director who commissioned Japanese gardens in Chicago and Minnesota. Finally, the various functions of gardens, which constitute their ultimate social meanings, are mentioned briefly in a few cases when these activities are particularly notable. The study of what people do—and have done—in North American Japanese gardens, and why, is the subject for another history.

FIVE EPOCHS IN THE HISTORY OF JAPANESE GARDENS IN NORTH AMERICA

The garden historian Makoto Suzuki has postulated three eras in the history of Japanese gardens in North America and Europe: the age of world fairs from about 1870 to 1940, the four post-war decades characterized by sister city gardens, and, beginning in the 1990s, a new period marked by greater exchange of information through conferences, journals, websites, and education programs, and an emphasis on adaptation rather than authenticity.[1] Although many useful periodizations might be proposed, and diachronic analysis of function and style is also valuable, this study locates the 26 case study gardens within five periods. We follow Suzuki's first and last phases, and divide his middle phase into three linked eras.

ORIENTAL EXOTICA
Fairs, Tea Gardens, and Estates in the Age of Madame Butterfly

The relatively sedate quality of most post-war Japanese-style gardens belies the lively nature of the pre-war generation. So ubiquitous were Japanese-style gardens that they appear frequently in literature. In his 1920 novel *This Side of Paradise*, F. Scott Fitzgerald has his protagonist Amory Blaine lament, "Trouble is I get distracted when I start to write stories—get afraid I'm doing it instead of living—get thinking maybe life is waiting for me in the Japanese gardens at the Ritz or at Atlantic City or on the lower East Side."[2] The rooftop Japanese garden at the Ritz-Carlton Hotel, created in 1916, was a favorite high society haunt, and the large tea garden in Atlantic City had been a sensation two decades earlier.

Japanese gardens were part of a larger infatuation with "things Japanese," expressed in *Madame Butterfly* and dozens of other popular plays and novels that present Japan as a storybook land of emperors, *geisha*, and gardens. Not merely confections spun from a Western desire to see Japan as an antidote to industrial blight and social regimentation,

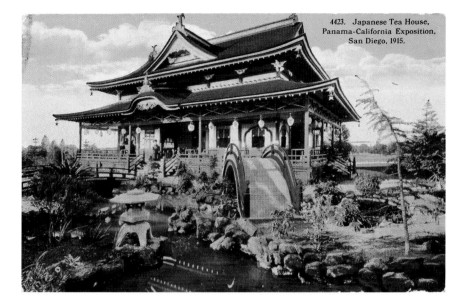

Fig. 2 Japanese Pavilion, Panama-California Exposition, San Diego, California, 1915.

early Japanese-style gardens were deployed by Japanese bureaucrats and entrepreneurs for their political and commercial value. Introduced through world fairs from the 1890s, Japanese garden styles quickly spread via ubiquitous commercial tea gardens and lavish gardens at the country homes of the great tastemakers.

The landscapes built at the great international expositions established Japanese gardens as exotic places filled with replicas of old buildings and populated with *kimono*-clad "musmees." Because these gardens were built by the Japanese government in historical styles and as "genuine parts of the Mikado," they initiated the practice of mining the past for inspiration and authorized the alluring idea of authenticity. Attracting great attention in the press, the appeal of these gardens spread beyond the millions who visited the fairs.

Whether magnificent, as at St. Louis in 1904, or small, as at San Diego in 1915 (Fig. 2), fair gardens were temporary. The buildings, plants, and stones were donated or sold to commercial or private gardens. The men who built them also often stayed on in North America. Exposition gardens directly spawned tea gardens that spread the commercial spectacle of the fairs across North America. Entrepreneurs like the peripatetic Yumindo Kushibiki and G. T. Marsh created garden-based attractions in tourist areas (Fig. 3). The

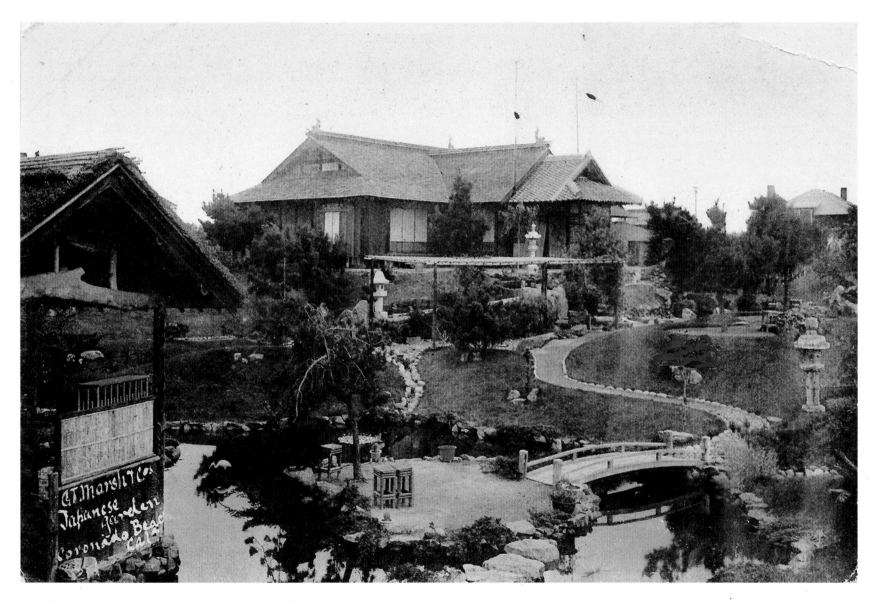

Fig. 3 G. T. Marsh & Co., Japanese Gardens, Coronado Beach, California, c. 1911.

single surviving example of this phenomenon is San Francisco's Japanese Tea Garden (pp. 20–5), born as Marsh's Japanese Village at the California Mid-Winter Fair of 1894.

Large tea gardens, up to six acres, resembled the major fair gardens with various buildings, tea and sweets service, and shopping opportunities. Small ones were gardens in name more than in fact, with a few lanterns and potted plants glorifying a restaurant. The fad for tea gardens was largely over by 1915, with the buildings and other contents sold to private estates. In 1911, Henry Huntington purchased Marsh's Japanese Tea Garden in Pasadena, relocating it to his estate (pp. 26–31).

At country homes like Huntington's "San Marino," American élites commissioned variations on the gardens seen at the expositions or on trips to Japan. Using Josiah Conder's *Landscape Gardening in Japan* as a guide, North American tastemakers prized Japanese gardens for their exotic plants and their air of artistic refinement. Many women, beginning with Boston's Isabella Stewart Gardner in 1885, commissioned Japanese gardens. For Western women reacting to the excesses of the Gilded Age, these Oriental gardens were spurs to the imagination, balms for the spirit, and even symbols of erotic allure.[3] Prominent examples of "matronage" include Isabel Stine's Hakone (pp. 40–5) and Sallie Dooley's Japanese garden at Maymont (Fig. 8, pp. 32–5).

These two gardens demonstrate the basic styles and types of estate gardens. As at Maymont, most residential gardens featured steams and ponds punctuated by wooden bridges, lanterns, and a viewing pavilion (*azumaya*). These gardens reprise designs seen at fair gardens and large tea gardens. They were often built around an existing pond or other low spot on the property, far removed from the European-style residence. Far more rare is the holistically designed estate represented by Stine's hillside retreat at Hakone, where a Japanese residence is integrated with a garden to provide a complete fantasy of life as a Japanese.

These early gardens were fashioned by Japanese immigrants about whom little is yet known. Of the first generation (*issei*) garden builders, only Takeo Shiota, creator of the garden at the Brooklyn Botanic Garden, is the subject of a published study. Preliminary research suggests that some of these men came to work at the world's fairs or with a goal of creating gardens while others drifted into garden work. The association of Japan with gardens led some wealthy North Americans to assume that their Japanese servants could create a garden—an assumption that led to a few strange gardens but, more often, to a network of *issei* who could provide requisite knowledge and labor. By the 1900s, these human networks were paralleled by commercial networks of importers that sold Japanese garden supplies from shops and via mail order.

Despite the tremendous vogue for Japanese gardens in the early twentieth century, by the 1930s political and economic tension with Japan led to their substantial decline. Even so, a handful of significant public and private gardens were made until the very outbreak of World War II. During the war, Japanese-Americans created many gardens at Relocation Camps, notably at Manzanar in California, Minidoka in Idaho, and Gila River in Arizona.[4] Recent excavations reveal complex and creative gardens that speak eloquently of the spirit of endurance, artistry, and even vital competition among internees. Apart from these remarkable gardens built behind barbed wire, during the war no other new gardens were made and extant ones were severely challenged. Some were destroyed, many were neglected, and a few continued under the names Oriental Garden and Chinese Garden as North Americans wrestled with a lingering attachment to Japanese gardens while fighting to destroy Imperial Japan.

BUILDING BRIDGES
Friendship Gardens in the Cold War Era

In sharp contrast to pre-war gardens, from the 1950s most gardens were sponsored by public institutions, with far fewer constructed at expositions, amusement parks, hotels, and restaurants. This shift reveals important social changes, with resulting transformations in why gardens were made and how they were understood.

Civic Japanese gardens were created in North America from the last decade of the nineteenth century, connected indirectly with the City Beautiful movement's goal of creating visually pleasing and spiritually uplifting public spaces. Municipalities strove to show their sophistication through the kinds of gardens that highlighted the fairs and adorned great estates. Many civic gardens were amateurish, but the Brooklyn Botanic Garden (pp. 36–9) proved that they could be subtly conceived and skillfully executed.

In the wake of World War II, public gardens flourished in response to the positive experiences of GI's in Japan and to the Federal government's concerted effort to rebuild bonds with Japan as a bulwark against Communism. The progenitor of these politicized post-war gardens was the Shōfūsō (pp. 48–51), a 1954 project led by the Rockefeller family intent on re-establishing philanthropic and business relations in East Asia. In 1956, at the height of the Cold War era, the Eisenhower administration promoted sister city relationships as the main cog in its "citizen diplomacy" program. The most obvious manifestations of this initiative are the myriad sister city and friendship gardens, and exemplified by those in Vancouver, Seattle, and Portland (pp. 58–63, 52–7, 70–5).[5] These

gardens are tangible products of international camaraderie and commerce, and, because they brought Japanese garden builders to North America for extended periods, they exemplify the people-to-people cultural exchange at the heart of citizens' diplomacy.

For North American municipalities, Japanese gardens provided opportunities to demonstrate goodwill and good taste. These fresh landscapes proclaimed their patron's openness to the Japanese culture and people shunned over the previous decades, even as they revealed a superior modern taste that rejected red moon bridges and bronze cranes. For Japanese designers, creating large public gardens in North America offered creative challenges, a chance to think and build at a scale then difficult in Japan. Patrons and designers sought to present a more sophisticated type of Japanese design, and, in so doing, demonstrate how Japan's rich cultural legacy could secure the nation's place as a leader in the arts of peace.

Influential civic garden accomplished these aims in three ways. Historic sampler gardens signaled the contemporary relevance of Japan's traditions. Naturalistic gardens linked Japanese design to the "power of nature" that is universal, yet a distinctive characteristic of Japanese art. Similarly, abstract designs had a special resonance with Japanese design even as they connected with ostensibly universal principles. Despite these modern approaches, many civic gardens paralleled the old fair gardens in their preference for dramatic size and historic reference. There was also a shared rhetoric of spiritual tranquility, even if the anxiety being soothed was the existential angst of the nuclear era instead of the material crassness of the gilded age. Finally, although post-war gardens continued to "perform" Japanese culture within a politically charged environment, in the era of Cold War Orientalism, Japanese garden art evolved from an exotic bauble to an increasingly well-integrated part of the North American experience.[6]

INNOVATION BY ADAPTATION
North America's "Backyards" Turn Japanese

The creation of impressive public Japanese-style gardens in the early 1960s re-launched "the Japanese garden" as a form appropriate for a variety of North American environments and as a style amenable to creative adaptation. The first generation of post-war public gardens was accompanied by a spate of new books that explained Japanese garden history as well as provided taxonomies of garden styles and related components. In addition, magazine features like *House Beautiful*'s famous "Japan" issues of August and September 1960 ("Shibui," and "How to Be Shibui

Fig. 4 (above) *Sunset Ideas for Japanese Gardens*, 1968.

Fig. 5 (right) Backyard swimming pool stone garden. Private residence, San Diego, California, c. 1970.

with American Things") explained why Japanese gardens and other arts should be important components of modern culture. How-to manuals such as *Sunset Ideas for Japanese Gardens* (Fig. 4) demonstrated the ways in which Japanese gardens could be adapted to North American backyards.

It is only a small stretch to connect the residential Japanese gardens that were a sign of suburban sophistication and personal creative expression with an evolution in civic and institutional Japanese gardens that constitute a public "backyard." Formally, the increase in residential *koi* ponds is easily linked to the upsurge in civic pond-style stroll gardens, while the fad for turning swimming pools into stone gardens (Fig. 5) parallels a brief vogue for adding dry gardens (*karesansui*) such as those seen at the Brooklyn Botanic Garden (Fig. 7) and the Huntington (pp. 26–32).

Although adaptation was becoming the *de facto* strategy for creating Japanese gardens in North America, most public gardens still insisted on the idea of authenticity. Paradoxically, this ideology provided designers with a kind of license that allowed for the construction of gardens tailored to their particular North American environment.

It may be that designers came to realize that not only was "authenticity" always relative, it could be used rhetorically to justify designs that increasingly were creative adaptations.

From the mid-1960s, Japanese gardens again became ubiquitous. Unlike the grand gardens in Seattle, Vancouver, and Portland, many of these gardens sought simply to adapt one main element from Japanese garden history appropriate for the particular space or function. The pond-style stroll garden (*chisen kaiyū-shiki teien*), associated with Edo-period warlords (*daimyō*), was accommodated very differently into a small urban park in San Mateo (pp. 78–83), a large forested park in Spokane (pp. 90–3), and an open prairie in Lethbridge (pp. 84–9). In some cases, most notably at Cheekwood in Nashville (pp. 100–5), familiar forms were jettisoned to concentrate on the affective experiences central to stroll gardens. Even when the sampler-type garden was continued, as at Fort Worth (pp. 94–9), an unmistakable spirit of adaptive creativity infuses these well-known formats.

EXPANSIVE VISIONS
Kōichi Kawana's Japanese Dreamscapes

Most gardens were created by Japanese specialists during work trips, Japanese designers who had relocated to the USA, and Americans trained in Japan. Despite their differences, all of these men were schooled in garden building. In contrast, the figure responsible for the greatest number of public Japanese-style gardens in North America and for their boldest revisioning, was trained neither as a landscape architect nor as a garden builder. The remarkable Kōichi Kawana was a renaissance man—a painter in ink (*sumi-e*) as well as in mixed media (Fig. 6), an *ikebana* master in the Adachi School, a potter, and an interior planner. Kawana had a B.S. in Economics from Yokohama Municipal University (1951), then from UCLA a B.A. in Political Science (1955), a M.A. in Political Science (1959), and finally a M.F.A. (1964) with a thesis on hospital interiors. After briefly lecturing in UCLA's Art Department, Kawana long worked as an interior designer for UCLA in the (non-academic) Department of Architects and Engineers. In 1966, he set up his own small landscape design firm, Environmental Design Associates. Kawana's doctorate came from the non-accredited Pacific Western University in 1979, when that new institution granted him their first Ph.D. in recognition of his professional accomplishment.

Kawana's familiarity with Japanese garden history and design stemmed from his teaching for UCLA Extension, a continuing education program aimed at working adults. His quarterly courses included "Japanese Domestic Architecture and Interiors," "Japanese Architecture: Public and Palace Architecture," "Japanese Garden Architecture," "Japanese House and Garden," and "Environmental Japanese Landscape Design." Gathering a circle of devoted followers, the so-called "Kawana-kai," Kawana also lectured widely on Japanese art in Southern California. Kawana's experience in garden design came from organizing the volunteers who created the Japanese garden at Descanso Garden in 1966, restoring UCLA's Hannah Carter Japanese Garden in 1968, then taking on several small commercial projects.

Given this untraditional "training," Kawana's body of work is astonishing, with magnificent gardens in St. Louis (pp. 108–13), Chicago (pp. 114–19), and Van Nuys (pp. 126–31), modest but creative gardens in Denver (pp. 120–5), Chanhassen (pp. 132–5), and at the Los Angeles County Museum of Art, and renovations in Memphis, Montecito, and Bainbridge Island (pp. 64–9). Kawana's essays, most notably "The Challenges of Building a Japanese Garden in the United States," do not elucidate a clear design ethos, simply affirming "The degree of authenticity of a Japanese garden depends, for the most part, on the creativity . . . of the designer, as the basic principles . . . are assimilated to the unique local environment."[7] And, despite criticizing gardens that are "merely an assemblage of typically Japanese features derived from books on Japanese gardens or copies from photographs . . . ," Kawana's gardens contain features easily

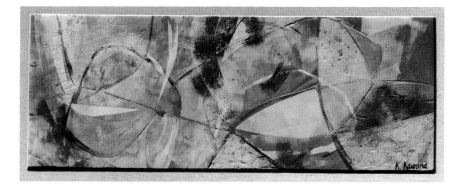

Fig 6 Untitled painting by Kōichi Kawana. Mixed media on paper, c. 1965. Collection of the author.

located among famous gardens. Further, his lectures and garden pamphlets repeat the orthodox mantra of authenticity and symbolism.

Yet, Kawana's best gardens exhibit a rare freshness of conception and boldness of vision. Unfettered by conventional training and with an abstract painter's creative capacity, Kawana sought to recreate the visual drama of great stroll gardens such as Okayama's Kōrakuen and Takamatsu's Ritsurin Park in the context of the Midwestern prairie or the Rocky Mountains. His methods were to expand scale, multiply design features, switch materials, and juxtapose elements. Although particularly adept at grand effects, as an interior designer Kawana was sensitive to how texture, color, and form could shape perception in intimate spaces. Kawana's improvisatory gardens built on

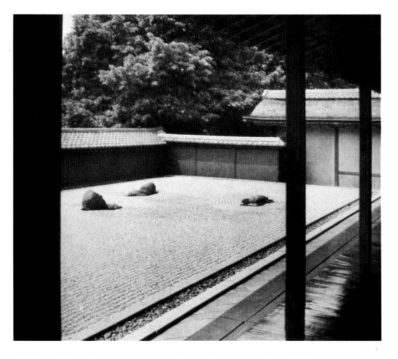

Fig. 7 Ryōanji Stone Garden, Brooklyn Botanic Garden, Brooklyn, New York, 1964. Photo courtesy of the Brooklyn Botanic Garden.

the ideas of Takuma Tono, Nagao Sakurai, Tadashi Kubo, Kingsley Wu, David Engel, and others. In Kawana's large gardens, the most distinctive features of Japanese garden art are mapped onto the expansive spaces of North America to create dream-like landscapes that may allude to other times and places but that give the visitor the experience of inhabiting a unique world.

TRADITIONS TRANSFORMED
Gardens for Changing Environments

In the 25 years from the Japanese Garden in Seattle of 1960 to Kawana's Suihō'en in Van Nuys of 1984, North American Japanese gardens increased dynamically in number, scale, and conception. In this realm of expanding possibilities, designers and patrons came to imagine Japanese-style gardens as capable of a range of functions. Most basically, it was no longer enough to show what a Japanese garden was and that it could be adapted to foreign soil. With those facts amply established, new gardens of note had to be better. They could be bigger and broader in their historic scope, as at the Morikami (pp. 154–9), more subtly attuned to their location, as at Montréal (pp. 144–9), and more daring in their environments, as in Phoenix (pp. 160–5). Alternately, they could be more natural, as in Hot Springs (pp. 166–71), or more overtly artistic, as at Boston. Or, they could strive to be almost all of the above, as at Rockford (pp. 138–43).

In an age when cultural institutions like museums evolved their missions from cultural uplift then education to social relevance, Japanese-style gardens too had to be more meaningful. Since simply "being Japanese" was not enough, claims to absolute authenticity were outmoded. For most gardens, the new paradigm was not authenticity in the service of cultural education about Japan, but evocative adaptation in the service of the visitors' perceived needs. These gardens are based on the assumption that they are authentic North American Japanese gardens, products of a real desire to evoke some of the best features of gardens in Japan as they make sense here and now. The ways of achieving these goals may differ, but none of these gardens is more authentic than the others.

Liberated from the responsibility of representing Japan, gardens were freed to rediscover their most basic functions. In recent gardens, these fundamental roles have been developed in ways and to degrees unmatched in earlier periods. These critical functions include exploring artistic creativity within a long tradition of design, creating culturally resonant evocations of natural landscape, and providing complex yet calming

environments that inspire and soothe. This last operation has become particularly vital, with many of these gardens utilized for social events like weddings and festivals, for art exhibitions, and for programs aimed at mental health. In short, these gardens have been transformed from primarily passive environments into far more active ones—a shift that makes them more like pre-modern Japanese gardens that were used for social activities.

Even as the idea of recreating Japan, as at world fair gardens and their progeny, has all but disappeared, neither has the opposite goal of internalizing Japanese principles to the exclusion of overt references been embraced, though Garven Woodland Gardens comes the closest (pp. 166–71).[8] Most gardens of the last two decades, and indeed the last 50 years, can be located on a continuum between these two poles. This fact reveals that a basic appeal of Japanese gardens in North America has long been their status as hybrids, though only recently has this condition been openly embraced. As artistic points of connection between and across cultures, the most resonant Japanese-style gardens encourage multiple forms of engagement and inspire different interpretations.

EPILOGUE
The Problem of Names in a Hybrid World

Because North America Japanese gardens cross cultures, they present challenges in writing about them in English. Paralleling the gardens' mixed status, in this book we use a hybrid system for Japanese names. To acknowledge the North American setting, and follow the conventions of most gardens and popular texts, Japanese citizens' names are given in Western order, with family name last. Thus, we refer to Jūki Iida, although in Japanese (and academic writing in English) he is Iida Jūki. However, because most gardens claim some degree of authenticity and seek to educate about Japan, we employ the "authentic" orthography of using ū and ō for names pronounced in Japanese with a long o or u. Finally, to create uniformity (and avoid the appearance of sloppy editing) among gardens that employ different systems of appending the suffix "en" (garden) to their name, in all cases we use 'en. Thus, the gardens that call themselves Sansho-en, Suiho en, and Ro Ho En, here become Sansho'en, Suihō'en, and Rohō'en.

Although the diverse ways of transcribing Japanese names are sacrificed for cognitive consonance here, readers should note them carefully. These divergent systems reveal the inescapable fact that North American Japanese gardens are not merely translations, they are transformations calibrated to their time and place and interpreted through social systems that add complex layers of meaning.

JAPANESE GARDEN IN MAYMONT PARK, RICHMOND, VA. 62779-C

Fig 8 Japanese Garden at Maymont Park, Richmond, Virginia, c. 1915.

1 Makoto Suzuki, "Kaigai no Nihon teien, kore made to kore kara" (Oversees Japanese Gardens, Until Now and From Now), *Shintoshi*, 61: 9, 2007.

2 F. Scott Fitzgerald, *This Side of Paradise*, New York: Charles Scribner's Sons, 1920, p. 197.

3 See Kendall H. Brown, "Constructing Japan in America: American Women and Japanese Gardens," in Noriko Murai and Alan Chong (eds.), *Inventing Asia*, Boston: Isabella Stewart Gardner Museum, forthcoming 2013.

4 See Anna H. Tamura, "Gardens Below the Watchtower: Gardens and Meaning in World War II Japanese American Incarceration Camps," *Landscape Journal*, 23: 1–4, 2004.

5 For a case study of a sister city garden, see Nancy M. Petitti's MA thesis, "The Japanese Friendship Garden in Balboa Park: The Evolution of an Idea," San Diego State University, 1994.

6 These gardens slightly complicate the examples discussed by Christina Klein in *Cold War Orientalism, 1945–1961: Asia in the Middlebrow Imagination*, Berkeley: University of California Press, 2003.

7 In "Japanese Gardens," *Plants & Gardens*, Brooklyn Botanic Garden Record, 1990, pp. 45–6.

8 These two approaches are detailed in David Slawson, "Authenticity in Japanese Landscape Design," in Patricia Jonas (ed.), *Japanese-Inspired Gardens: Adapting Japan's Design Traditions for Your Garden*, Brooklyn: Brooklyn Botanic Garden, 2001.

CHAPTER ONE
ORIENTAL EXOTICA

Fairs, Tea Gardens, and Estates in the Age of Madame Butterfly

Japanese-style gardens appeared first in North America in an age when Japan was striving to make a name in the world and when Japan was a new and magical discovery for Westerners. From the 1890s to the 1920s, Americans were infatuated with "the Japan idea"—a state suggested by the popularity of "Madame Butterfly" in print (1897), on stage (1900), at the opera house (1906), and on film (1915). Gardens were the ultimate manifestation of Japan's magical culture. Picturesque landscapes composed of gurgling ponds, arched bridges, and miniature trees, these gardens were feminine in their improbable beauty and the presence of *kimono*-clad women. Such exoticizing images were constructed at world fairs by Japanese government officials in large "Imperial Gardens" and by entrepreneurs in intimate Japanese Villages.

These influential landscapes spawned three kinds of progeny: commercial tea gardens at ubiquitous tourist traps, estate gardens at the "country houses" of tastemaking economic élites, and civic gardens thought capable of turning an industrial town into a "city beautiful." These diverse patrons found guidance in a handful of books and articles on garden philosophies and styles. The actual gardens, however, were built by the first generation of Japanese immigrants, men anxious to succeed financially and to leave the forms of their ancestors in the lands of their descendants.

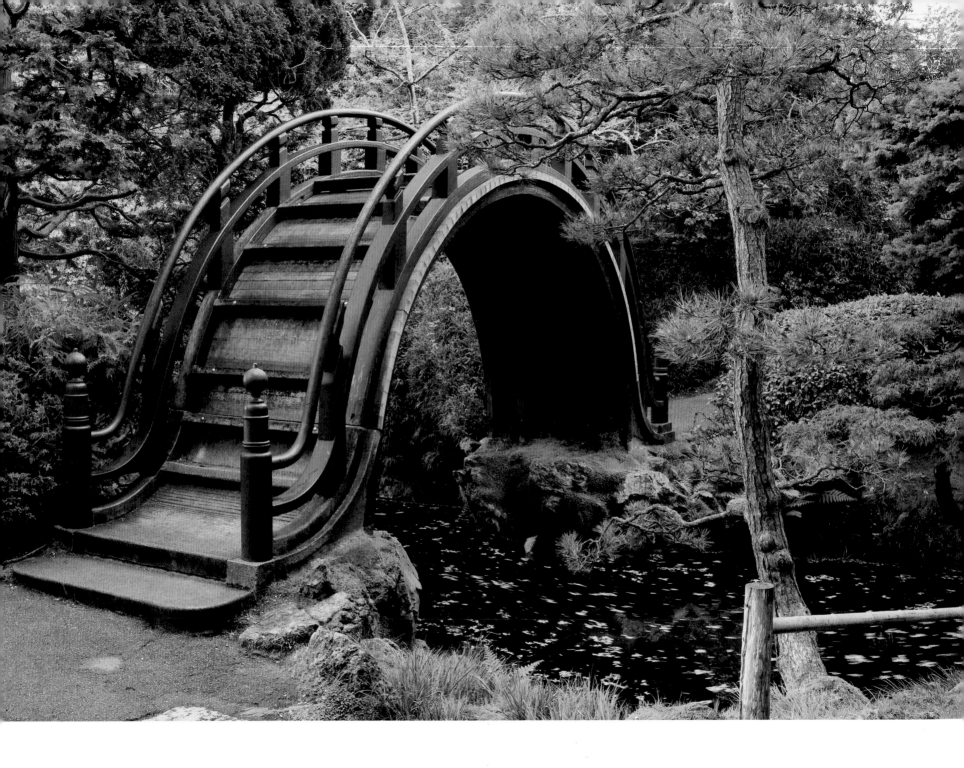

JAPANESE TEA GARDEN IN GOLDEN GATE PARK

LOCATION **SAN FRANCISCO, CALIFORNIA** DESIGNED BY **NAOHARU AIHARA, NAGAO SAKURAI, AND OTHERS** OPENED 1894 MAJOR ADDITIONS 1908, 1953, 1966

Previous spread The full moon bridge spans the pond at the Huntington Japanese Garden.

Opposite The drum bridge was created for G. T. Marsh's Japanese Village in 1894 by Shinshichi Nakatani.

Below The quiet "dry garden" was created by Nagao Sakurai in 1953 to update the garden.

The Japanese Tea Garden in San Francisco's Golden Gate Park is the oldest extant public Japanese garden in North America and, as one of its city's perennial tourist attractions, likely the most visited. Despite this status, the garden is virtually unique. With myriad structures and ornaments, it differs dramatically from other gardens in Japan or abroad. The garden projects a veritable Japanesque fantasy, an impression that stems from the Tea Garden's historical status as the product of two world fairs. Its roots are in George Turner Marsh's Japanese Village at the 1894 California Midwinter Fair, and its "western addition" was augmented by various structures when it was a commercial tea garden run by the Hagiwara family from 1902 to 1942. These embellishments—including the moon bridge, long bridge, Shinto shrine, and Buddha statue—culminated with the addition of a five-story pagoda from the Fair Japan concession at the 1915 Panama Pacific International Exposition. Artist Toshio Aoki may have designed the initial hillside landscape, then Naoharu Aihara created the new pond-style stroll garden during the era of Makoto Hagiwara.[1] The garden today is the product of many hands and sensibilities, reflecting more than a century of ideas about public Japanese gardens.

When the Hagiwara family was removed from the garden in 1942 as part of the relocation and interment of Japanese-Americans, the City of San Francisco took greater control. Renaming it the Oriental Garden, city officials destroyed the shrine, aviary, a wooden Buddha (replacing it with a bronze Buddha in 1949), and the Hagiwara house (turned into a

"sunken garden" in 1943). They also hired Chinese to work in the tea house and gift shop. A year after the signing of the US-Japan Peace Treaty in San Francisco in 1951, the garden's old name was restored, and new immigrant Nagao Sakurai was hired to design a dry garden in the northwest corner, then redo the entry area. To celebrate the normalization or relations, the Peace Lantern—a gift from the children of Japan—was dedicated in 1953, beginning the addition of commemorative lanterns and plaques.

In 1965, Samuel Newsom designed a new dwarf conifer hillside, with waterfall, in the western area, using specimen trees from the Hagiwara-Fraser collection removed during the war. The eastern section was also refurbished when the adjacent Asian wing of the de Young Museum was completed in 1966. Even though the garden and its structures have been renovated or restored several times, in 2005 the San Francisco Parks Trust and the San Francisco Recreation and Park Department commissioned historic structures and "cultural landscape" reports together with an assessment plan. Recognizing that the garden requires both repair and a vision that accommodates increased use while preserving history, these administrative groups have begun to position the garden for the twenty-first century.

Despite its history of contentious change and atmosphere of rampant exotica, the Japanese Tea Garden has exerted a powerful appeal. For many people, it is their first experience of a "Japanese garden." While the garden signals San Francisco's colorful charm for tourists, for locals it stands as an emblem of the city's diverse cultural heritage. As an icon of

the adaptation of Japanese culture in America, the garden has long appealed to novelists, appearing in passing in Japanese immigrant sagas, including Yone Noguchi's *The American Diary of a Japanese Girl* (1901) and Danielle Steel's *Silent Honor* (1996), and figuring in the climax of both Frank Norris's epic *The Octopus: A Story of California* (1901) and Marcia Savin's children's book *The Moonbridge* (1995).

1. The complex, and often conflicting histories of the garden are offered in Kendall Brown, "Rashōmon: The Multiple Histories of the Japanese Tea Garden at Golden Gate Park," *Studies in the History of Gardens and Designed Landscapes*, 1998; in Tanso Ishihara and Gloria Wickham, *The Japanese Tea Garden in Golden Gate Park, 1893–1942*, privately published, 1979; and in David Newcomer, *Public Japanese Gardens in the USA, Present and Past: Northern California*, privately published, 2007.

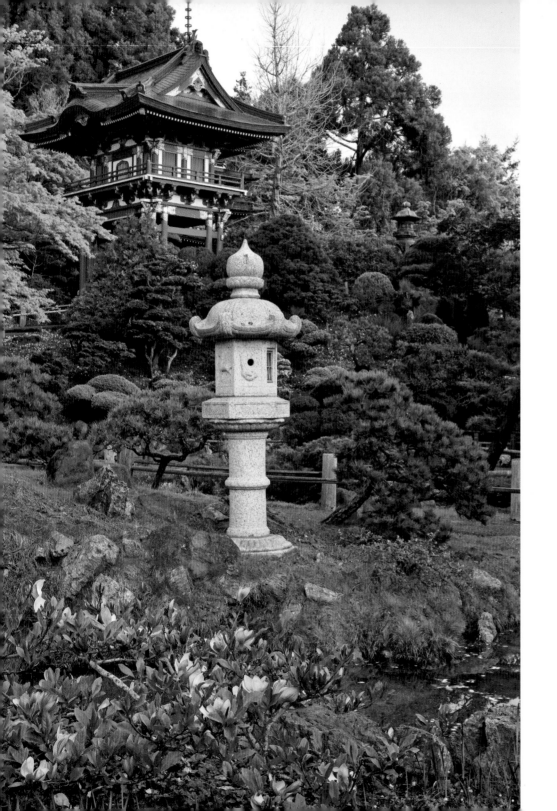

Above The boat-shaped water basin was gifted to the garden by the S. & G. Gump Company in the early 1960s.

Left The shrine building was moved from the Panama Pacific International Exposition of 1915 by Makoto Hagiwara.

Left Stone lanterns, in the Kasuga and other styles, enliven the garden.

Right Tea has been served in the hipped-roofed pavilion since the Japanese Village at the 1894 California Midwinter Fair.

Below The v-shaped "flying geese" pattern of this stone bridge reprises a motif from Kenroku'en in Kanazawa.

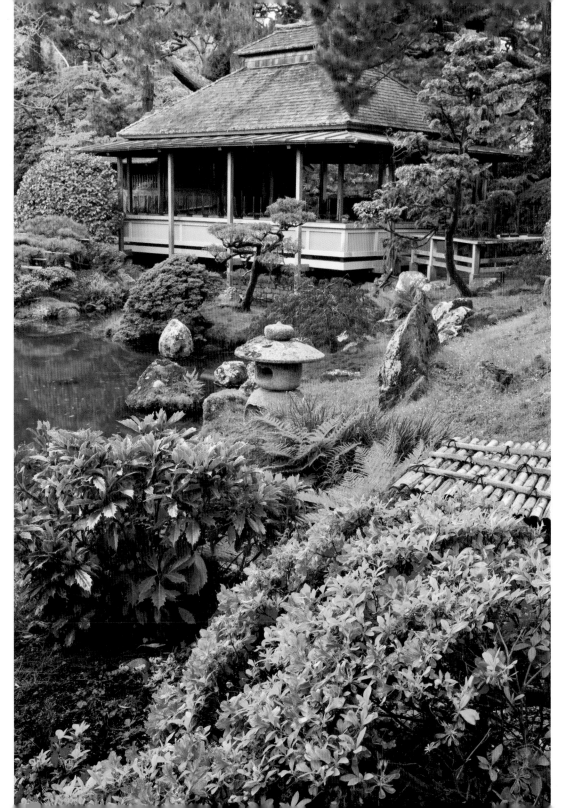

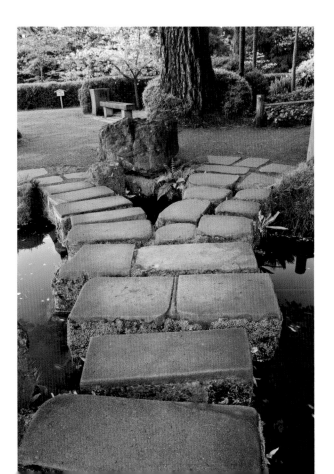

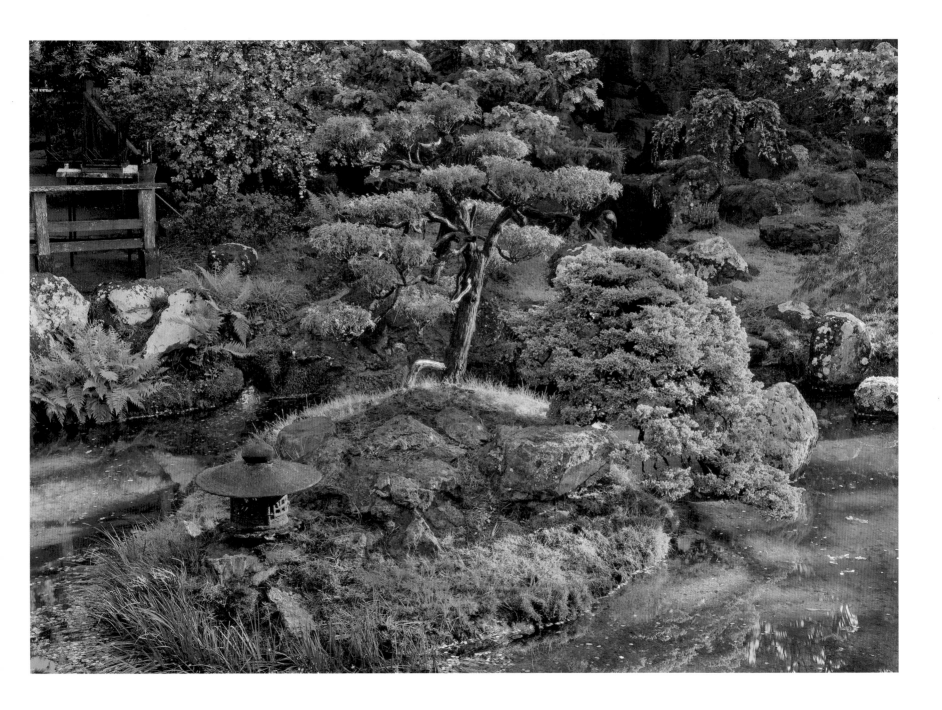

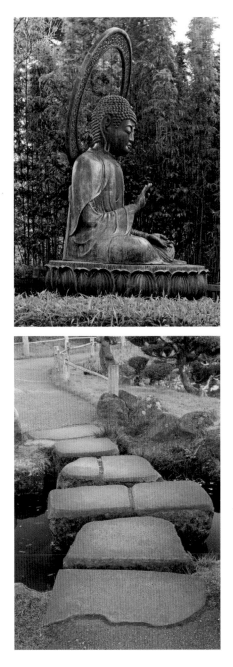

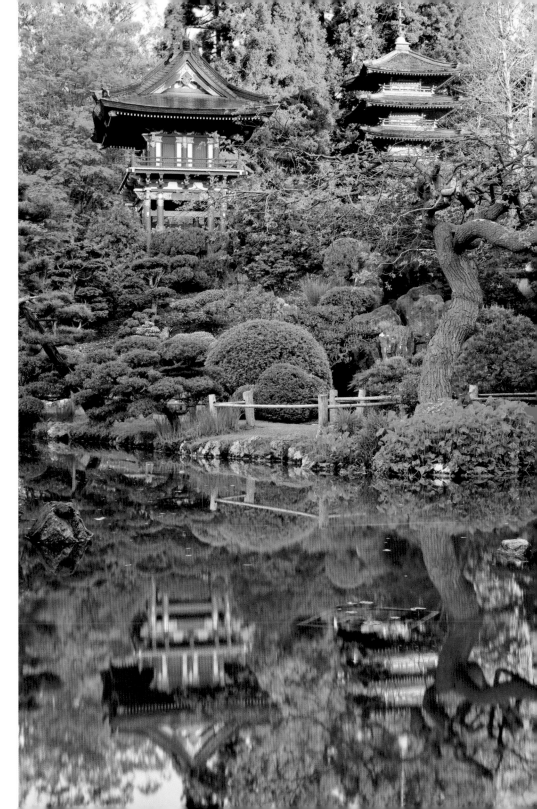

Opposite The so-called tortoise island is part of the entry area renovated by Nagao Sakurai.

Above left This 1.5 ton bronze Buddha, donated by Asian art importer S. & G. Gump in 1949, was cast in 1790 for the Taionji temple.

Left Stepping stones provide an elegant stream crossing.

Right The Shinto Shrine and Buddhist five-story pagoda are reflected in the shallow pond of the "western addition."

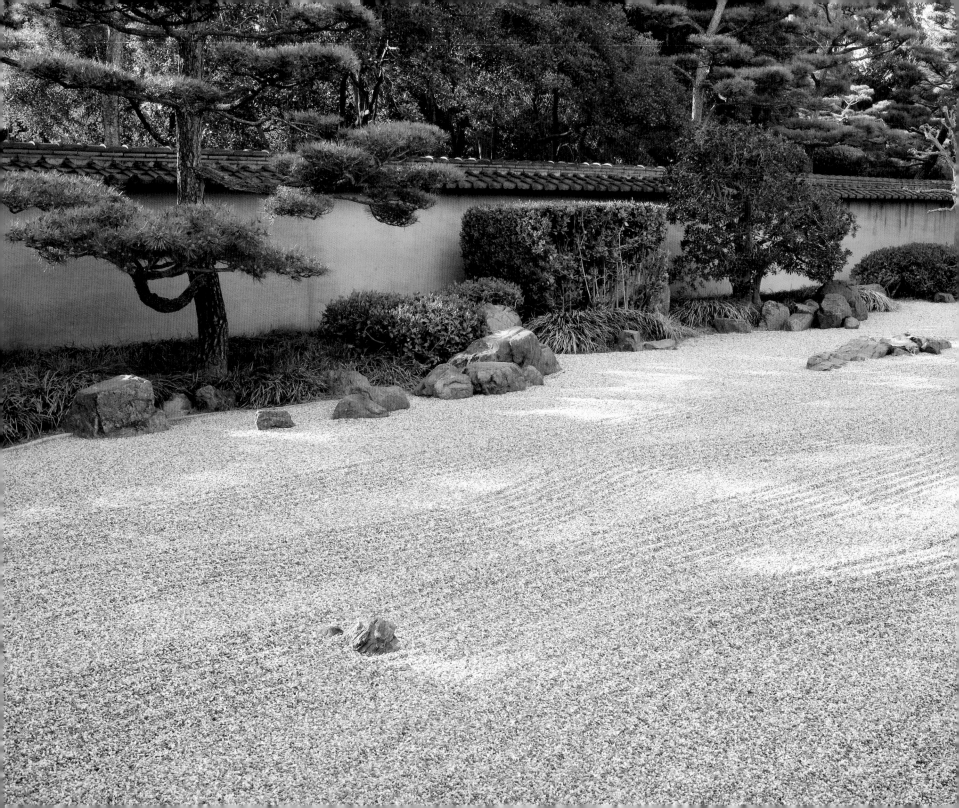

JAPANESE GARDEN AT THE HUNTINGTON BOTANIC GARDEN

LOCATION **SAN MARINO, CALIFORNIA** DESIGNED BY **WILLIAM HERTRICH, ROBERT WATSON, TAKEO UESUGI** OPENED **1911** MAJOR ADDITIONS **1968, 2012**

The series of Japanese gardens at the Huntington offer dramatic testimony to the rich history of Japanese gardens in North America. The Huntington gardens reveal the impact of exotic world fair and commercial tea gardens in the early twentieth century, the post-war discovery of "dry gardens," and the continued fascination with Japanese gardens in the twenty-first century. They also disclose the role of women in instigating and preserving gardens, and the ways in which generations of Japanese immigrants have sought work and identity in Japanese gardens. Most basically, these gardens reveal the multiple styles and meanings that have made Japanese gardens a staple of North American landscape design.

After the success of his Japanese Village at the California Midwinter Exposition, art dealer G. T. Marsh created Japanese gardens in several California resort cities. One of the first was the 3-acre G. T. Marsh and Co. Japanese Tea Garden at Pasadena in 1903. When it struggled financially, in 1911 Marsh sold the garden's contents to railroad baron Henry E. Huntington, who was seeking to transform his working ranch into a gentleman's estate. Huntington's impetus was likely his impending marriage to his widowed aunt Arabella, who needed sufficient cultural refinement if she were to live in Southern California a few months each year. Huntington's foreman, William Hertrich, directed

Above A hexagonal *yukimi* (snow-viewing) style lantern sits above a "rock" outcrop of textured concrete.

Opposite The "dry garden" was added in 1968 by Robert Watson, who based it on the garden at the chief abbot's residence at Daitokuji, Kyoto.

carpenter Tōichirō Kawai's relocation of the Marsh garden's house, two small pavilions, and entry gate to the Huntington estate, then Kawai's construction of two new gates and a bell tower. Hertrich personally supervised the molded concrete used for the pond, "rock" outcroppings, and mysterious grotto. This village-like garden set along a small valley was stocked with stone and iron lanterns, and further dressed with many Buddhist votive statues, also from the Marsh garden.

After Huntington's death in 1927, the estate became a library, art museum, and garden open to the public. Over the war years, the Japanese garden was neglected so that by the late 1950s many of the rotted structures were removed and the entire site slatted for destruction. However, local Japanophile Mary B. Hunt and the San Marino League fought to save the garden, conducting docent tours and eventually erecting the Ikebana House. Building on this renewed interest, and inspired by the Brooklyn Botanic Garden's replica of the Ryōanji stone garden, curator Robert Watson (aided by Eiichi Nunokawa and Sueo Serisawa) completed a new stone garden in 1968. Watson's design sensitively adapts the garden of the abbot's quarters at Daitokuji in Kyoto. Approached via a dramatic bridge from the Japanese house, and cantilevered on the hillside, it is surrounded by a walled courtyard. This enclosure leads to the Bonsai Court, created to house the Golden State Bonsai

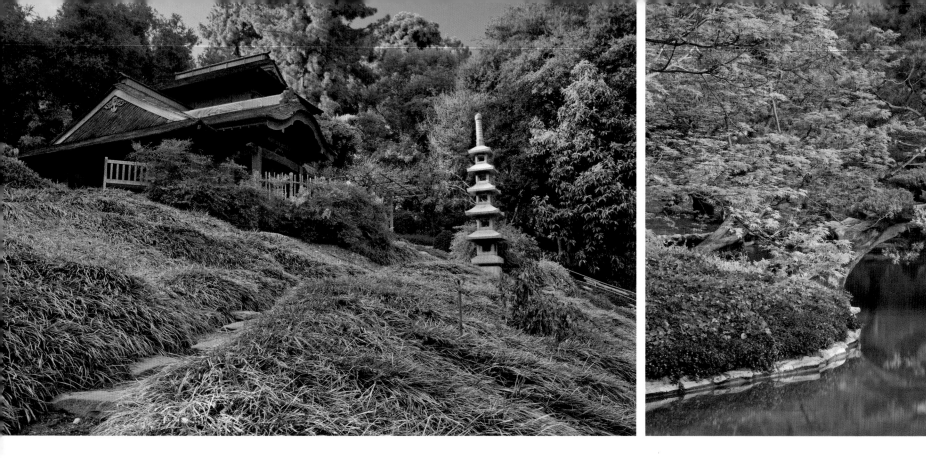

Federation's southern collection. Here the style shifts to what can be called "Japan-inspired California Patio," popularized in *Sunset Magazine* in the 1960s.

This tradition of transformation increased exponentially in 2011–12 when, under the supervision of Botanical Garden Director James Folsom, the Huntington carried out a simultaneous restoration and expansion to mark the centenary of the original garden. Spurred by the creation of Liu Fang Yuan, the Huntington's 4-acre Chinese garden opened in 2008, the institution undertook a major restoration of the Japanese House and the pond garden. In addition, using Hunt's bequest for a tea house, the Huntington acquired the Seifūan created in 1964 by Urasenke for the Pasadena Buddhist Church, had it refurbished in Kyoto by Nakamura Sotoji Construction, the company that originally built it, then assembled it in a tea garden (*roji*) designed by Takuhiro Yamada. Its location west of the stone garden led to Takeo Uesugi's redesign of the adjacent hillside. It is the first part of a planned multi-acre woodland-style Japanese garden—including a Treasure House to display *ikebana*, *bonsai*, *suiseki*, and art works—that extends west of the present garden complex. This ambitious project that preserves the past, addresses the needs of the present, and looks to the future is documented in a book published by the Huntington.[1]

1. T. June Li (ed.), *Harmony with Nature: 100 Years in the Huntington's Japanese Garden*, San Marino: Huntington Library, 2013.

Far left The Japanese House crowns the steep hill on the garden's west flank.

Left A rustic bridge of molded concrete supports a carefully pruned cypress.

Right The moon bridge gets its name from the circular "full moon" image created by the bridge and its reflection.

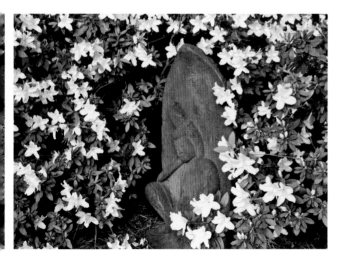

Far left A path through the camellia garden leads to Liu Fang Yuen, the Huntington's Chinese garden.

Left One of many votive statues, this stone sculpture, showing the Buddhist divinity Nyoirin Kannon, was inscribed in 1688.

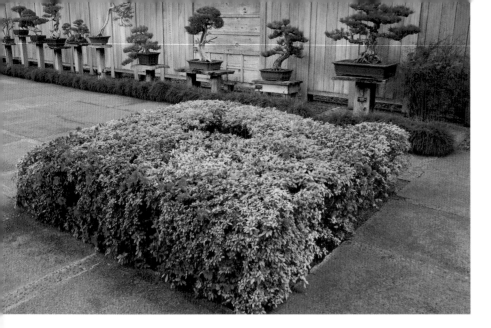

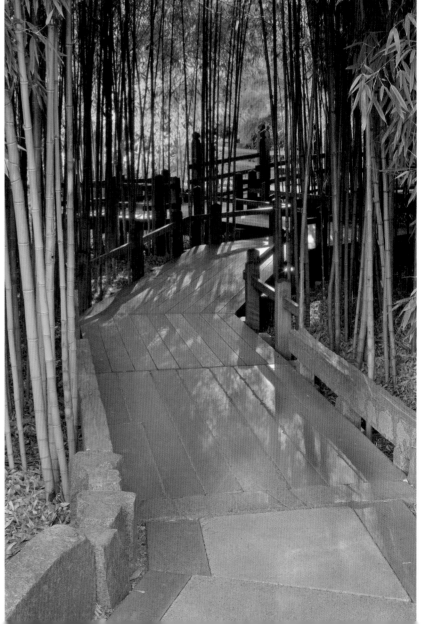

Above The Bonsai Court houses the Golden State Bonsai Federation's southern collection.

Below A stone statue of Buddha was added to the garden in the 1960s.

Right Curving through a bamboo forest, a path leads from the Japanese House to the new Tea House.

Opposite The moon bridge, built in 1912 by Tōichirō Kawai, originally was painted vermilion.

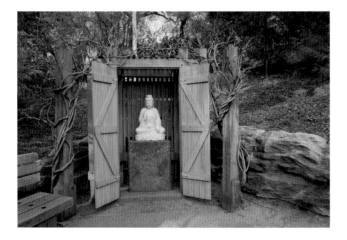

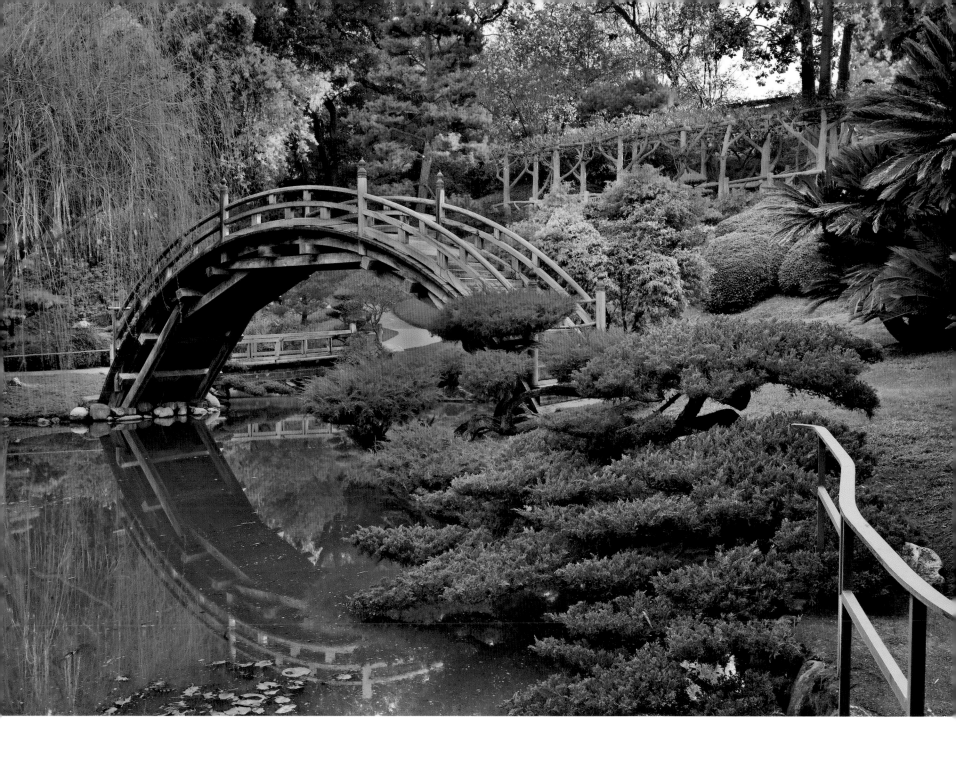

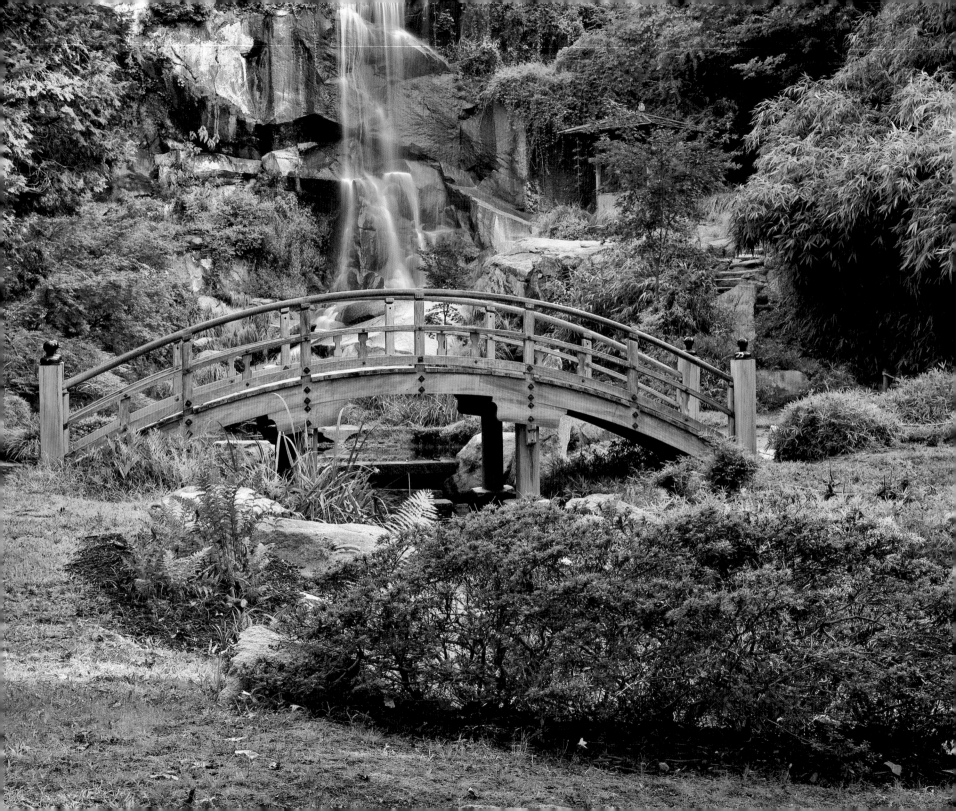

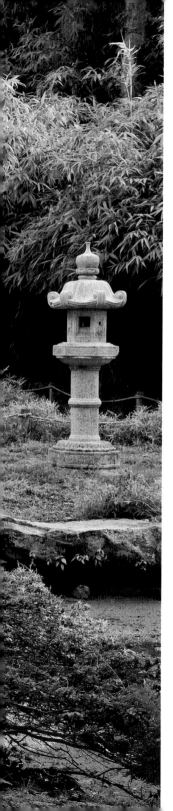

MAYMONT JAPANESE GARDEN

LOCATION RICHMOND, VIRGINIA DESIGNED BY Y. MUTO, BARRY STARKE OPENED 1911 MAJOR ADDITION 1977

In 1911, a half century after Richmond was the capital of the Confederacy, Major James H. and Sallie Mae Dooley commissioned a Japanese garden at Maymont, their 100-acre estate. The garden was part of the early twentieth-century vogue for Japanese gardens on the East coast, an area with few Japanese immigrants yet where "things Japanese" signaled good taste. When that fashion passed, old gardens often fell into disrepair and many of these have been destroyed. Some linger in decrepitude, and a few have been restored. Another option is sensitive preservation and expansion—as the current garden at Maymont demonstrates. In Richmond, the Dooley estate was given to the city in 1925 and transformed into a public park, with the resulting deterioration of the Japanese garden. The formation of the non-profit Maymont Foundation in 1975 led to the creation of a new garden that preserves elements of the original but expands it to respond better to the site and public use.

Typical of late Gilded Age élites, the Dooleys built an opulent house then surrounded it with expansive lawns, exotic plants, and fashionable gardens—including a Japanese Garden in 1911. Because the Dooleys' documents burned in 1925, the degree of their interest in Japan is unknown. Oral history and a 1933 *Richmond Times-Dispatch* article credit the garden to a Japanese named Y. Muto (possibly Mutō), who built the Japanese gardens in Philadelphia for John and Lydia Morris from 1905 to 1912, and in Fairmount Park in 1908. Photos show that Muto's garden was created at the base of the 40-foot artificial waterfall that descends the granite cliff separating the main house from the James River. A small pavilion perched besides the falls, and a gentle stream

Left Y. Muto created the original arched bridge and pavilion in 1912, although both have been replaced.

Above right A gate added in 1977 by Barry Starke creates a sense of formal entry.

was spanned by an earthen bridge and a path lined by a Kasuga-style stone lantern and smaller Tasoya (Who goes there?) wooden post lantern. All four elements are found in Josiah Conder's popular *Landscape Gardening in Japan*. Muto's trademark is his dramatic use of stones that stand in the garden and project boldly from the stream bank.

In 1975, the Maymont Foundation selected local land-scape architect Barry Starke to submit a Master Plan for the property. This plan called for a restoration of the 1907 Italian Garden but a renovation of the Japanese garden, given its generally poor condition and lack of historic significance. Although Starke had no experience designing Japanese-style gardens, he spent his honeymoon in 1976 studying gardens in Japan. His plan preserved the core of Muto's garden, and created a much larger garden around it. Starke based his design on the basic Japanese garden principles of sensitivity

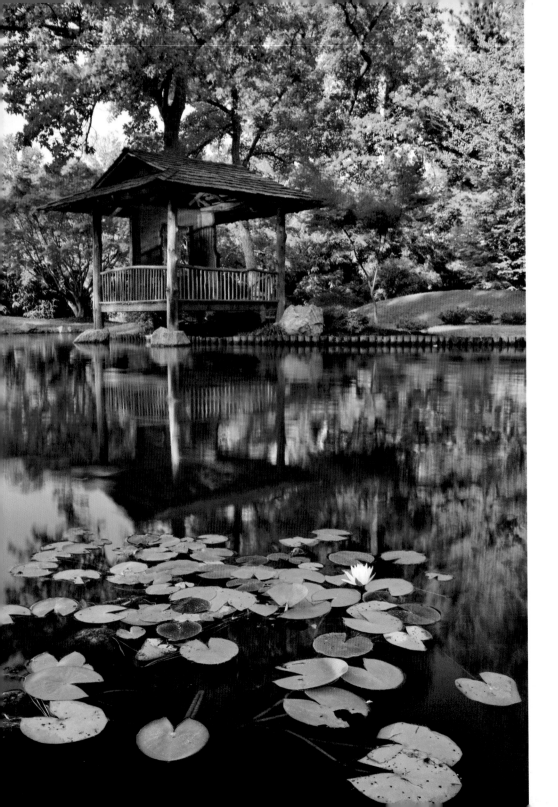

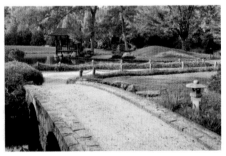

Left The rustic pavilion was placed by Junko Leisfeld in 2005 to add a rest spot and visual drama.

Top The artificial 40-foot waterfall is the garden's most dramatic feature.

Above A curved stone bridge traverses the eastern pond.

Opposite above A rectilinear wooden bridge contrasts with the undulating edge of the western pond.

Opposite below A fresh interpretation of a stone garden connects the west entrance and the historic garden core.

to the site and use of "found" materials—an approach necessitated by budget limitations and enthusiastic but unskilled labor provided by the City of Richmond's Young Adult Conservation Corps. A garden estimated at over $2 million was created for around $800,000. Starke also realized that, as a public park with a small staff and budget, the best way to control damage from picnicking and jogging was to design features that all but mandated quiet strolling through a series of controlled views.

Starke built a main western gate to create a sense of arrival, granting access but limiting views. For those descending the hillside from the north, he erected a small gate then arranged weathered boulders and "pools" to evoke a dry stream like that at Saihōji in Kyoto. From the west entrance, Starke created a stream meandering between moss-covered mounds, transforming an area of waterways and concrete islands added at some point by the city. This introductory garden leads to Muto's garden, where the defunct pavilion was rebuilt, a pool created at the base of the falls, and the earthen bridge replaced by a gently arched wooden bridge. Although concrete paths were demolished, the extant stone lantern, stones, and Japanese maples and ferns were retained. Starke also worked to isolate an incongruous grotto located along the cliff.

East of Muto's garden, Starke created a stroll-type pond garden by joining two straight-edged ponds into a single undulating lake with Japanese-style edging and a central island. Symbolizing the ocean in Starke's program, the lake concludes the theme of flowing water that unites the entire garden. A granite stone bridge along the lake's western edge connects the mainland to the island, and the island's east edge leads to the mainland via an eight-planked bridge (*yatsuhashi*) that traverses a cypress grove redolent of the Tidewater area. The lake's north side features water iris and a series of round stepping stones reminiscent of those at Kyoto's Heian Shrine. In 2005, and extraneous to Starke's original design, a wooden pavilion was donated for placement on the east edge of the lake, providing a focal point in the lake area, an elevated place to view the lake, and a spot for weddings or other events.

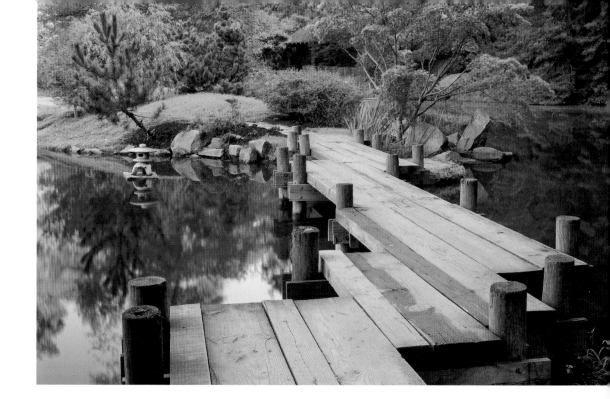

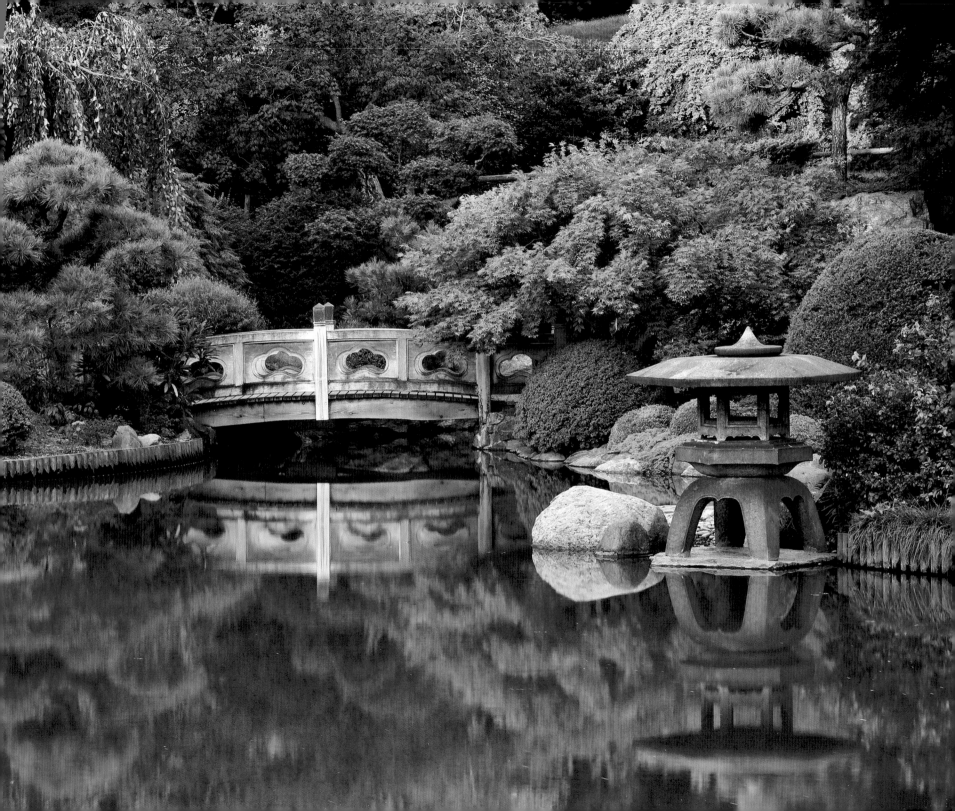

JAPANESE HILL-AND-POND GARDEN AT THE BROOKLYN BOTANIC GARDEN

LOCATION **NEW YORK, NY** DESIGNED BY **TAKEO SHIOTA** OPENED 1915

Opposite A *yukimi*-style lantern flanks the arched bridge that spans a stream between the waterfall and tortoise island.

Below This functional wooden bridge provides a view of the decorative drum bridge.

When Alfred T. White hired Takeo Shiota to design a Japanese garden at the Brooklyn Botanic Garden (BBG) in 1914, Japanese gardens had existed in North American city parks for 20 years. However, Shiota's garden in Brooklyn was the first constructed at an American botanic garden, and reportedly the first open free of charge. It is the only surviving pre-World War I civic garden—as distinct from the commercial "tea garden" in San Francisco's Golden Gate Park. More importantly, the Brooklyn garden marks the initial transformation of a *daimyō* pond-style stroll garden into a form that fits smoothly into the kind of pastoral park setting then being created across North America by the Olmstead firm. Furthermore, Shiota represents the first generation of immigrants who made careers designing gardens. Finally, the BBG holds a leadership position in the Japanese garden field, publishing handbooks on American Japanese gardens[1] and, in 1999, conducting a restoration that signaled the historic significance of North American Japanese gardens.

The Japanese garden was very much the project of White. A housing reformer known as "the heart and mastermind of Brooklyn's better self," White chaired the BBG board and donated $13,000 for the Japanese garden. After emigrating to the US in 1907, Shiota created six residential gardens in the greater New York area, but only the 3.5-acre garden in Brooklyn conveys his idea that a garden, like a landscape painting, should express the essence of nature in a limited space. Shiota held that the Japanese landscape was itself picturesque, like a perfect park, and encouraged relaxation and spiritual harmony—ideas that meshed with White's ideas for the Brooklyn Botanic Garden, adjacent to Olmstead and Vaux's famous Prospect Park.[2]

Leading a team of Japanese and Italian workers and one horse, Shiota created a large pond, said to be shaped in the character *shin* 心 (heart/mind). The pond is anchored on the east by a viewing pavilion that affords views across the water, past the turtle island and drum bridge, to a series of waterfalls that spill over concrete and stone grottos, or "echo caverns." South of this vista is a "sacred" axis that leads across the pond, through a Shinto *torii* like the famous one at Itsukushima, and to a small Inari shrine located in a grove at the back of the garden. Stone lanterns and bronze cranes enliven the shore and hillside. Plantings are generally restrained, though in spring the garden blossoms with azaleas on the north hillside, irises and tree peonies at the pond's north inlet, and a dramatic esplanade of cherry trees.

The shrine, which was gutted in an arson fire in 1939, was rebuilt in 1960, and likewise the viewing pavilion was reconstructed in 1963 after it burnt down in 1948. The garden remained little changed and largely was kept in good condition after the hire of Frank Okamura in 1947. However, steady plant growth and the silting of the pond necessitated a year-long $3 million restoration, completed in 2000. Although some consultants suggested renovation, Director

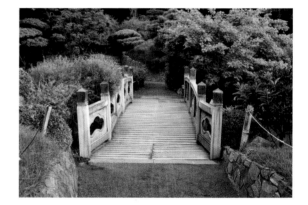

Judith Zuk decided to preserve Shiota's original vision, returning the bronze cranes and the lotus in the pond, as well as rebuilding the original shoreline. This care was not extended to a second Japanese garden, the "Ryōanji Stone Garden" suggested by Director George S. Avery in 1960 and created in 1963 by Prof. Takuma Tono. Located adjacent to the BBG's main building, the garden found little favor from visitors who expected plants, not stones, at a botanic garden. Even after Polly Faiman of Princeton created a *roji* (tea ceremony style) garden adjacent to it in 1972, the austere rock and gravel garden struggled for attention. It was finally removed in 1981.

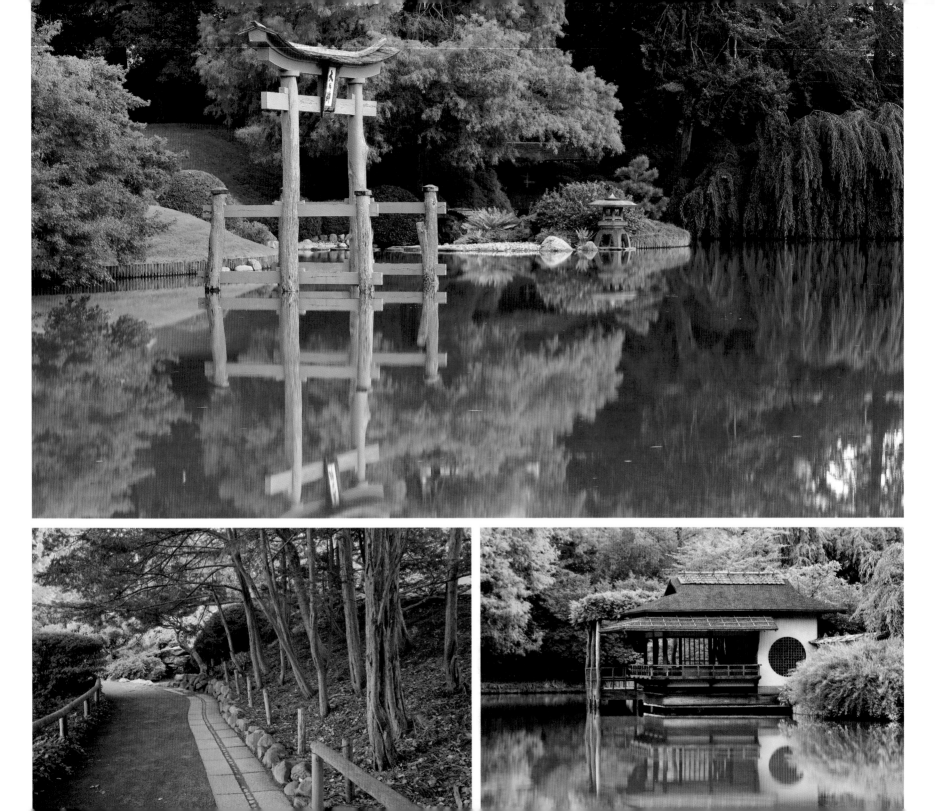

Left The great vermilion *torii*, based on the famous one at Istukushima Shrine near Hiroshima, is the garden's focal point.

Below left Curving paths parallel the pond and wind through a wooded grove.

Below right The elegant "viewing pavilion," originally called the Tea House, was renovated in 1999.

Right The "upper falls" cascades over poured concrete grottoes that increase its sound.

The creation of the "Zen garden" in the 1960s was likely an attempt to remain relevant and increase attendance. Far more successful has been the BBG's Sakura Matsuri (Cherry Blossom Festival), held throughout the entire facility on the first weekend in May. Started in 1981 and at first focused on traditional Japanese arts, in 2011 the festival drew around 72,000 people (at $15 for adults) over three days. This popularity is due largely to the addition of contemporary Japanese cultural forms, including pop music, *sudoku*, *manga*, *anime*, and cosplay (costume play). Tours draw youthful attendees to the old hill-and-pond garden, where hopefully they can realize a kinship between the creativity and fantasy that inspired the Japanese garden in the early twentieth century and their fascination with Japanese culture in the early twenty-first century.

1. These handbooks, focusing on creating and maintaining Japanese gardens in North America are Kan Yashiroda (ed.), "Japanese Gardens and Miniature Landscapes," *Plants and Gardens*, 17: 3, 1961, 6th printing 1979; Claire Sawyers (ed.), "Japanese Gardens," *Plants and Gardens*, 41: 3, 1983, reprinted 1990; and Patricia Jonas (ed.), "Japanese-inspired Gardens," *21st Century Gardening Series*, 2001.

2. For Shiota's biography, see Clay Lancaster, "Takeo Shiota's Japanese Gardens," *Plants and Gardens*, 14: 1, 1958/9, pp. 304–7. Shiota describes his philosophy of gardens in the pamphlet *The Miniature Japanese Landscape*, Newark, NJ: Newark Museum Association, 1915. See also Bunkio Matsuki, "The Japanese Garden of the Brooklyn Botanic Garden," *Brooklyn Botanic Garden Record*, 19: 4, 1930.

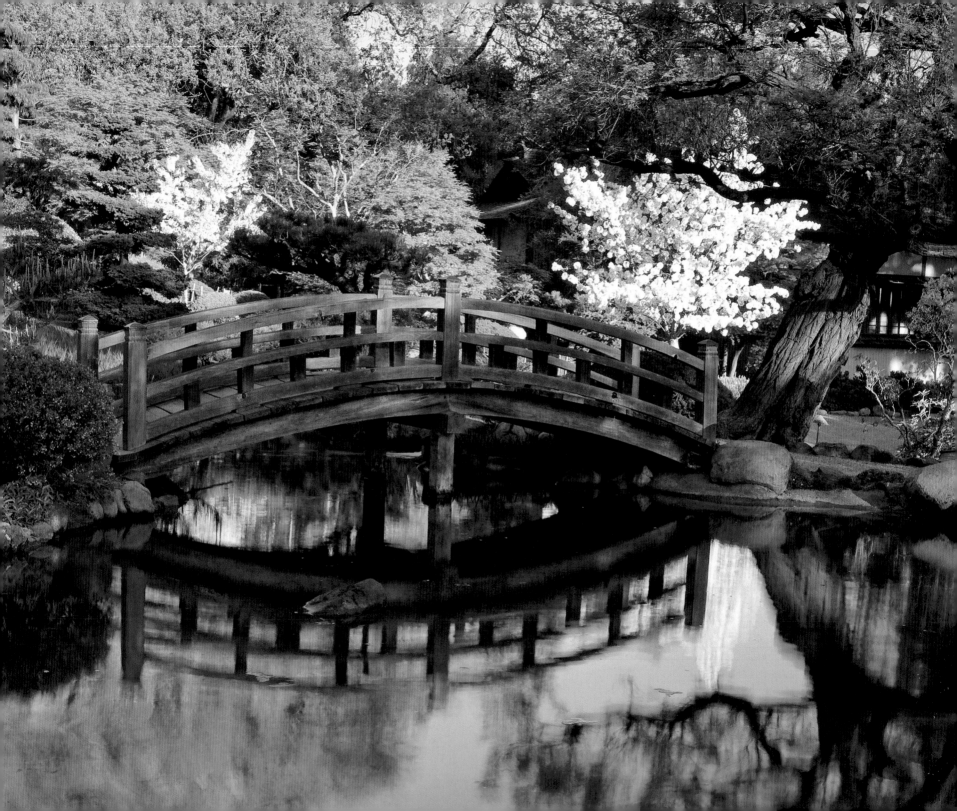

HAKONE ESTATE AND GARDEN

LOCATION SARATOGA, CALIFORNIA DESIGNED BY **NOBUHARU AIHARA, TANSO ISHIHARA** OPENED 1918 MAJOR ADDITION 1987

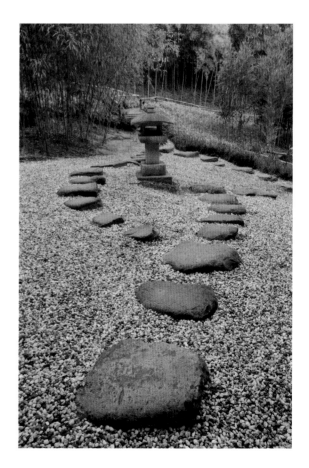

Opposite The familiar arched bridge marks this hillside garden as a product of the early twentieth century.

Below Stepping stones surround a Kanjuiji-style lantern in a "sea" of gravel on the upper terrace of the bamboo garden originated in 1987.

Although Hakone is the physical expression of one American woman's fantasies of Japan, it signals the broad fascination for Japanese gardens by women in North America. Different from other residential Japanese gardens, Hakone is not a garden attached to a country home. Rather, it was created by Isabel Longdon Stine as a sanctuary integrating dwellings and gardens. So compelling is the site, and so deep were Stine's passions for Japan and opera, that she staged a performance of Puccini's *Madame Butterfly* there in 1923. Since those halcyon days, Hakone has struggled for sustainability and identity. In the 1970s, it was an "authentic Japanese garden" in a city park. More recently, it is run by a foundation that embraces its history to present it as a Japanese-themed California retreat that can provide a meaningful space for the lone visitor, the couple getting married, or the corporate meeting.

Born and raised in San Jose, Isabel Stine may have visited Japanese gardens in Golden Gate Park, at resorts like G. T. Marsh's Owl's Nest in Mill Valley or Nippon-mura in Los Gatos, and at the estates of some of the Bay Area's leading citizens. However, it was at San Francisco's Panama Pacific International Exposition in 1915 that she fell in love with Japanese gardens. After Isabel and Oliver Stine purchased a Saratoga estate for a summer house in 1916, Isabel journeyed to Japan to study gardens and *kabuki*. When Oliver died in 1918, Isabel pressed ahead with plans for a Japanese-style

villa. She hired carpenter Tsunematsu Shintani to build a hillside house, featuring *tatami* mats and beautiful sliding *fusuma* panels, likely painted by Chiura Obata. Nobuharu Aihara, who had worked at the Golden Gate Park Tea Garden, landscaped the hillside with 43 cherry trees, a waterfall, and pond garden. The Lower House was finished in 1922, and a "cookhouse" and caretaker's residence soon after. Stine remarried at Hakone in 1924, but, after suffering losses in the stock market crash, sold the 16-acre property in 1932. Major Charles Tilden added a large entry gate in the late 1930s.

A Tilden heir sold the badly overgrown property to six families in 1961. Fearing commercial development, the City of Saratoga purchased the property in 1966. To maintain it, they hired Tanso Ishihara, who had cared for Kotani'en, a nearby Japanese estate also built in the 1920s. Ishihara initiated the major changes that mark the second part of Hakone's history. In addition to doing the first significant pruning and repair in decades, Ishihara also planned the creation of the dry garden in the courtyard of the Lower House. Together with local librarian Gloria Wickham, he wrote a book on Hakone.[1] Before his death in 1980, Ishihara connected Hakone with Kyoto area builder Kiyoshi Yasui. Initially, they founded the Japan Bamboo Society of Saratoga and created a large bamboo garden at Hakone. The two men helped establish a sister city relationship between Saratoga

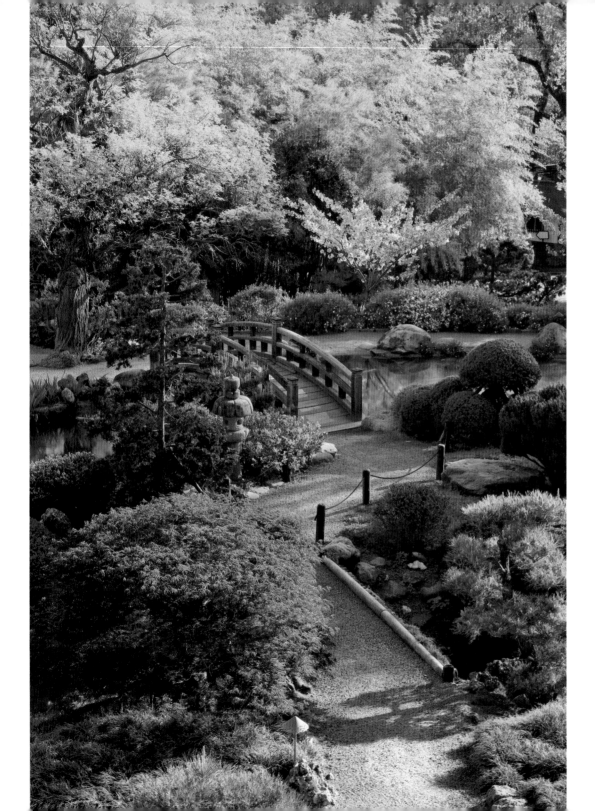

and Mukō, a small city near Kyoto where Yasui had strong connections. That tie was formalized in 1984, the same year that the Hakone Foundation was formed with the goal of "preserving, enhancing and developing Hakone." Utilizing funds borrowed from the City of Saratoga, the Foundation and Yasui's company built a Cultural Exchange Center on the site of the old cookhouse. Created in the style of a nineteenth-century Kyoto merchant's row house, the building altered the atmosphere of Hakone from a mountain villa to a kind of Japanese village. The Cultural Exchange Center adds an educational space, combining Japanese rooms with a cement-floored public area used for small exhibitions, performances, or meetings.

Over a century, Hakone has matured physically and socially. The Foundation has found greater financial stability through external grants and earned revenue. In addition to working out a new arrangement with Saratoga and revamping its leadership structure, the Foundation's advisory board is implementing a master plan focused first on the quality of the garden and training of the staff. Hakone has also made connections with specialists at the local, state, and national levels, moving to embrace practices commensurate with its rich history.

1. Tanso Ishihara and Gloria Wickham, *Hakone Gardens*, Kyoto: Kawara shoten, 1974, and "Hakone Gardens, Saratoga," in *California Horticultural Journal*, 1974. Both studies mix solid fact with conjecture and highly romantic visions of Hakone and "traditional Japanese gardens."

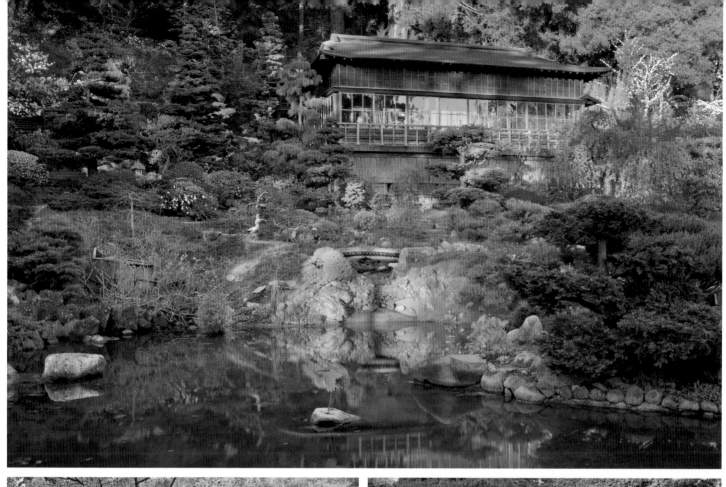

Left The Upper House, built by carpenter Tsunematsu Shintani, originally featured views over the Santa Clara Valley.

Far left The wood lantern was likely adopted from Josiah Conder's influential book, *Landscape Gardening in Japan*.

Left Bronze cranes were a standard feature for garden ponds, sold by Japanese garden supply shops in Japan and North America.

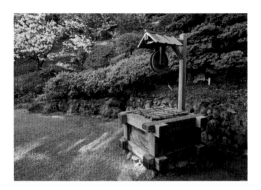

Above left A rustic well was another common feature in American Japanese gardens.

Above Kizuna'en, the Bamboo Park at Hakone, features about 20 plant varieties on a 2-acre site.

Left The Lower House, added to the estate in 1922, originally had three bedrooms but was remodeled in 1980 to serve as a meeting space.

Left Steps connect the pond and the Lower House with the Upper House and then the Tea House on the steep hill behind it.

Below Garden ornaments mix with real birds and *koi* in the pond.

CHAPTER TWO

BUILDING BRIDGES

Friendship Gardens in the Cold War Era

During the destructive years of World War II, Japanese-style gardens bloomed in the American west when internees strove to turn desolate internment camps into cultural and physical oases. The immediate post-war decades saw the flowering of civic "friendship gardens" that merged the culture of civic improvement with President Dwight Eisenhower's new sister city program. A key plank in Cold War cultural diplomacy that sought to promote human ties with former enemies, these peaceful and constructive sister city ideals were easily symbolized by gardens. With their aura of tranquility and pedigree of refinement, Japanese gardens were fitting cultural ambassadors in the tense nuclear age. A Japanese-style friendship garden offered living testimony of a city's internationalism as well as of its commitments to beauty and peace. If the garden helped build business relations with Japan, so much the better.

The hopeful message imparted by friendship gardens extended to selecting noted Japanese designers to create them. Many Japanese utilized this opportunity to work abroad to create large and sophisticated designs that referred to Japan's diverse garden history. These men usually had lofty plans but limited time in North America. As a result, most of these civic gardens shared the grand scale and hasty construction of pre-war exposition gardens. Those gardens that have flourished have done so through commitments to maintenance and to evolution of the original mission.

SHŌFŪSŌ JAPANESE HOUSE AND GARDEN

LOCATION **PHILADELPHIA, PENNSYLVANIA** DESIGNED BY **TANSAI SANO, DAVID ENGEL** OPENED **1958**

As the first example of Japanese architecture and garden art in North America after World War II, Shōfūsō helped recalibrate the popular perception of Japanese design from exotic effusion to modernist simplicity. As part of its "House in the Garden" exhibition series in 1954, the Museum of Modern Art in New York exhibited a Japanese house designed by Junzō Yoshimura, flanked by a small pond garden created by Tansai Sano. Named Shōfūsō, or Pine Breeze Villa, by MOMA curator Arthur Drexler, the house gave Americans a glimpse of a more refined type of Japanese architecture, interior design, and domestic garden style. Closely adapted from the *shoin*-style architecture of the seventeenth-century Buddhist subtemple Kōjō'in in Ōtsu near Kyoto, the Exhibition House was a success. Whether viewed as a minimalist Zen design, the product of *samurai* culture, or simply as timeless elegance, it was widely heralded as corrective to both post-war American industrial excess and lingering Beaux Arts romanticism. After Shōfūsō closed in New York in 1956, it was moved to Centennial Park in Philadelphia to commemorate that site—the location of the Japanese buildings at the 1876 Centennial Exposition— as the birthplace of Japanese culture in the United States.

Philadelphia's Park Commission accepted the house as the third Japanese structure in the park, following the 1876 Japanese buildings and a Buddhist temple gate that, imported for display at the 1904 St. Louis Exposition, graced the park from 1908 until it burned in 1955. Isao Okura was charged with moving the house and building a new entry gate. Sano was tasked with creating a larger garden around it by

Previous spread At the Portland Japanese Garden, visitors stroll through a variety of Japanese garden styles within a woodland setting.

Opposite The Japanese House appears behind a screen of trees from the road that circles it.

Below A stepping stone path lined with hostas leads to the tea house.

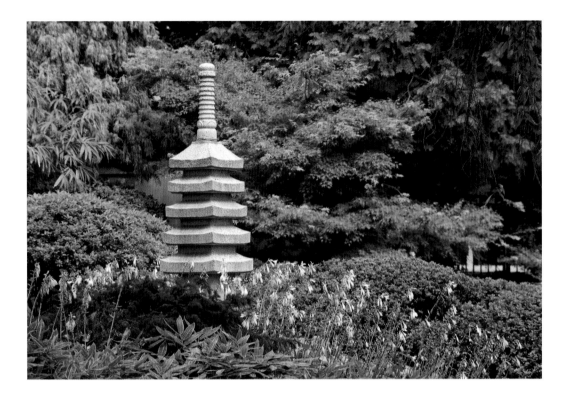

Above A five-story stone pagoda is one of several ornaments that add contrast to the lushly planted pond garden.

Left A flower arrangement graces a corner in the Japanese House.

Construction, and of the garden by Ken Nakajima's Tokyo Garden Architecture Institute. They created a drainage system, rearranged stones and lanterns, and constructed a berm to offer some protection for the garden and screen out views of Lansdowne Drive. To care for the property, Friends of the Japanese House was founded in 1978, incorporated in 1982, and hired its first salaried director in 1990. The non-profit group, which leases the house from the City of Philadelphia, is responsible for upkeep using money from the city and raised through donations and grants. Projects have included reroofing with cypress (*hinoki*) shingles in 1999 and then again in 2011, and adding a perimeter fence in 1993. As part of the fiftieth anniversary, much of the interior was restored in 2006 and, to honor the lost paintings, artist Hiroshi Senju donated a suite of his 26 *fusuma* paintings of waterfalls titled *Water Curtain*, *Imagination of Dynamics*, and *Imagination of Silence*.[1]

Though beautiful, the appropriateness of the murals is a subject of debate. So too is the garden, where Sano's original plan was never fully executed. Some have called for the installation of his planting scheme, while others have favored Hōichi Kurisu's 2003 plan to create a path around the rear of the pond to allow views to the house. Although Hiroshi Makita long worked replacing the stones brought from MOMA, the pond edge is an ongoing concern. In similar fashion, consultant Asher Brown has suggested new plantings and the removal of trees that block the original view to Memorial Hall.

Although Shōfūsō faces significant challenges, its invigorated leadership, active fundraising, and events—ranging from the conventional Sakura Matsuri to dance performances in the garden—point to a dynamic future. With a new emphasis on education, long-term plans call for the creation of a visitor center on the site of the Japanese Bazaar from 1876.

adapting the old stream and pond garden that had surrounded the recently destroyed gate. Sano worked on the site in the summer and fall of 1957, then turned the job over to David Engel, who had just returned from several years studying with him in Kyoto. After opening on October 19, 1958, Shōfūsō was initially popular. By the mid-1970s, however, visitors dwindled as neglect and vandalism quickly reduced the once elegant structure to a shadow of its former self. The crowning indignity came in 1974 when vandals destroyed the interior *fusuma* paintings by the renowned artist Kaii Higashiyama.

Shōfūsō began its rebirth with a Japanese-funded restoration of the house, implemented by Nakamura Sotoji

1. For photos of the paintings, and a thorough study of the garden, see Yūichi Ozawa, *Story of Shōfūsō*, Philadelphia: Friends of the Japanese House and Garden, 2010.

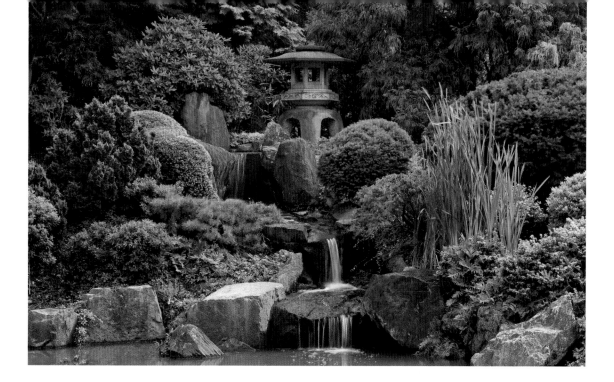

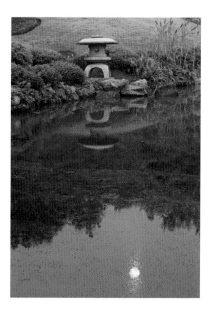

Above The pond is fed from the south by this pump-driven waterfall and by a natural stream from the north.

Above right The shoreline includes a Misaki-style lantern and stones, brought from the exhibition house garden at MOMA.

Right The stately Japanese House presents a seventeenth-century temple residence interpreted in a lightly Modernist style.

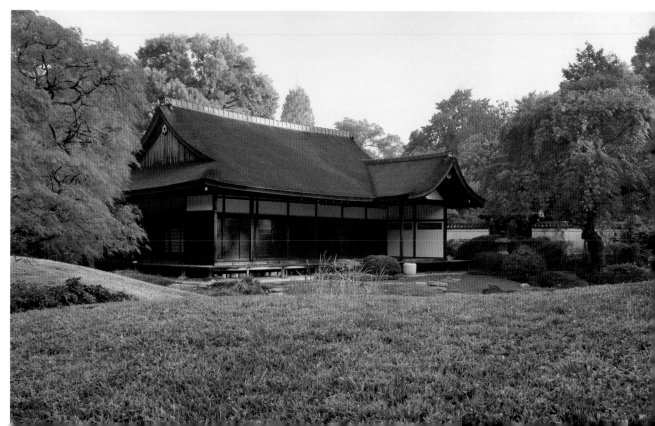

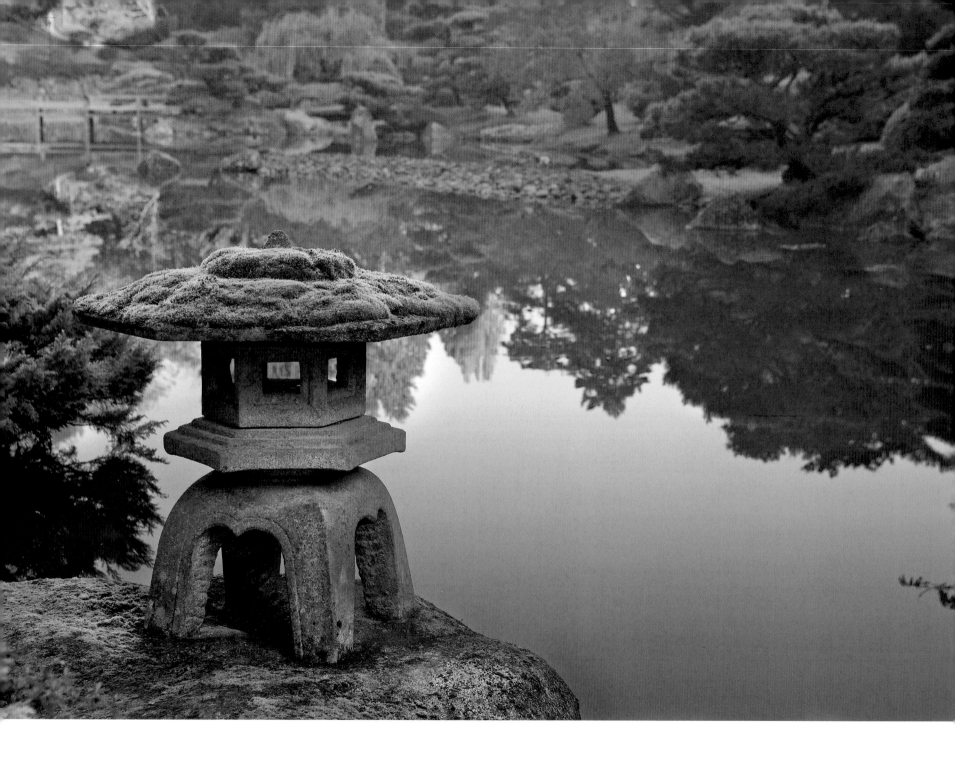

JAPANESE GARDEN AT THE WASHINGTON PARK ARBORETUM

LOCATION SEATTLE, WASHINGTON DESIGNED BY JŪKI IIDA, KIYOSHI INOSHITA OPENED 1960

Opposite This hexagonal *yukimi*-style lantern stands sentinel over the stone beach that recalls the famous Amanohashidate feature at Katsura Villa, Kyoto.

Below A cut stone bridge and electric street lights give parts of the garden the feeling of a rural village.

This compelling garden, arguably one of the finest in North America, culminates a rich history of Japanese garden building in Seattle that started with a garden at the Alaska-Yukon-Pacific Exposition in 1909. It was the first major public Japanese garden built on the West Coast after World War II, and its creation inspired a flowering of public gardens from Vancouver to San Diego. The Seattle Japanese Garden also set a new standard as the earliest major permanent garden built in North America by well-established designers from Japan. Working on a large scale and with a sense of freedom, those designers were inspired to create a garden complex in design and rich with historical allusion that would project Japan's position in the post-war world as simultaneously retrospective and progressive.

In 1937, Seattle's recently founded Arboretum Foundation invited Japan's International Cultural Society to landscape a 5-acre section of Foster Island. The war postponed that general idea until 1957, when the Arboretum Foundation's Emily Haig—with the blessing of the University of Washington and a generous donation from Prentice Bloedel—proposed a Japanese garden in a part of the Washington Park Arboretum that sloped from a forest to a marsh. Diplomatic contacts led to Tatsuo Moriwaki, chief of the Tokyo Metropolitan Park and Green Space Bureau, who discussed the project with his former colleague, Kiyoshi Inoshita, then head of the Japan Institute of Landscape Architects (Nihon zōen gakkai). For the job, they chose Jūki Iida, an important figure in creating naturalistic, modern gardens in Tokyo. Under Inoshita's guidance, Iida and five colleagues in Tokyo's Park Bureau drafted an extensive

plan for a 3.5-acre garden to be built around the tea house given to Seattle by the City of Tokyo in 1959.

The garden was designed in three sections. In the analysis of Prof. Makoto Suzuki, Iida designed the informal southern section that merges a rustic Japanese garden with a woodland full of pines and oaks. In this forest, earthen paths cross streams then a gentle waterfall, before merging at the tea house which has the character of an elegant mountain villa. The tea house marks a transition to a semiformal section of the garden, where the forest opens to reveal the southern section of the lake. With its distinctive stone beach punctuated by a Misaki-style lantern, this part of the garden references the Amanohashidate (Floating Bridge of Heaven) area at Katsura Villa, one of the Kyoto gardens visited by Iida and Inoshita when planning the Seattle garden.

This stony peninsula points to an island, reached by bridges from either shore, which divides the lake into two sections. The northern half of the lake, likely designed by Inoshita, is formal in style, featuring sharp angles epitomized by the straight-edged boat landing stone. One drawing shows a large pavilion overlooking the lake from the hill at the north end of the garden. This area was meant to symbolize a fishing village along the ocean, so that the water in the garden flows symbolically from the mountains to the sea. Suzuki speculates that this area represents a Garden of the Immortals (Hōrai'en), and was Inoshita's recreation of the early seventeenth-century garden of the Matsuura clan—a garden destroyed by the Tokyo government in 1937 despite Inoshita's attempt to preserve it. The distinctive Omokage-

style lantern on the north shore in Seattle reprises the signature lantern in that defunct *daimyo* garden.[1]

Because of careful planning and study trips to Seattle, construction was done between March 8 and the garden's opening on June 5, 1960. Iida and Nobumasa Kitamura, of the Tokyo Parks Bureau, were in charge of construction. They excavated the site and set—using a crane for the first time—500 stones gathered from Snoqualmie Pass. The two Japanese were aided by the Japanese-Americans Kei Ishimatsu, William Yorozu, and Richard Yamasaki. The original entry gate was in the middle of the garden on the east side, directly from Arboretum Drive, but lack of easy access led to a new entrance near the parking lot on the south. The other major change was the destruction of the original tea house by arson in 1973, and the creation of a new one, called Shōseian (Arbor of Murmuring Pines) in 1981, with money raised locally and through contributions by the Urasenke Foundation.

Despite the garden's strong design by illustrious designers, its maintenance long suffered due to poor management and scanty funds. In 1981, the University of Washington and the Arboretum Foundation transferred management to the Seattle Department of Parks and Recreation, though the garden was quickly adopted by the Arboretum Foundation's Unit 86 as part of the city's "Adopt-a-Park" program. The Friends of the Japanese Garden group was incorporated in 1983, and the City's Parks Department formed a Japanese Garden Advisory Council in 1993. The garden's fiftieth anniversary in 2010 prompted serious discussion about transferring full or partial management to a non-profit group. This increased attention

also resulted in a spate of maintenance projects during the 2000s. These included dredging the pond, reconstructing the moon-viewing deck, resurfacing the bed of the waterfall and stream, replanting iris beds, and building a new South Gate along with a gatehouse that includes a small exhibition room.

1. Nobumasa Kitamura, "The Japanese Garden in Seattle," *Toshi kōen*, 26, 1960; "Our Japanese Garden," *Washington Park Arboretum*, XXIII: 4, 1960; Jūki Iida, "The Japanese Garden at the University of Washington," *Niwa*, 13, 1974; Makoto Suzuki, "The Japanese Garden of Seattle: Significant Features of the Plan and Design," *Zōen gijutsu hōkokushū*, 2011.

Top The russet tones of a maple brighten the garden in fall.

Above The naturalistic stream was designed and built by Jūki Iida, a pioneer of the informal garden style.

Left Earth and gravel paths skirt the pond, creating variety through their tone, texture, and shape.

Opposite left In morning light, the pond reflects the trees, shrubs, and stones that edge its undulating shoreline.

Opposite right A Kasuga-style lantern shows an image of the sacred deer at Nara's Kasuga Shrine.

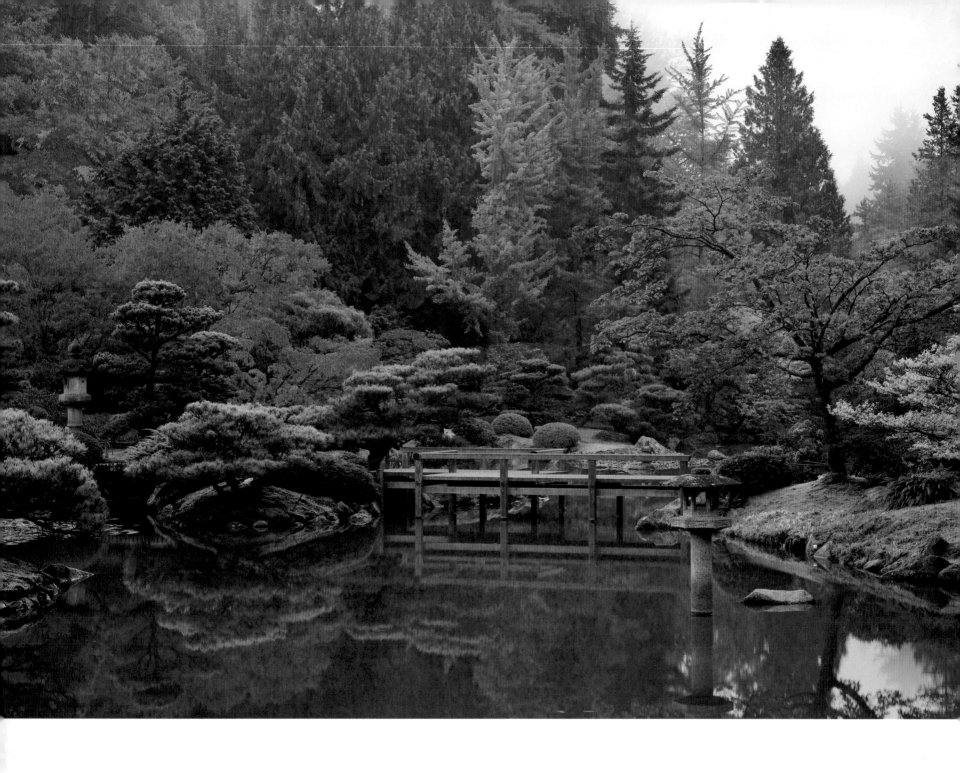

Left The rectilinear bridge and *tachi-yukimi*-style lantern mark the north end of the pond garden, designed by Kiyoshi Inoshita.

Above The delicacy of the tea house is underscored by several varieties of Japanese maple.

Above right A Misaki-style lantern marks the point where the pond transitions from its semiformal southern area to the formal north section.

Right The sharp geometry of this lantern sets off the natural feeling of the garden's entry area.

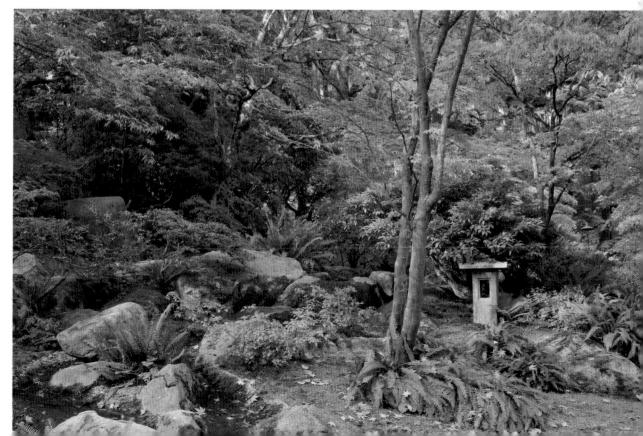

NITOBE MEMORIAL GARDEN AT THE UNIVERSITY OF BRITISH COLUMBIA

LOCATION VANCOUVER, BRITISH COLUMBIA DESIGNED BY KANNOSUKE MORI OPENED 1960 MAJOR ADDITION 1993

Below left The pond edge reflects the subdued renovation by Shunmyō Masuno in 1994.

Right The pavilion provides views of the tortoise island and the earthen bridge.

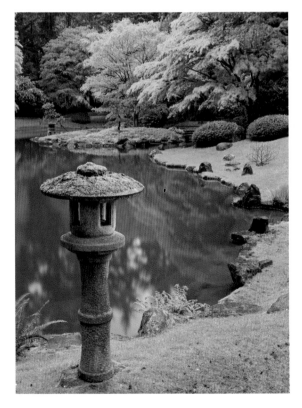

The Japanese garden at the University of British Columbia serves at least two vital missions for its patrons: it demonstrates the university's progressive international legacy, and it expresses the broader Canadian community's commitment to Japan and to its own Japanese-Canadian citizens, who were not merely interned during World War II but banned from returning to British Columbia until 1949. For the designer, Prof. Kannosuke Mori, the garden's messages of international friendship and outreach to the local Japanese community were no less important. Similarly, both client and designer desired a Japanese garden that, rather than recreating a traditional style, would evince the time and place of its creation in the spirit of a world renewed after the destruction of war.

When famous Japanese educator and diplomat Dr Inazō Nitobe died in Victoria, BC, in 1934, to honor Nitobe's vision his local associates erected a lantern and small garden on the UBC campus. After this memorial was destroyed to accommodate new dormitories in the early 1950s (having been vandalized during WW II), the local Japanese-Canadian community, with the support of the Japanese government, sought a new memorial to Japan's best-known statesman. University President Norman MacKenzie

supported the project by donating 2.2 acres of university land along Marine Drive, and the Japan-Canada Society and Vancouver area citizens contributed funds. To design a garden, Prof. Mori was selected with the help of the Japanese Consul General in Vancouver. Mori, who had studied in the US and Germany from 1931 to 1934, founded the Landscape Architecture program at Chiba University where he had taught since 1922. At UBC, where he spent three months in design preparation then several more supervising construction, Mori worked with J. W. Neill, Associate Director of the Botanical Garden, and with many members of the local Japanese-Canadian community. Although the university's rhetoric sometimes stressed an "authentic" Japanese garden, evidence suggests that, with the university's blessing, Mori intended to create a "Canadian Japanese Garden."

To achieve this goal, for this pond-style "Shinto strolling garden" Mori sought to maximize local materials, including about 500 stones from various mountains and rivers near Vancouver, and plant species native to the area. These materials were used in daring ways. For instance, along the lake edge Mori placed colorful stones to add a polychrome element, and arranged others in dramatic fashion. Mori also purposely juxtaposed Canadian plants with cherry, maples,

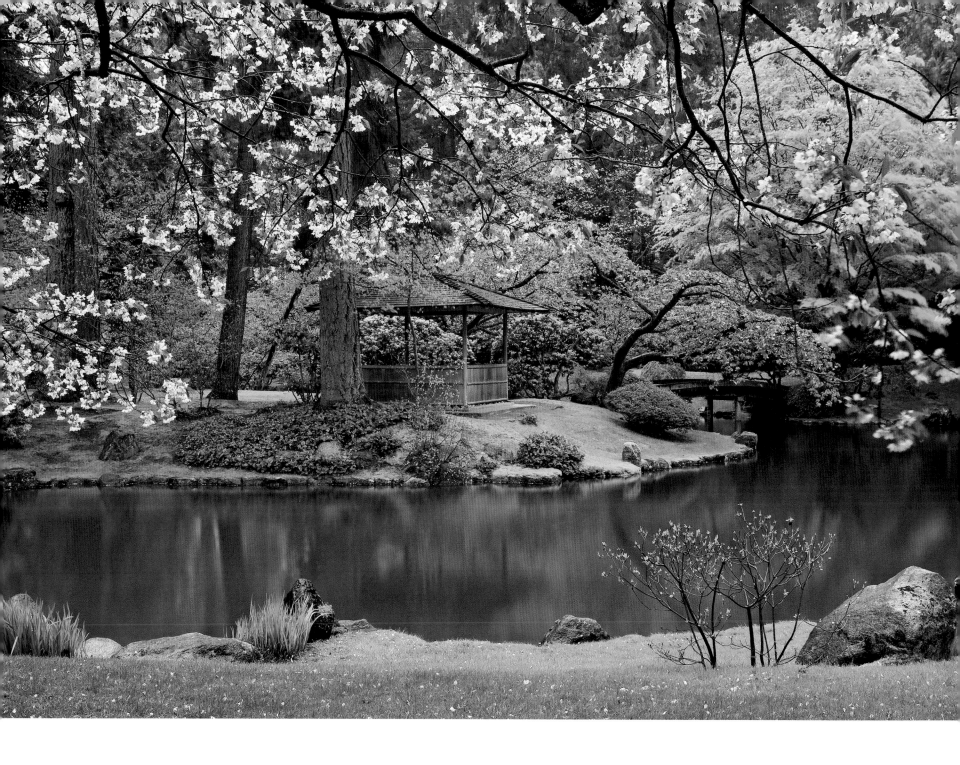

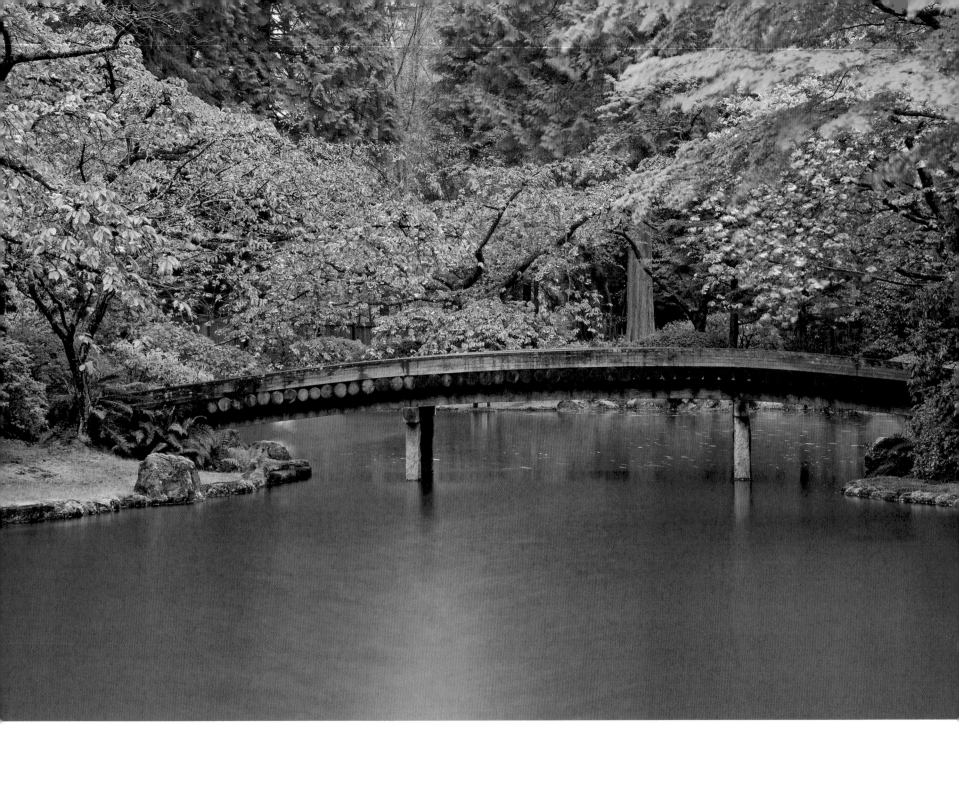

rhododendrons, and iris brought from Japan. He deployed chrysanthemums and azaleas in vibrant groupings around the Nitobe Memorial Lantern in order to demonstrate Japan's contributions to the local environment. Mori also sought to bring together people through the garden, staying in Vancouver for a month after the garden's opening on May 3, 1960 to teach proper maintenance techniques to local Japanese-Canadians. His efforts led to the founding of the Vancouver Japanese Garden Association, and a 27-year legacy of skilled Japanese-Canadian gardeners working in the Nitobe garden.

Despite this commitment to maintenance, by the early 1990s the garden canopy was largely overgrown, the tea house was aging, and the pond was marred by a leak as well as a shifting shoreline. In 1992, the Japanese garden—now part of a campus Culture Zone—received funds from local and Japanese cultural and business organizations for major repairs. On the recommendation of the Nitobe Restoration Committee, Japanese landscape architect and Zen priest Shunmyō Masuno was selected to renovate the garden. Working with Shin'ichi Sano, heir to the famous garden construction family from Kyoto, as well as with local contractors, Masuno restored the Ichibō'an tea house, created a new garden wall to dampen traffic noise, added an entrance

Opposite Called the "77 log bridge," this gently arching bridge is made of pounded earth within a superstructure of 77 timbers.

Above Broad paths lead around the pond, passing beneath a grove of maples.

Right The waterfall feeds the large pond from the garden's north corner.

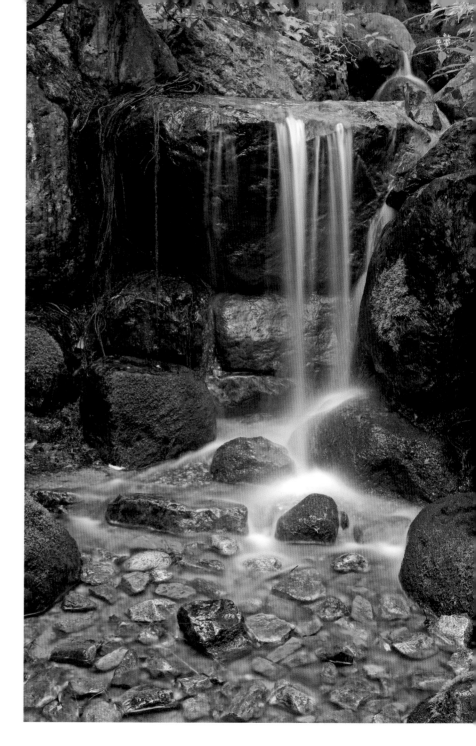

gate, did major pruning, and replaced Mori's colorful azaleas along part of the pond. More controversially, in addition to adding a pebble beach in front of the waterfall, the team substituted 100 tons of new stones for many of Mori's stones on the shoreline, creating a far more subdued appearance to the garden's main feature. Reflecting the new "Zen" interpretation of the garden, the symposium conducted to celebrate the garden's reopening in 1994 focused on the spirit of "traditional Japanese gardens." Reportedly, the Japanese-Canadian gardeners who were central to Mori's concept and the garden's history were estranged by the renovation.[1]

After publication of an article by a Chiba University graduate criticizing Masuno's renovation, the beach area was removed as were some of the "new" plantings. In 2011, UBC hired a new garden curator who studied at Chiba, and received a study visit from Chiba landscape architecture faculty and graduate students to report on ways that Mori's design might be restored. In these ways, the Nitobe Memorial Garden brings into sharp focus the important debate over restoration versus renovation, and throws into relief the notion that some North American Japanese gardens are important historical spaces that deserve preservation despite the continuing desire of designers and patrons to create gardens that are more "authentic" or even simply "more beautiful."

1. John Neill, "Nitobe Memorial Garden: History and Development," *Davidsonia*, 1: 2, 1970; Patrick Mooney, "Achieving Serenity: Learning from Nitobe," *Landscape Architectural Review*, 10: 4, 1989; *Nitobe Memorial Garden International Symposium Proceedings*, Vancouver: University of British Columbia, 1994; Shunmyō Masuno, "Renovation of Nitobe Memorial Garden in Vancouver," *Journal of Japanese Institute of Japanese Architecture*, 58: 3; and Seiko Gotō, "Maintenance and Restoration of Japanese Gardens in North America: A Case Study of Nitobe Memorial Garden," *Studies in the History of Gardens and Designed Landscape*, 29: 4, 2009.

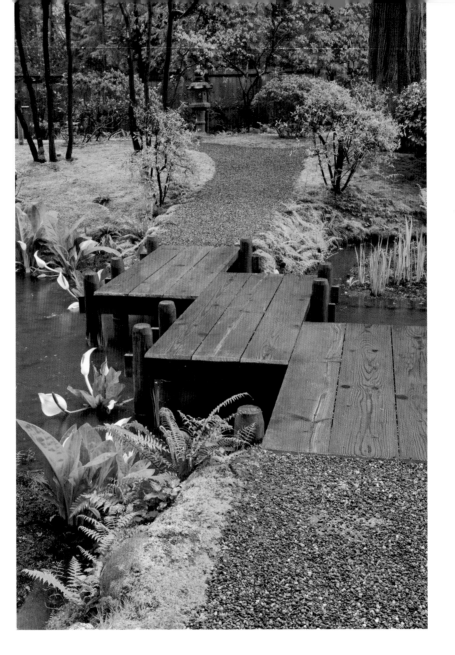

Above The *yatsuhashi* bridge traverses an iris marsh in the pond's southeast corner.

Right The Ichibō'an tea house sits aside a grove of cherry trees.

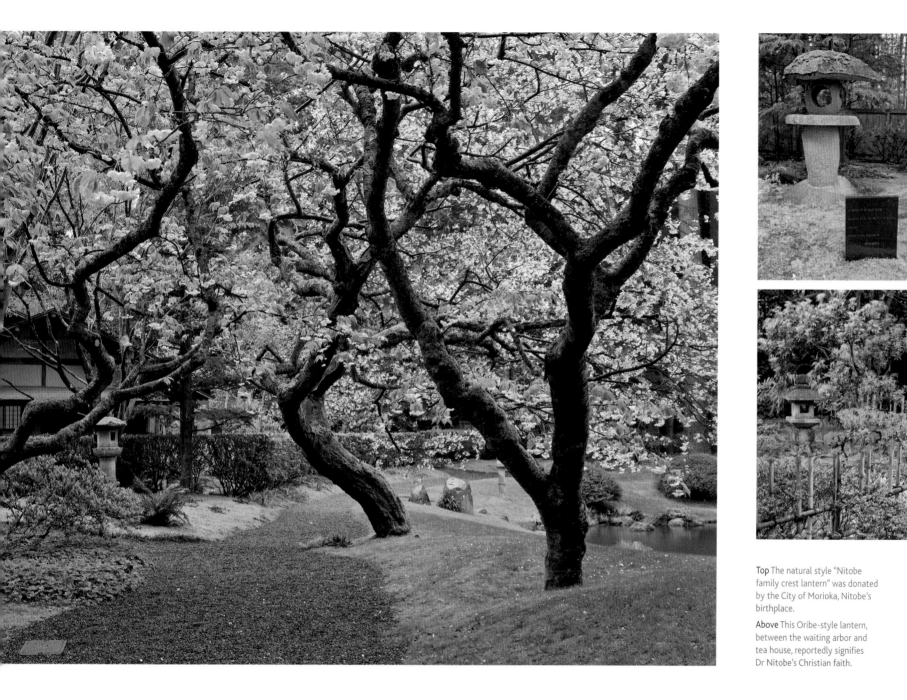

Top The natural style "Nitobe family crest lantern" was donated by the City of Morioka, Nitobe's birthplace.

Above This Oribe-style lantern, between the waiting arbor and tea house, reportedly signifies Dr Nitobe's Christian faith.

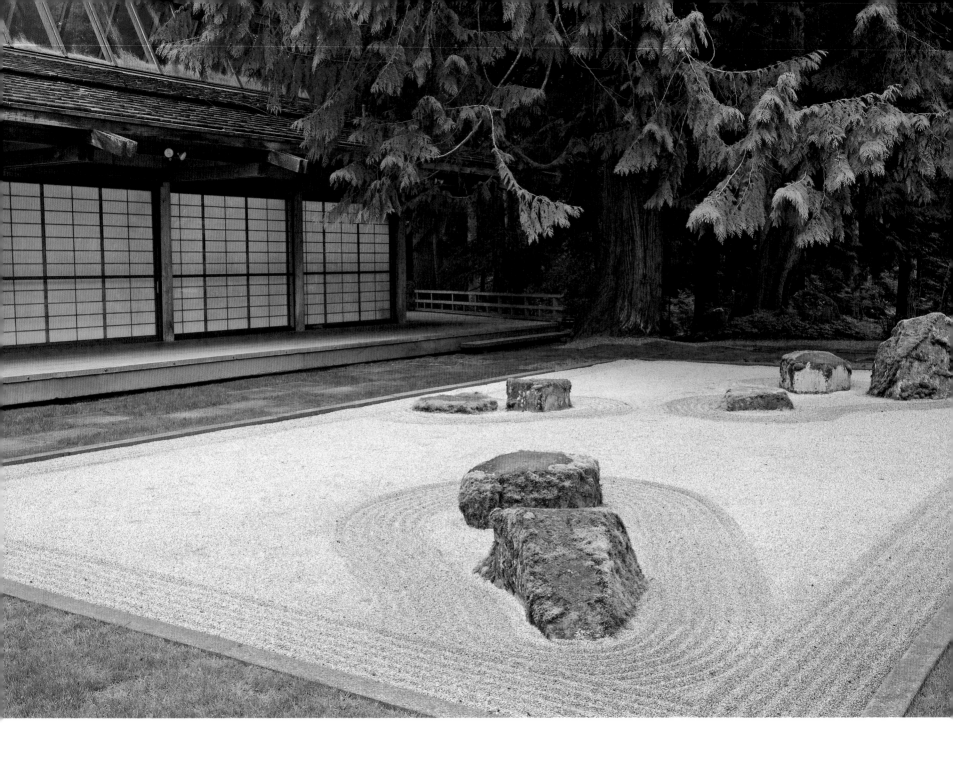

JAPANESE GARDEN AT THE BLOEDEL RESERVE

LOCATION BAINBRIDGE ISLAND, WASHINGTON DESIGNED BY FUJITARŌ KUBOTA, KŌICHI KAWANA, OTHERS OPENED 1961 MAJOR ADDITIONS 1978, 1986

Opposite The familiar dry garden by Kōichi Kawana replaced an abstract garden of hillocks by Richard Haag.

Below The pond garden allows visitors to rest as they tour the large property.

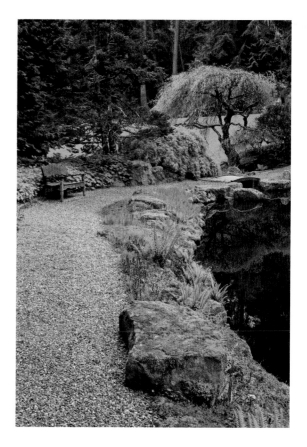

In the post-war decades, Japanese gardens appealed equally to civic groups and to private individuals as North Americans sought to remake their environments as spaces of beauty and tranquility. For America's social and economic élite, Japanese gardens, when trimmed of the exotic details characteristic of pre-war iterations, continued to offer a potent means of expressing refined taste. While pond gardens remained popular, dry gardens gained momentum as emblems of a Japanese garden style consistent in form and ideological content with modernist values. Representative gardens of both kinds are found at the Bloedel Reserve, the former estate of the lumber industry magnate Prentice Bloedel. Bloedel was committed to environmentalism, art, and gardens, writing in 1977 of his respect for the "divine order" of nature that is expressed in Japanese gardens with their qualities of "naturalness, subtlety, reverence, tranquility."

In 1957, Bloedel donated the money that initiated the Japanese Garden in Washington Park. In 1961, a year after that garden was finished, Bloedel hired Fujitarō Kubota to create a garden around the Middle Pond of his 160-acre estate—a property distinguished by discrete gardens set into thick forests and broad meadows. Kubota was Washington's most renowned builder of residential Japanese gardens, best known for the gardens at his 20-acre nursery in south Seattle

(now Kubota Garden). Kubota even created gardens when interned at Minidoka, Idaho. Kubota's characteristic designs adapted Japanese landscaping principles to the scenery of the Cascades. For Bloedel, Kubota abjured lanterns, bridges, and other superficial emblems of Japanese gardens to concentrate on the rich palette of textures and colors created by red, black, and white pines, lace-leaf maple, yew, juniper, cedar, and cypress. Flowing between the trees and mounds of moss are dry cascades of stone and gravel as well as actual cataracts and streams. After Kubota's death, Richard Yamasaki modified elements of the garden. Later, Yoshirō Watanabe created a Japanese-style stone path and fence leading from the driveway to the guesthouse.

In the area west of Kubota's garden, architect Paul Hayden Kirk was hired to create a guesthouse that fused modernism, Japanese design, and a Native American longhouse. Kirk also built a *torii* gate at the west entrance to the guesthouse and suggested that earthen mounds divide the swimming pool behind the house from the meadow beyond it. In 1978, eight years after gifting the property to the University of Washington, Bloedel hired noted landscape architect Richard Haag to create a garden in the area occupied by the pool. Haag had studied at Kyoto University in the mid-1950s on a Fulbright Fellowship, and was deeply mindful of Japanese aesthetics. In that spirit, he designed

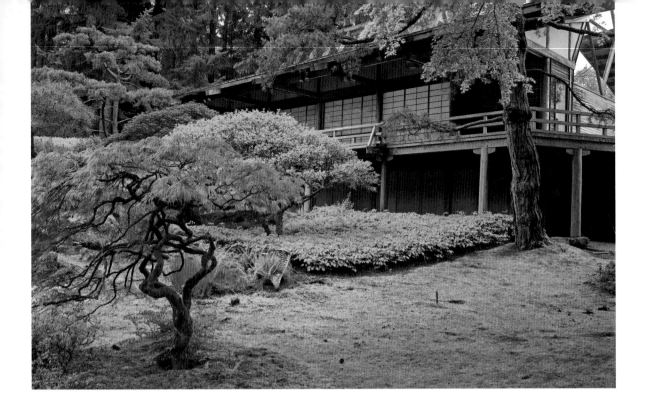

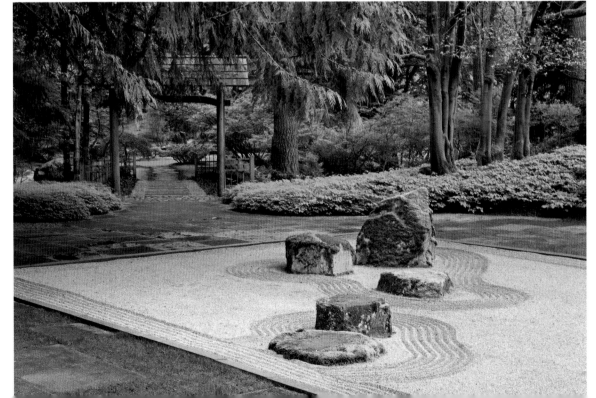

Left The guesthouse was designed by Paul Hayden Kirk to refer to a native American longhouse and a Japanese *shoin*-style building.

Above The simple bamboo fence must be periodically rebuilt.

Below The monochromatic stone garden contrasts dramatically with the verdant color of the rest of the garden.

the "Garden of Planes," also called the "Buddhist Garden of Mindfulness," featuring a "rectangle of two nuanced, but unequal, pyramids," rising above a flat plane comprised of squares of moss or stone. The moss-covered pyramids were composed of seven planes, but no more than five were visible from any vantage point. The highly abstract, minimalist design was meant to evoke fundamental responses to land-scape. After Bloedel's death, and the transfer of the property from the University of Washington to the privately run Arbor Fund, the trustees removed the garden, in 1986 hiring Kōichi Kawana to create a prosaic rectangular rock and sand garden in its place.

1. Richard Haag, "Contemplations of Japanese Influence on the Bloedel Reserve," *Washington Park Arboretum Bulletin*, 53: 2, 1990; Patrick Condon, "The Zen of Garden Design, Richard Haag's Three Linked Gardens at Bloedel," in William Saunders (ed.), *Richard Haag, Bloedel Reserve and Gas Works Park*, Princeton: Princeton Architectural Press, 1998. The Bloedel garden and Kubota garden are discussed in Kendall H. Brown, *Japanese-style Gardens of the Pacific West Coast*, New York: Rizzoli International, 1999.

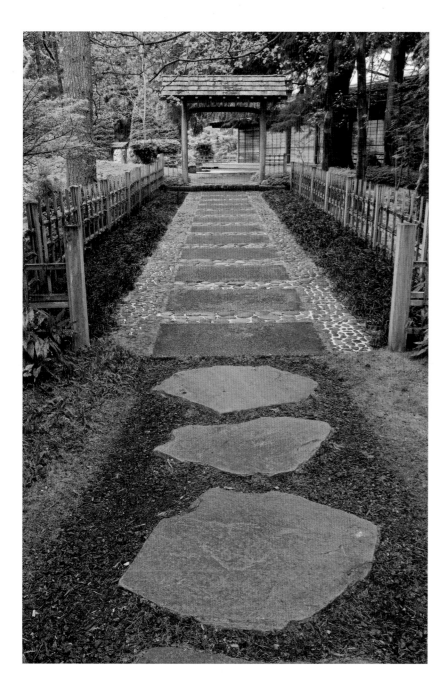

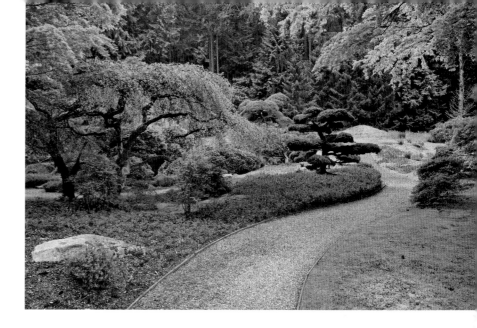

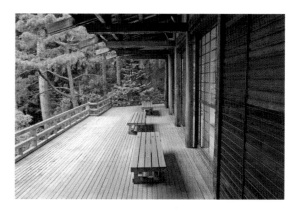

Left The path leading to the guesthouse was created by Yoshirō Watanabe.

Top Fujitarō Kubota's pond-style stroll garden uses a rich palette of Japanese plants and those native to the Northwest.

Above Benches at Kirk's guesthouse allow visitors to sit and observe the pond garden.

Above Trillium is one of the woodland flowers that bring color in the spring.

Above right Small shrubs, flowers, and moss combine with stones to create gardens in miniature.

Right Huge skunk cabbages dot the moss garden.

Opposite Diverse plantings produce a rich palette around the Middle Pond.

Below This stone sculpture showing a *tanuki*, the Japanese badger and trickster, adds an element of humor.

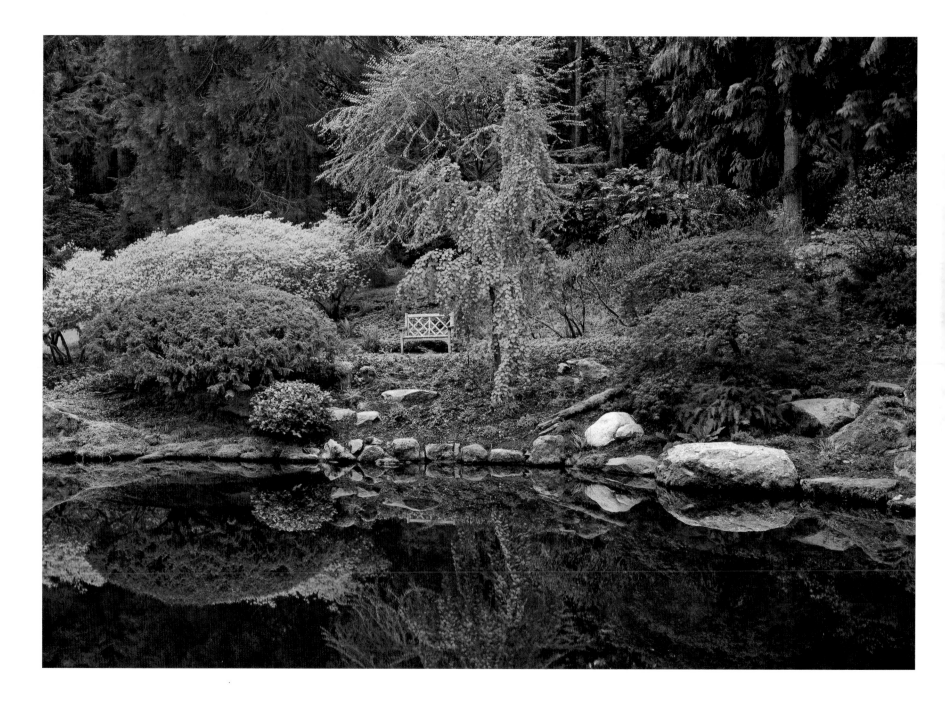

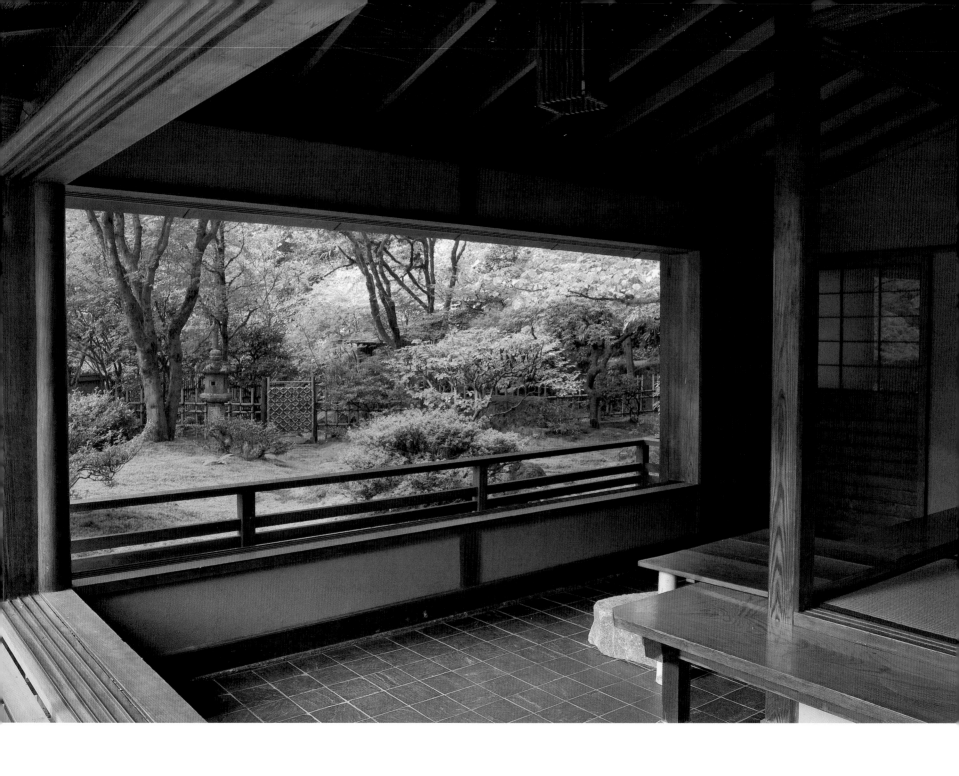

PORTLAND JAPANESE GARDEN

LOCATION **PORTLAND, OREGON** DESIGNED BY **TAKUMA TONO, OTHERS** OPENED 1963 MAJOR ADDITIONS 1966–1991

Opposite The tea house looks into the inner tea garden and middle gate.

Below The five-story stone pagoda was a gift from Sapporo, Portland's sister city.

Right The Poetry Stone reads "Here I saw the same soft spring as in Japan."

Of all the Japanese gardens in North America, the Portland Japanese Garden has long been the most successful in promoting friendship between Japan and the United States. This spectacular garden has facilitated diverse kinds of exchange through its social structure and cultural programs, and the garden itself is a living monument to the harmonious interaction between citizens of Japan and America. In the true spirit of post-war people-to-people diplomacy, the garden is the product of the optimistic vision and hard work of citizens who founded and maintain the Japanese Garden Society of Oregon. It is equally the creation of landscape architect Takuma Tono who laid out the garden's novel physical plan and its innovative organizational blueprint. Although the Japanese Garden follows Seattle and Vancouver chronologically, its "sampler style," demonstrating different types of gardens, became a model for many later gardens.

With the establishment of a sister city relationship between Portland and Sapporo in 1959, the Japan Society of Oregon formed a committee to consider a Japanese garden. After settling on the site of the defunct Washington Park Zoo, the non-profit Garden Commission (registered in 1963 as the Japanese Garden of Oregon) was incorporated in 1961, and the City of Portland gave them a 91-year lease on the zoo

site. In 1963, they hired as designer and consultant supervisor Takuma Tono, a 1922 Cornell graduate in landscape architecture who had taught in the Landscape Architecture Department at the Tokyo University of Agriculture since 1953. Though Tono specialized in Western-style landscape in Japan, he lectured widely on Japanese garden design. In 1962, Tono began work on a replica of the stone garden at Ryōanji for the Brooklyn Botanic Garden, and then a small garden at a library in Gardena, California. For Portland, Tono decided to educate Americans in Japanese garden art by creating four distinct landscapes: the Flat Garden, the Pond Garden, the Stone-and-Sand Garden, and the Tea Garden with tea house. This integrated "combination plate" (or *bentō* box) approach may have been influenced by some temple complexes that include pond gardens, dry gardens, and tea gardens, and by Kinsaku Nakane's mix of Heian, Muromachi/Momoyama and modern gardens at Jōnangū in Kyoto, begun in 1954.

During his time in Portland, Tono worked largely with volunteers, using machines and materials lent by Portland's Parks Department. Most importantly, he was aided from 1964 by Kin'ya Hira, who would become the first garden director. Tono's long study of Japanese gardens had taught him that professional maintenance and ongoing design were

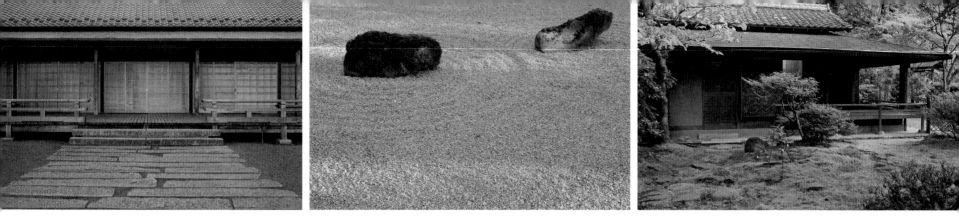

critical elements of garden culture in Japan absent in North America, and thus he established a program of sending young garden builders from Japan to serve as successive directors in Portland. Although effective as maintenance specialists who could sustain a knowledge base, these directors also served as human liaisons with the local community. As such, they put into practice the citizens' diplomacy central to the sister city idea. Tono's brilliant program also gave critical experience for young Japanese garden professionals, helping them build careers in Japan or America.

At Portland, these directors were also responsible for fleshing out, and substantially adding to, Tono's original design. Between 1964 and 1969, Hira completed the garden's core components, even learning carpentry skills to help install the tea house. From 1968 to 1972, Hōichi Kurisu, and then Hachirō Sakakibara from 1972 to 1974, broadened Tono's original garden to include a Natural Garden and lower pond. Following the precepts of Prof. Kenzō Ogata, they broke from Tono's "classical" symbolic orientation to create spaces redolent of local natural scenery. The four following directors focused primarily on maintenance, though the area around the Pavilion—built in 1980 by Skidmore, Owings and Merrill—was landscaped by Masayuki Mizuno, and Takao Donuma expanded the natural garden between 1985 and 1987. In an intensive term from 1988 to 1991, Tōru Tanaka, the last of the consecutive directors, redid much of the Natural Garden, renovated the Tea Garden, and added a hill garden leading from the lower parking lot to the entrance.

This tradition of change gained momentum from the late 1990s. Beginning with the contentious decision in 1998 to replace the Sand-and-Stone Garden with a naturalistic garden designed by David Slawson, followed by the equally contentious decision in 2003 to restore the original garden, the Japanese Garden has grown dramatically on multiple fronts. Under the leadership of Executive Director Stephen Bloom and Garden Director Sadafumi Uchiyama, the Japanese Garden embraced its past, hosting a reunion of former garden directors in 2011. At the same time, it expanded its mission beyond education about Japan by adding activities that include art exhibitions in the garden as well as science and art programs for young school children. The Portland garden has also been a leader in establishing the North American Japanese Garden Association, dedicated to building dialog and education within the field. Finally, in 2011, the garden announced the selection of renowned architect Kengo Kuma to design a major expansion project that includes new garden spaces, a cultural and educational center, a garden store, and a public tea house.

1. Bruce T. Hamilton, *Human Nature: The Japanese Garden of Portland, Oregon*, Portland: Japanese Garden Society of Oregon, 1996; Makoto Suzuki, "Takuma P. Tono: The First Japanese 'Landscape Architect,'" *Journal of the Japanese Institute of Landscape Architecture*, 60: 4, 1997; Takao Donuma and Makoto Suzuki, "A Study on the Characteristics of Establishing Japanese Gardens in Washington Park, Portland, Oregon," *Journal of Architecture, Planning and Environmental Engineers*, 521, 1999.

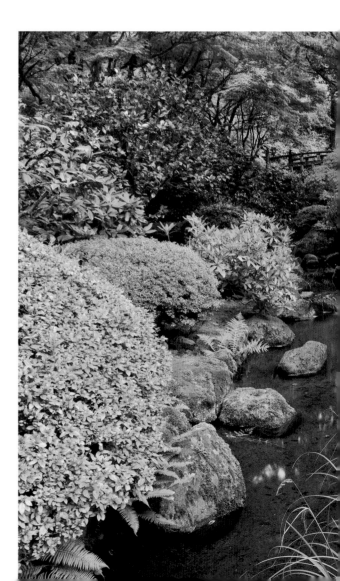

Far left The Pavilion houses seasonal displays of art, crafts, and *ikebana*, and hosts such activities as the annual moon-viewing party.

Center left The Dry Garden features ten small stones, like these, around one vertical standing stone.

Left The tea house was begun under the direction of Takuma Tono and completed by Kin'ya Hira.

Right The eight-planked bridge traverses a marsh planted with many species of iris.

Below The dramatic *kotoji* (zither tuner shape) style lantern stands aside the stream flowing from the pond.

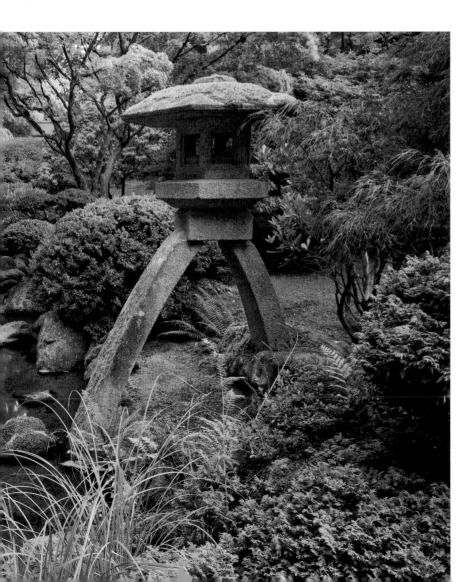

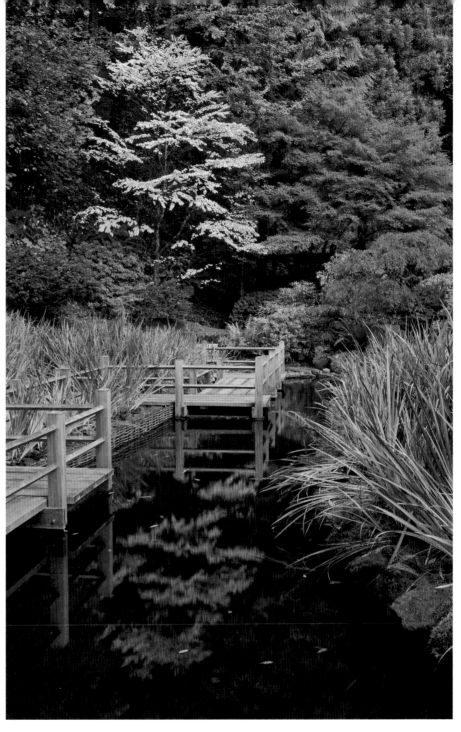

Right The dramatic Heavenly Falls occupies the former bear pit when the property was Portland's zoo.

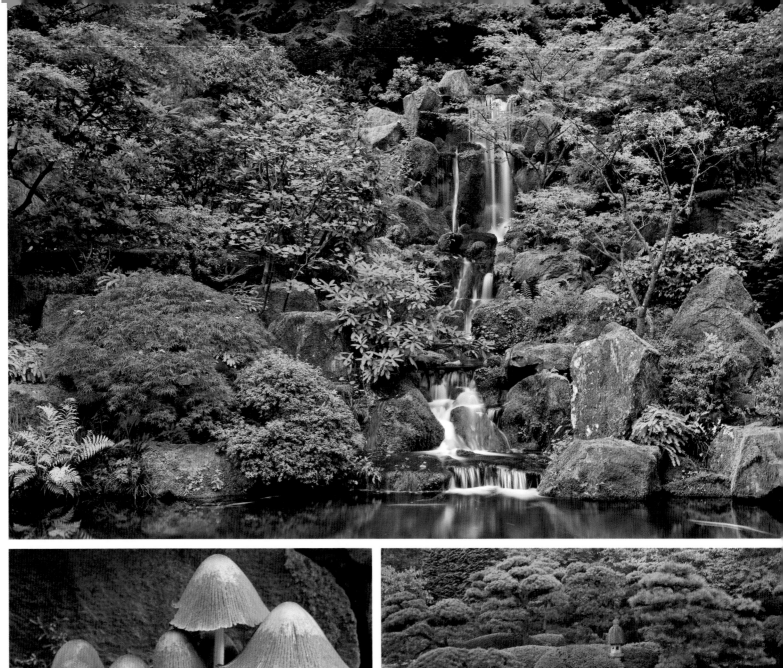

Right Mushrooms appear in the Natural Garden each spring.

Far right The Flat Garden bears the felicitous design of a gourd and *saké* cup.

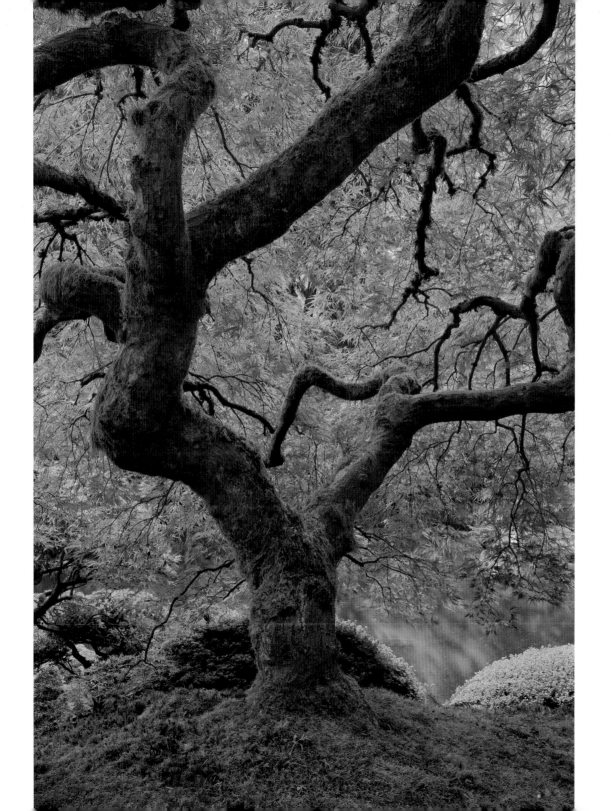

Left Maples add dramatic hues in the fall.

Below In the outer tea garden, the waiting arbor is used by guests before they enter the tea house.

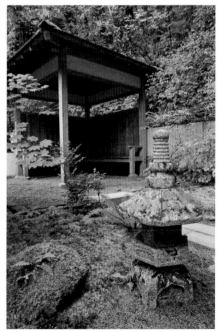

CHAPTER THREE

INNOVATION BY ADAPTATION

North America's "Backyards" Turn Japanese

In the 1960s and 1970s, socially mobile North Americans embraced Japanese gardens and brought them home. Nourished by a handful of how-to books and countless articles, the resulting boom produced Japanese-style gardens at a range of middle-class residences. Japanese garden features updated urban bungalows, added sophistication to suburban "ranchettes," and lent respectability to apartment complexes. In an era known for its proliferating merchandise and glittering slogans, Japanese landscape forms too were transformed to suit almost any taste and budget even while being sold as "authentic" imports. Moreover, like radios and cars, gardens were seen as evidence both of the superiority of Japanese design and its endless adaptability.

Public parks—every municipality's "backyard"—jumped on the Japanese garden bandwagon, hiring designers from Japan or men trained there. Even while maintaining a rhetoric of authenticity useful for raising funds and friends, most garden builders adapted the familiar pond-style stroll garden to fit the confines and contours of their budget and topography. However radical the disjuncture between design and declaration, the presence of familiar symbols and the sister city's seal of approval signaled the garden's Japanese identity. More sophisticated viewers realized that the Japanese heart beating in the most sensitive Japanese-style gardens was found in the design principles, the particular arrangement of stones, and the style of pruning, not in the stone lanterns, arched bridges, or colorful *koi*.

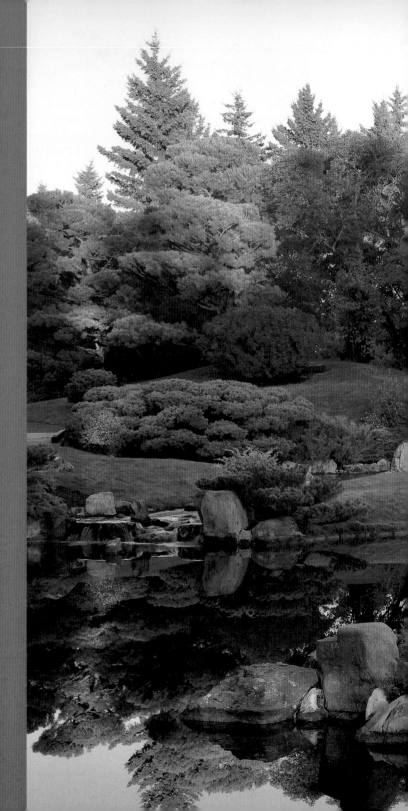

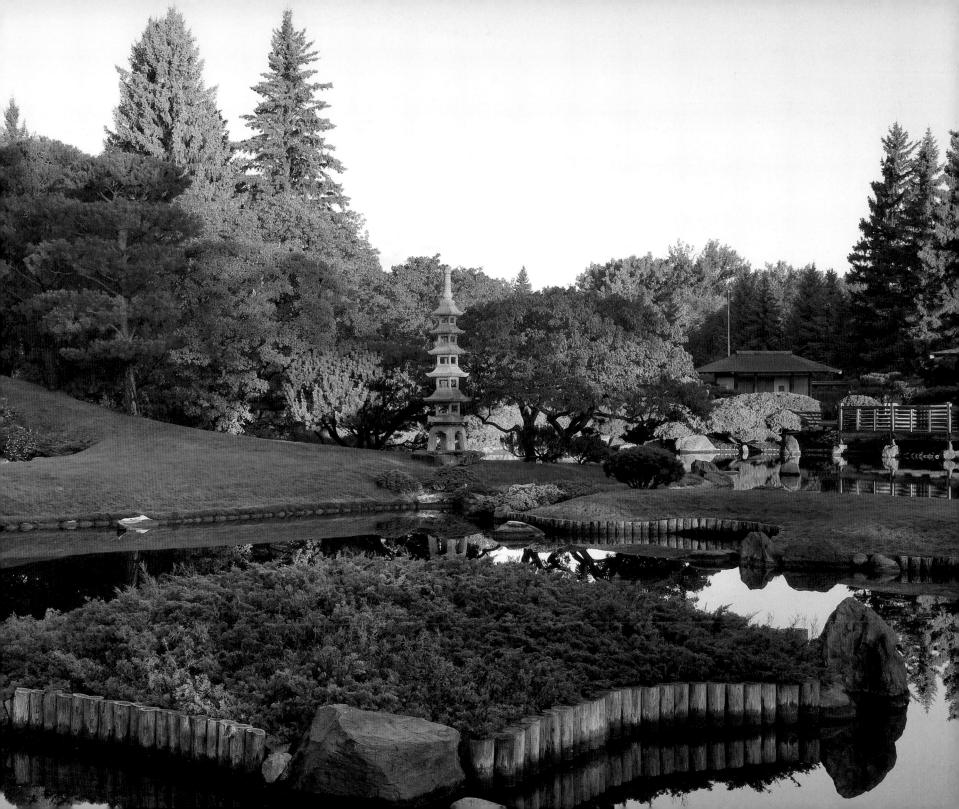

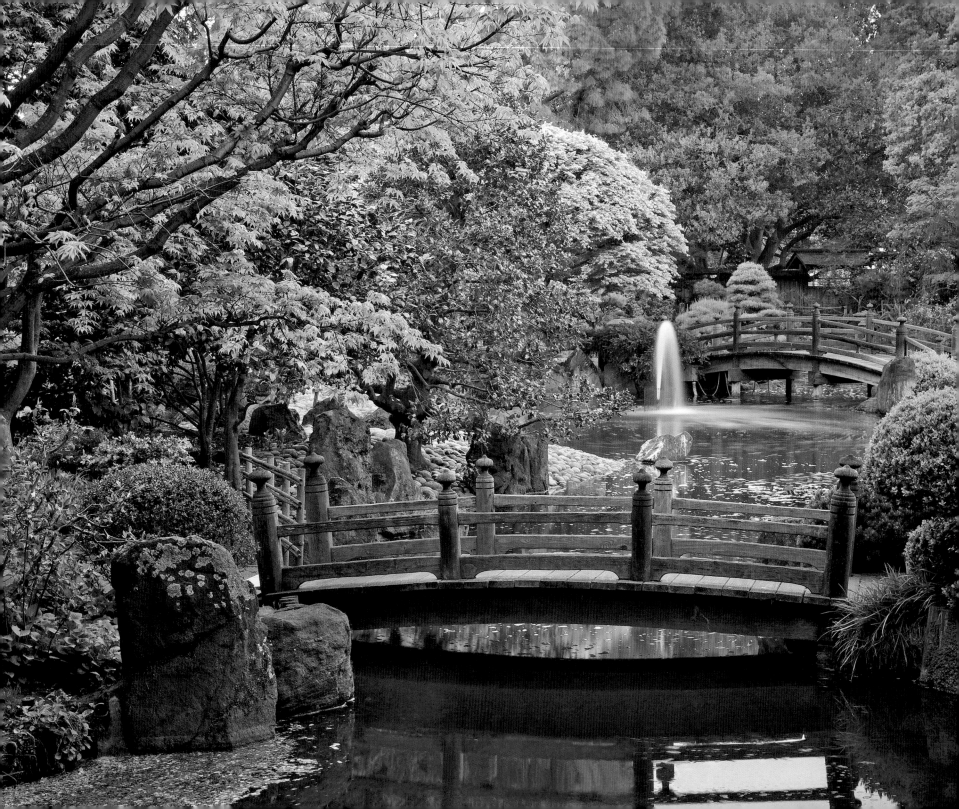

JAPANESE GARDEN IN SAN MATEO CENTRAL PARK

LOCATION SAN MATEO, CALIFORNIA DESIGNED BY NAGAO SAKURAI OPENED 1965

By the mid-1960s, large Japanese gardens, reintroduced in the Northwest, filtered down to smaller cities that sought to create a similar atmosphere of culture and beauty. In San Mateo, an upper middle-class suburb of San Francisco, this desire merged with the aspiration of local Japanese gardeners to create a landscape that would signify their contribution to society and advertise their professional skills.

As early as the mid-1950s, the San Mateo Gardeners' Association determined to create a Japanese garden at the San Mateo City Hall to reaffirm their commitment to America in the wake of the internment of Japanese-Americans during World War II. After San Mateo and Toyonaka signed a sister city agreement in 1963, the Japanese Garden Kōen-kai raised $16,000, gathered materials, labor, and broad public support, and thus persuaded the city to donate matching funds and land in its Central Park. To design the garden, they selected Nagao Sakurai, then a Berkeley resident who had created gardens for San Francisco's Golden Gate Exposition (1939), the Japanese Tea Garden in Golden Gate Park (1952), and Micke Grove Park in Lodi (1961), as well as at several residential gardens near San Francisco. His Guiberson garden in Bel Air (1961) was later donated to UCLA as the Hannah Carter Japanese Garden. With broad community support from local businesses and trade unions, the garden was built in less than a year and dedicated on August 28, 1966. A two-room tea house, constructed in Japan, was reassembled in San Mateo in 1968.

The stroll garden, entered through an elegant Main Gate, centers on a large pond that is fed by a dramatic waterfall in the northeast. The pond is bisected at its narrow center by an arched bridge, and also features a large island reached by bridges from either shore. Sakurai's consummate skill is evident in the artful placement of 200 tons of stone, most obvious in the elegant shoreline that alternates stones with wooden stakes and pebble beaches. The garden provides multiple sight lines as visitors stroll around and across the pond. On a hillock in the southwest corner, a viewing pavilion—built with money donated by the Garden Study Club, and housing a map of the garden—offers views across the entire garden. The space is punctuated by a two-ton five-story stone pagoda donated by the City of Toyonaka. Another sister city gift, placed inside the gate, is the three-foot-high wooden Shinden-style Shinto shrine donated in 1990. Four stone lanterns provide focal points along the shore of the pond, and one lantern stands by the stream that feeds the pond from the east side. Filled with about 150 different types of trees, shrubs, and flowers, this over-abundance likely results from the generous donations of local gardeners and nurseries.

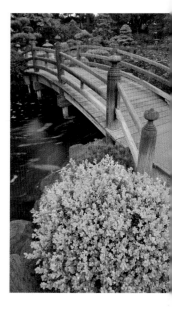

Above Hoping to be fed, *koi* gather below one bridge.

Opposite The two bridges are a distinctive feature of the garden.

Previous spread The path around the large pond at the Nikka-Yūkō Japanese Garden offers broad views befitting its prairie location.

The enthusiasm and knowledge of the Japanese-American community that created the garden has long sustained it. In a legacy stretching from Sadao Sugimoto through Mitsuo Umehara to Isamu (Sam) Fukudome, the garden is maintained by Japanese "curators," with two commemorated by garden plaques. For many years, Japanese-American women clad in *kimono* or *yukata* served tea and snacks at the tea house during summers. The garden has long hosted a variety of Japanese cultural events.

1. The garden is described in greater detail in Kendall H. Brown, *Japanese-style Gardens of the Pacific West Coast*, New York: Rizzoli International, 1999, and David Newcomer, *Public Gardens in the USA, Past and Present: Northern California*, Mill Valley, CA: Japanese Gardens USA, 2007.

Above The bold combination of stones and pines distinguish this small but theatrical garden.

Left The stately Main Gate opens directly onto a corner of the pond.

Right The garden is filled with many plant species and blossoming trees, including this cherry.

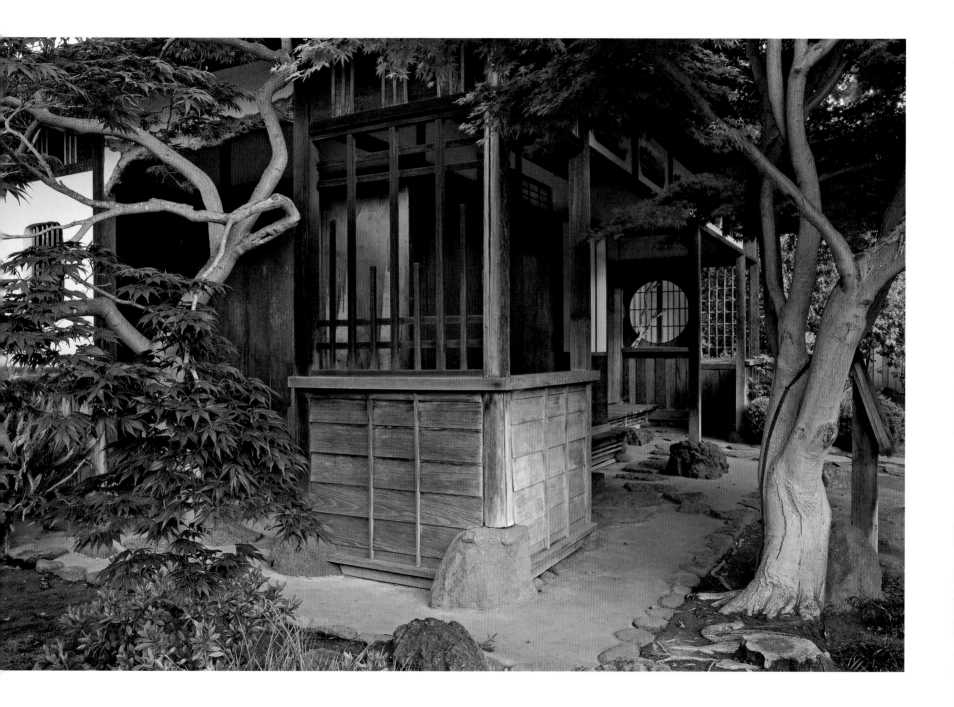

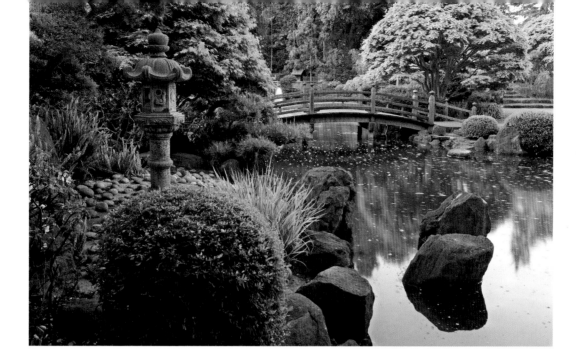

Left The vertical orientation of this Kasuga-style lantern balances the bridge.

Below A small Shinto shrine was gifted in 1990 by Toyonaka, San Mateo's sister city.

Left The large tea house was constructed in Japan, then reassembled on site.

Below A wooden lantern stands to the side of the tea house.

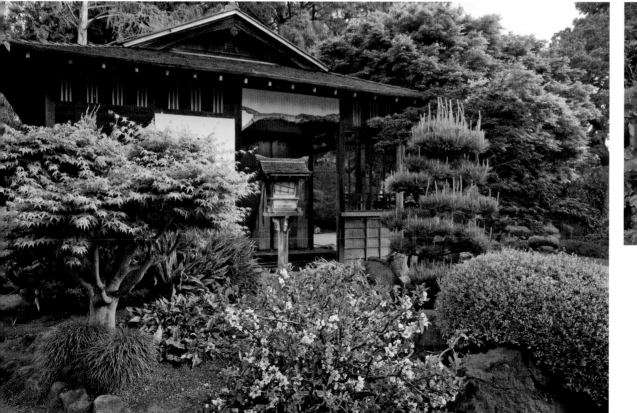

NIKKA-YŪKŌ JAPANESE GARDEN

LOCATION LETHBRIDGE, ALBERTA DESIGNED BY TADASHI KUBO OPENED 1966

Above This sleeve-shaped (or crocodile mouth) lantern recalls the famous one at the Lower Villa of Shugakuin Imperial Villa, Kyoto.

Top right Carefully raked gravel focuses attention on a stone in the dry garden.

Opposite An earthen bridge leads to the viewing pavilion.

The presence of a successful 4-acre Japanese garden on the windswept prairie of southern Alberta eloquently expresses the power of Japanese gardens to motivate people and the adaptability of Japanese landscape styles to diverse environments. The garden's symbolic role is conveyed in its name: *nikka* means Japan-Canada, *yūkō* signifies friendship; the word centennial in its original title signaled the 100th anniversary of Canadian Confederation in 1967. Broadly, the garden celebrates the close relationship between Canada and Japan as well as the contributions of Japanese to Canada's history—a powerful statement after the harsh treatment of Japanese-Canadians during World War II.

The Japanese-Canadian population in Lethbridge resulted from the relocation of "enemy aliens," the 22,000 persons of Japanese descent living in British Columbia, to areas east of the Rockies in 1942. By the early 1960s, when the roughly 3,000 Japanese-Canadians in Lethbridge had put down roots in this region of rolling fields and coal mines, the idea for a Japanese garden was proposed independently by Reverend Yūtetsu Kawamura and by Cleo Mowers, publisher of *The Lethbridge Herald*, who sought to recognize the contributions of the relocated Japanese. In addition, Kurt Steiner, head of the municipal convention bureau, was eager to create a tourist attraction and helped promote the garden idea to diverse constituencies, including the city's Centennial Committee. Support of Japanese-Canadians was secured in 1964, with the provisos that Japanese-Canadian representatives sit on the Japanese Garden Committee and a specialist from Japan design the garden to insure authenticity. The Japanese Consul General in Winnipeg suggested Tadashi Kubo, professor of Landscape Architecture at Osaka Prefectural University, who was then in San Diego building the Japanese garden at the Murata Pearl Village at SeaWorld. Kubo was accepted by the board after declaring that a "Canadian garden in Japanese style" was feasible in Lethbridge.

In Osaka, Kubo solicited designs from his students and presented the top dozen, the Lethbridge garden committee and City Council favoring the same one. This plan harmonizes the stroll garden around a large pond with the "borrowed scenery" of Lake Henderson and the adjacent

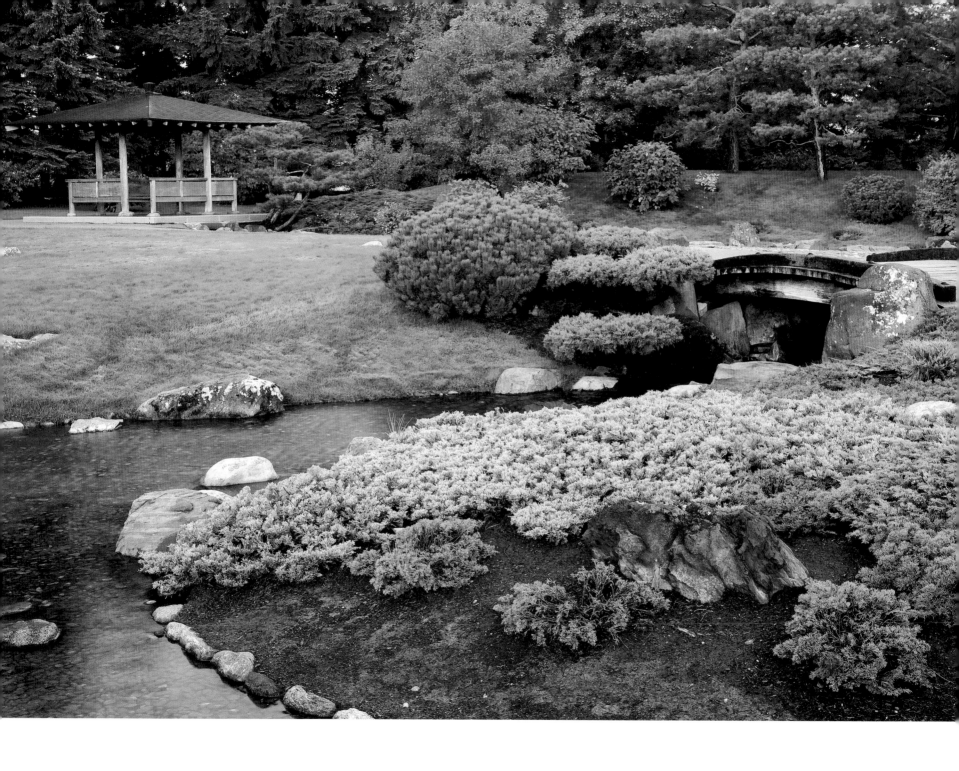

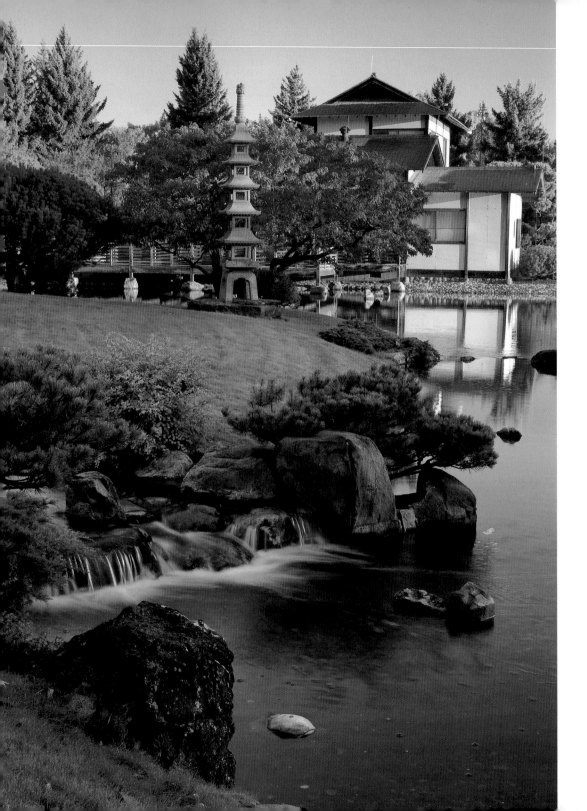

prairie. Because of his teaching responsibilities, Kubo had his assistant Masami Sugimoto oversee the construction. Sugimoto worked closely with Mel Murakami, manager of a local construction company, and the City's Parks and Facilities staff. The garden is viewed first from the two-story pavilion that, on the first floor includes a tea ceremony room that looks onto an intimate stone garden. Where the dry garden focuses attention inward, the broad stroll garden presents an unfolding variety of scenes across the pond, containing two islands, and enlivened by an undulating shoreline edged with stones and pebble beaches. The path passes the large stone pagoda, crosses an earthen bridge to a viewing pavilion, and, at the far end, includes a bell tower.

The garden materials are both Japanese and local in origin. The buildings, including the large main gate, were fabricated in Japan then constructed on site over three months by Tōru Kamakura and a team of five Japanese craftsmen. Most of the stones were gathered by Sugimoto and Tosh Kanashiro from a farm near Crowsnest Pass, due west of Lethbridge in the Rockies, while the volcanic stones used around the waterfall were brought from Coleman. The plants are from southern Alberta, as the few specimens imported from other areas failed to survive the harsh winters. After the garden's unofficial opening on July 3, 1966, and official dedication on July 14, 1967 (attended by Prince and Princess Takamatsu), the garden continued to evolve. Kubo returned in May 1972, offering 21 points for improvement, and Sugimoto also made follow-up visits. As a result, trees were added to block views of the garden fence and screen out a road, and stepping stones were placed in the prairie area to provide a different view of the pond.[1] Like other gardens in harsh climates, the Nikka-Yūkō Japanese Garden is closed for the winter and the pond drained. The garden is well maintained, serving as a popular place of quiet escape from May 7 to October 10, and one day each February for the Yuki Matsuri or snow festival.

1. Lynne Van Luven, *Nikka Yūkō Centennial Garden: A History*, Lethbridge: Lethbridge and District Garden Society, 1980.

Opposite A five-story stone pagoda sits on a spit of land projecting into the pond, allowing views of it and the two-story Pavilion.

Right The path changes to stepping stones after circling the pond.

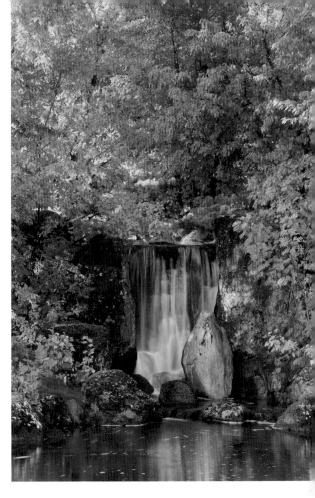

Above The sheer waterfall feeds a short stream that feeds the pond.

Left Stones brought from the Rockies create a natural looking pond edge.

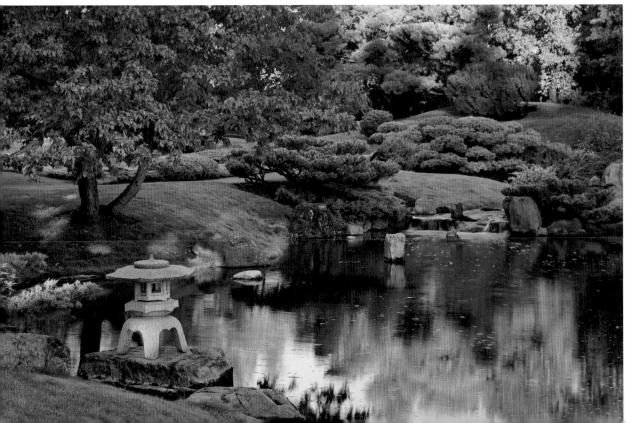

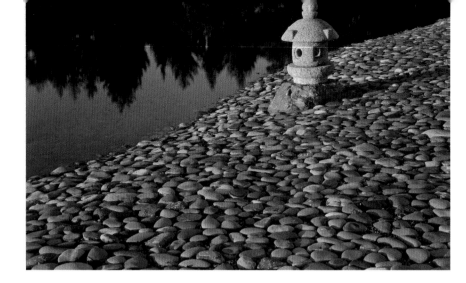

Left A Misaki-style lantern sits on a stone beach, culminating the path around the pond.

Below The large Pavilion provides display space and a focal point from across the pond.

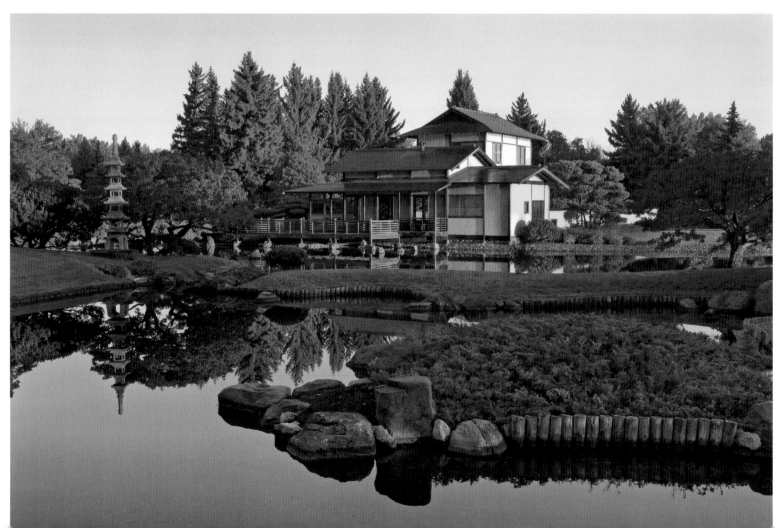

Right A gently arched bridge pulls the eye to the "borrowed scenery" of Lake Henderson, which lies outside the garden's perimeter.

Below left The bell tower occupies the most distant part of the garden.

Below right A dry garden fills a small courtyard by the tea ceremony room inside the Pavilion.

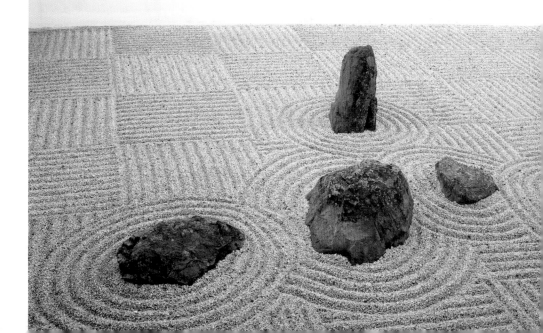

NISHINOMIYA GARDEN IN MANITO PARK

LOCATION SPOKANE, WASHINGTON DESIGNED BY NAGAO SAKURAI OPENED 1974

Opposite The diverse stone placements demonstrate the style of Nagao Sakurai.

Below This Kasuga-style lantern is one of several donated items

The Nishinomiya Garden, like many others of the 1960s and 1970s, was born of a powerful combination of civic pride, the drive of Japanese-Americans, and desires for international friendship and commerce. These social goals merged with the deep-rooted conviction that Japanese landscape aesthetics could be integrated into American parks so those parks might better serve the public. In the language of Native Americans in western Washington, the word *manito* means "spirit pervading nature." The name change of Spokane's premier park from Montrose to Manito Park in 1903 suggests a growing appreciation of the power of nature together with the desire to place human activity in this nurturing realm. In 1962, that continuing ethos was joined with the hope of local Japanese-Americans to create a physical symbol of Spokane's new sister city relationship with Nishinomiya. The result was a plan for a Japanese garden in Manito Park.

Under the determined guidance of local businessman Edward Tsutakawa, between 1964 and 1967 the garden's site was chosen, community interest and funds were raised, and noted garden designer Nagao Sakurai was selected. In 1967, Sakurai, fresh from the Japanese Garden in San Mateo, visited Spokane, personally selecting stones for the waterfall and instructing Tsutakawa to gather basalt, volcanic basalt, and granite stones from Spokane's suburbs. The US Army Reserve transported over 500 tons of stones, and labor on the watercourse was donated by Vern Johnson's construction company. The garden's distinguishing feature is the elegant pond, fed by recycled water from the waterfall and by fresh water. The adroit placement of stones in and around the pond took place using Sakurai's dictum that there are no bad stones, only poor locations for them. Because the elderly Sakurai suffered a stroke early in the construction process, his son Ken Sakurai helped finish the pond. Like the pond at San Mateo, it features an arched bridge and an island reached by bridges from either shore.

Between 1968 and 1973, Sakurai, working from his bed, and Tsutakawa designed the perimeter fence, entry gates and viewing pavilion, and planned the paths. Much of the final work was done by Shosuke Nagai and Hirohiko Kawai, who had come from Nishinomiya for the task. Roughly 500 trees were donated by the Riverside Nursery and other companies. After a trip to Japan to view gardens, Tsutakawa oversaw the purchase of 14 black pines from Seattle's recently closed Kubota Nursery. The garden has continued to evolve after its opening in 1974, in conjunction with the Spokane World's Fair. Additions include cherry trees, a dry mountain stream, a lantern (dedicated to Polly Mitchell Judd, former President of the Spokane Federation of Gardeners), a wooden Shinto shrine donated by Nishinomiya, and a wisteria arbor. Despite this proliferation of objects extrinsic to the basic plan, the fluid waterway under a cover of Japanese and North American trees integrates Nishinomiya Garden into the surrounding park.

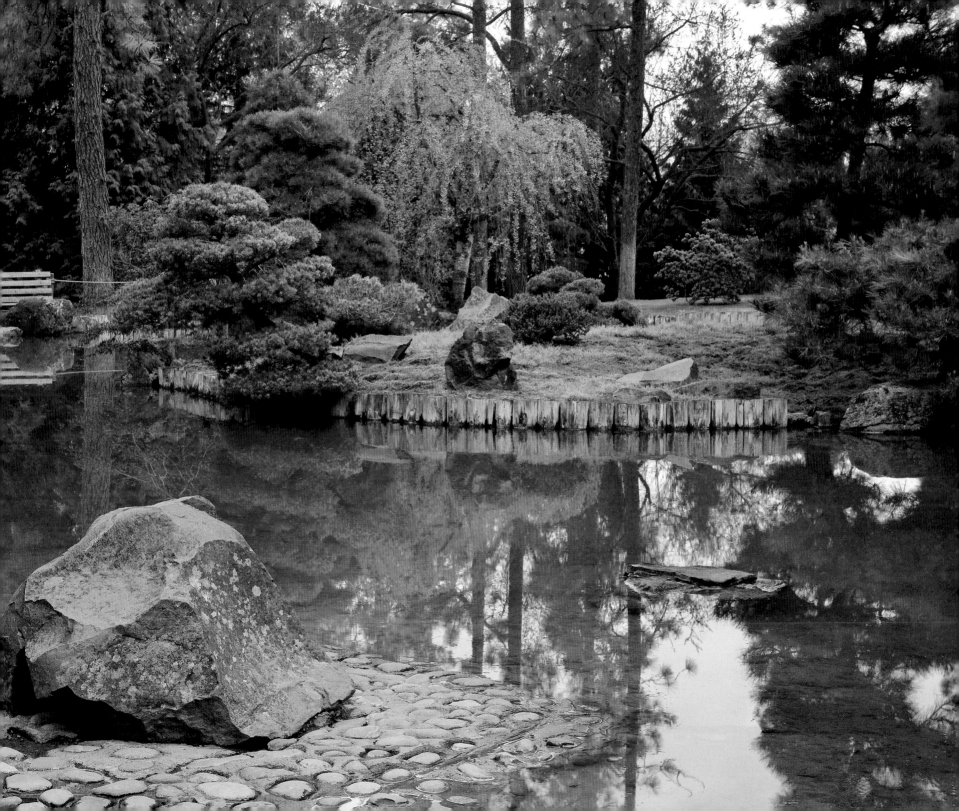

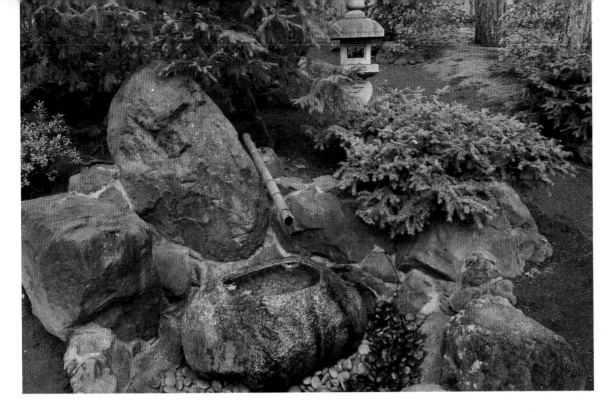

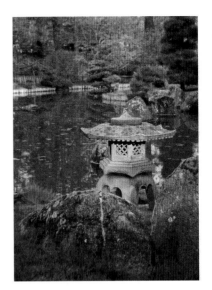

Above A bamboo tube feeds a water basin in front of an Oribe-style lantern.

Above right The geometry of a hexagonal *yukimi*-style lantern contrasts with the stones around it.

Right The pond is fed both by a natural stream and by this waterfall using pumped water.

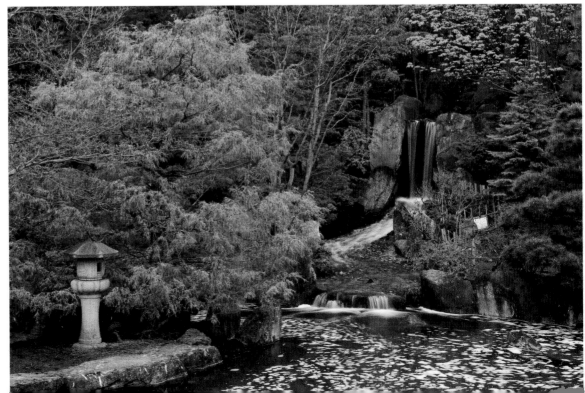

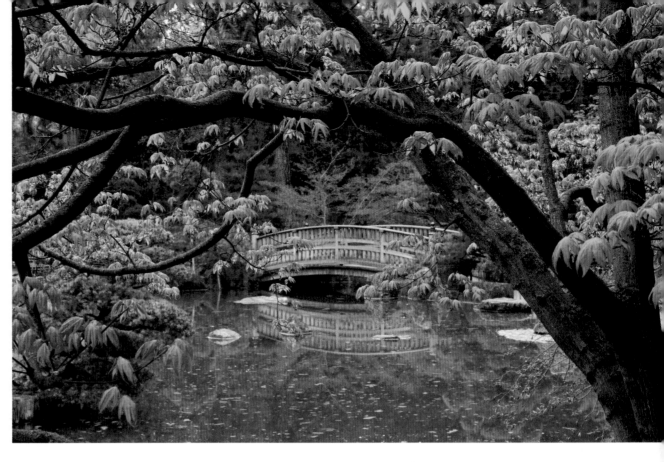

Above A wooden bridge spans the narrowest portion of the pond.

Left Broad paths are bounded by a simple bamboo fence.

Right The arched bridge provides a smooth transition from the path.

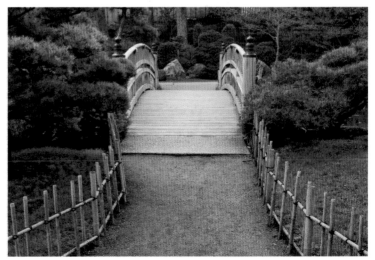

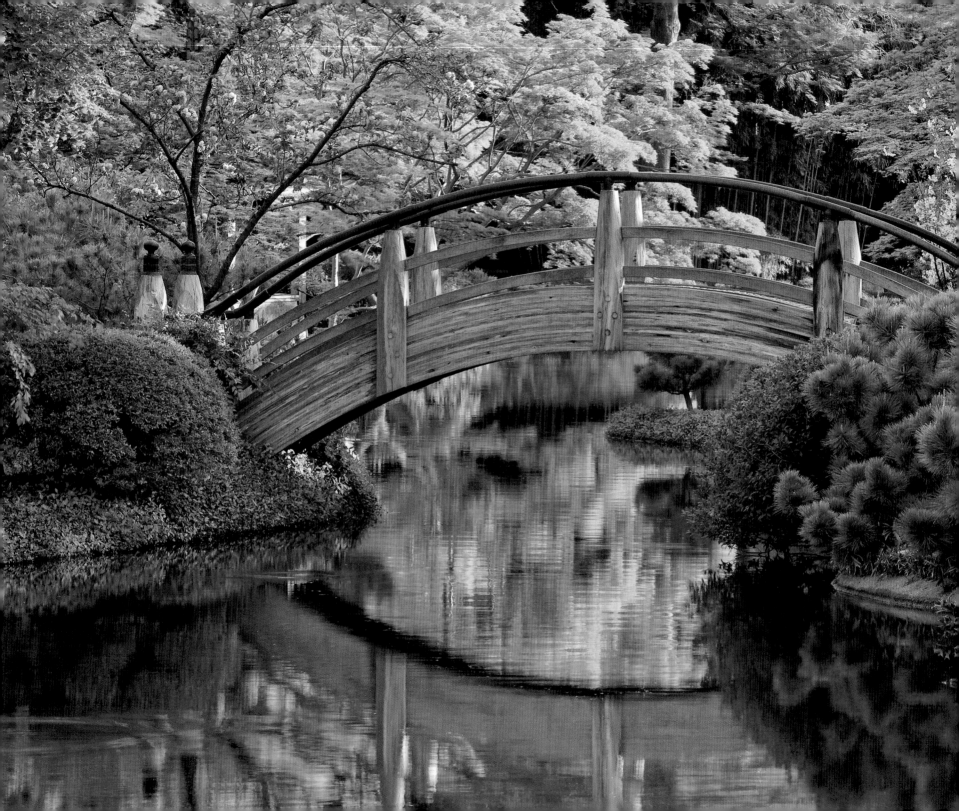

JAPANESE GARDEN IN THE FORT WORTH BOTANIC GARDEN

LOCATION **FORT WORTH, TEXAS** DESIGNED BY **KINGSLEY WU** OPENED **1973**

Opposite The moon bridge leads to an island in the middle pond.

Below Gently curving paths are edged with ground cover, shrubs, and trees.

It is often said that everything is bigger in Texas. While the accuracy of this statement is debatable, when the 7.5-acre Japanese Garden was built at the Fort Worth Botanic Garden (FWBG) between 1968 and 1970, it was the largest Japanese garden in North America at the time. Though it has been surpassed in size since then, it remains one of the most dramatic interpretations of the series of garden suites initiated by Takuma Tono at Portland. Although in many ways a product of its era, the garden combines physical grandeur and creative vision in a way achieved by few other Japanese gardens in North America.

Between 1950 and 1975, the FWBG created several new structures and gardens. The most popular of these additions was the Japanese Garden initiated and overseen by Director Scott Sikes, a landscape architect. In 1973, Sikes acquired a 6-acre gravel pit turned trash dump on the facilities' western edge. After a group of landscape architecture graduate students suggested an "Oriental garden" for the site, Sikes made a study trip to public Japanese-style gardens in Seattle, Portland, San Francisco, Brooklyn, Philadelphia, and Birmingham. In 1969, Sikes commissioned a master plan from Kingsley Wu, then a professor of Environmental Living at Texas Women's University in Denton and a graduate of the University of Tokyo.

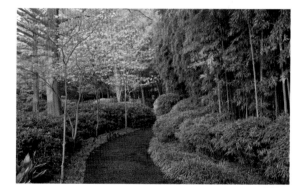

Wu's plan utilized the undulating natural topography for ponds and viewing areas, placing in the depressions a Sunken Garden and a Stroll Garden around and across three large ponds that also can be viewed from several viewing arbors. The waterways—lined with 450 cubic yards of steel-reinforced concrete—are spanned by eight bridges, each in a different style. Atop the cliffs, Wu placed a Moon-Viewing Deck, an elevated "Teahouse Complex," and a large waterfall. In the flat areas, he designed a stone-and-gravel Meditation Garden and a pagoda accessed along a path from a *torii* gate. In 1976, the FWBG added an impressive Main Entrance Gate designed by Albert Komatsu, who was responsible for

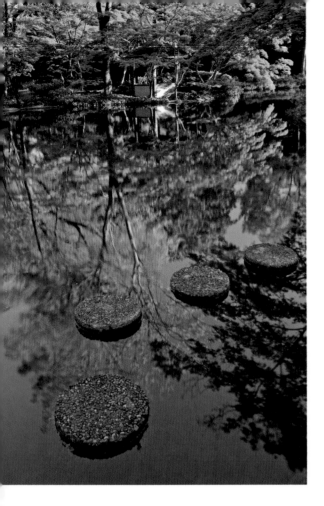

Above Kingsley Wu borrowed the design of stepping stones across an inlet in the middle pond from the garden at Heian Shrine, Kyoto.

Right The Mary K. Umstead tea house seems to float among irises at the end of the lower pond.

Far right A waterfall spills into the upper pond.

most of the gabled shrine-like structures in the garden. The large waterside "Treasure Tree" gift shop was designed by Jim Bransford in 1985. The Japanese Garden is operated by the Fort Worth Botanical Society, Inc., in partnership with the municipally run FWBG.

Following the precedent of many Japanese gardens in North America, and perhaps historic gardens in Japan, Sikes and Komatsu cleverly utilized human and material resources to maximize their modest budget. The hundreds of tons of stone were donated from the Holloway and Nivens' farms in Wise County, and placed with a crane loaned from Tarrant County. Of the roughly 75,000 new plants used in the garden, those not grown in the FWBG's new production greenhouses were donated by park departments in Arlington, Texas and Muskogee, Oklahoma, as well as by several garden clubs and individuals. More than 400 trees were added to the elm, hackberry, and mesquite growing on the site. An army buddy of Sikes in Chicago donated Japanese maples, and the Director enlisted drug rehabilitation patients at a local Fort Worth hospital to transplant about 100 live oak saplings from a farm in Stephenville. Posts, poles, and cross ties in the garden were donated by the Highway Department and Texas Electric. Old street paving bricks were given by the City of Thurber, and red granite left over from the Tarrant County Court House was used for retaining walls. Most of the lanterns were private gifts.[1]

The natural scenery and lush planting of the ravine create a rich environment for Wu's modernist interpretations of different Japanese garden styles. The design uses such Japanese garden features as "hide and reveal" and "borrowed views" on a grand scale, and it creatively references famous gardens in Japan. For instance, a Ryōanji-like stone garden is surrounded on four sides by a latticed and roofed walkway, and the round concrete moon-viewing mound recalls the sand mound at Ginkakuji, but with its large scale it is used as a stage for weddings and other performances. Set within this diverse landscape are other structures, including the Shrine, housing a *mikoshi* (festival float) given by the sister city of

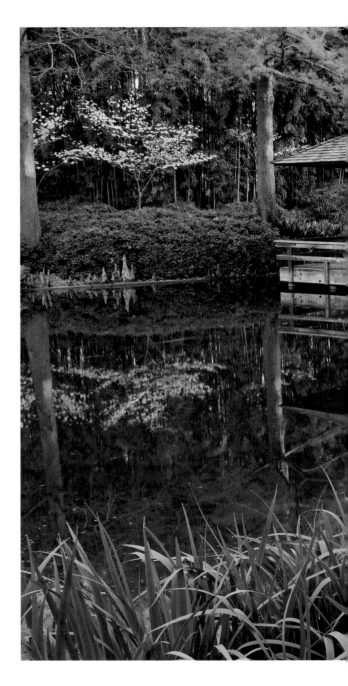

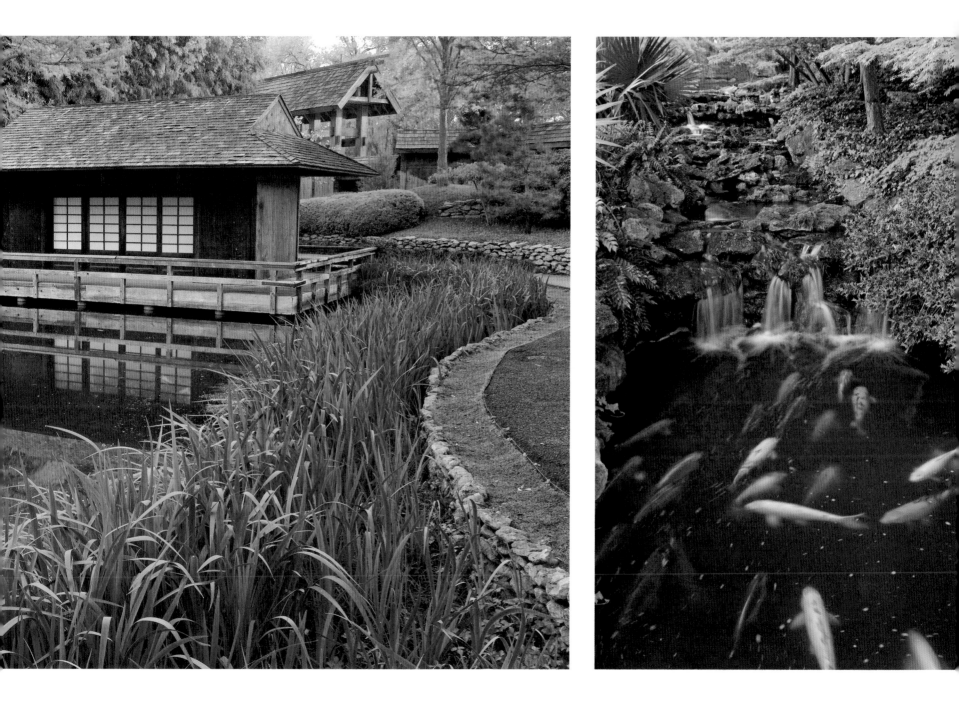

Nagaoka, and the five-tiered pagoda, created by park labor. These structures and garden features provide a kind of cultural and historical counterpoint to the lush landscaping. In similar fashion, the numerous paths and dry steams form visual breaks amid the sea of green.

While the rest of the FWBG is open free of charge, the Japanese Garden has long charged a fee to offset costs of maintenance and repair, and to limit use by casual picnickers. The garden also raises revenue—and awareness—through rental for weddings and other special events, including Japanese festivals held in the spring and fall. As with other gardens created on a dramatic scale, it looks best when filled with people who are enjoying it, and it comes alive with celebratory events.

1. Scott Fikes, "A Piece of the . . . Forth Worth Botanic Garden History," *The Redbud*, 1995.

Above A ten-story stone pagoda, near the Meditation Garden, is one of many stone ornaments.

Left Wooden ramps lead from the ponds at the bottom of the ravine to the pavilions on its edge.

Right The large wooden "pagoda" stands close to a *torii* near the garden's exit.

Opposite above left The Suzuki Garden, in a walled enclosure by the entrance, is a recent addition.

Opposite below left The so-called Meditation Garden adapts the typical stone garden by providing a viewing verandah on all four sides, not just one.

Opposite right Multiple A-frame structures, connected by decks or a paved courtyard, make up the Pavilion area used for food service and events.

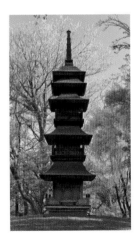

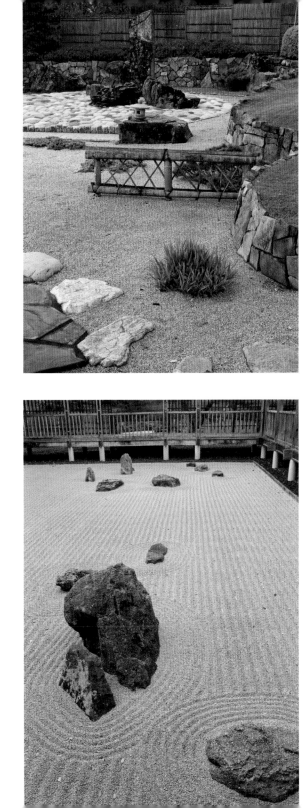
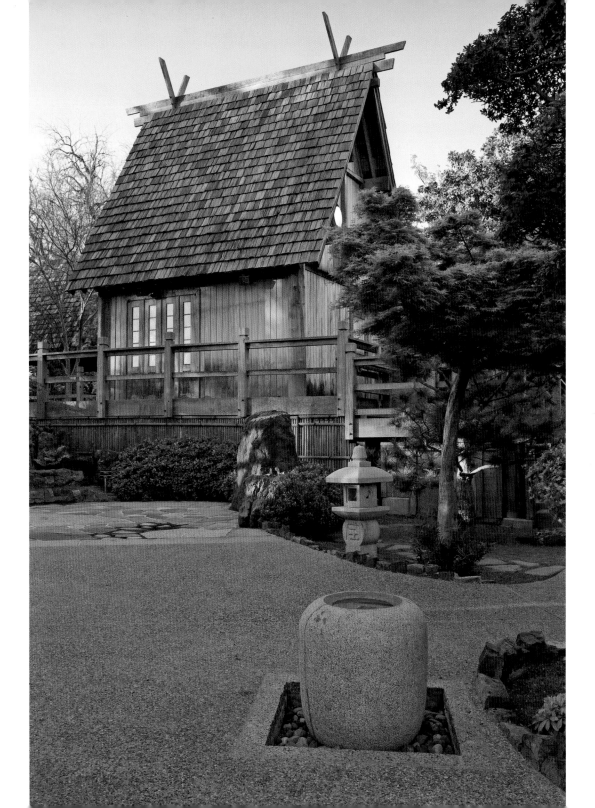

SHŌMU'EN (PINE MIST GARDEN) AT CHEEKWOOD

LOCATION NASHVILLE, TENNESSEE DESIGNED BY DAVID ENGEL OPENED 1990

Right A stepping stone path leads into the transitional bamboo grove.

Below This Nishinoya-style lantern marks the transition to the semi-formal courtyard in front of the viewing pavilion.

Opposite The curving shape of the path adds mystery to the bamboo grove.

As designers adapted Japanese landscape styles for North American gardens in the post-war decades, pond-style stroll gardens and sand-and-stone gardens predominated. In a distinct break with these two styles, at Cheekwood, a botanical garden and art museum on a former estate, David Harris Engel created a complex garden based on an experiential approach to Japanese gardens as careful calibrations of movement through space and as stage-like displays observed from a single point. Although these qualities are present in other gardens, at Shōmu'en they are more concentrated and thus are understood more easily by most viewers.

When Cheekwood added a Botanic Hall in 1970, Mrs Coleman Helme created a small "tea garden" around the entrance. This humble landscape planted the seed for a Japanese garden behind the Botanic Hall, where a tennis court sat at the base of a hill when the property was the estate of Maxwell House Coffee investors Leslie Cheek and Mabel Wood. In 1977, after Betty Weesner, a former president of the Ikebana International chapter, gave a generous gift, Cheekwood began to look for a designer. Kingsley Wu submitted a conventional plan for a large pond and a sand-and-stone garden. It was rejected in favor of one by David Engel that elucidates many of the ideas in his *Japanese Gardens for Today* (1959).[1] Engel wrote that book based on his years of study in Kyoto with garden builder Tansai Sano. Engel also consulted with Makoto Nakamura of Kyoto University and Tadashi Kubo of Osaka Prefectural University, who designed the gardens at the Dawes Arboretum in Ohio (1964) and at Lethbridge, Canada (1966), respectively. In America, Engel designed impressive Japanese gardens at Kykuit, the Rockefeller Estate (c. 1962), and at Gulf States Paper, Tuscaloosa, Alabama (1970), but Cheekwood is his only public project. Construction began in 1979 but, delayed by the pace of private funding, the garden's first phase was not completed until 1990.

Shōmu'en is composed of three linked segments visited sequentially. First is the "Roji" or tea-style garden, entered

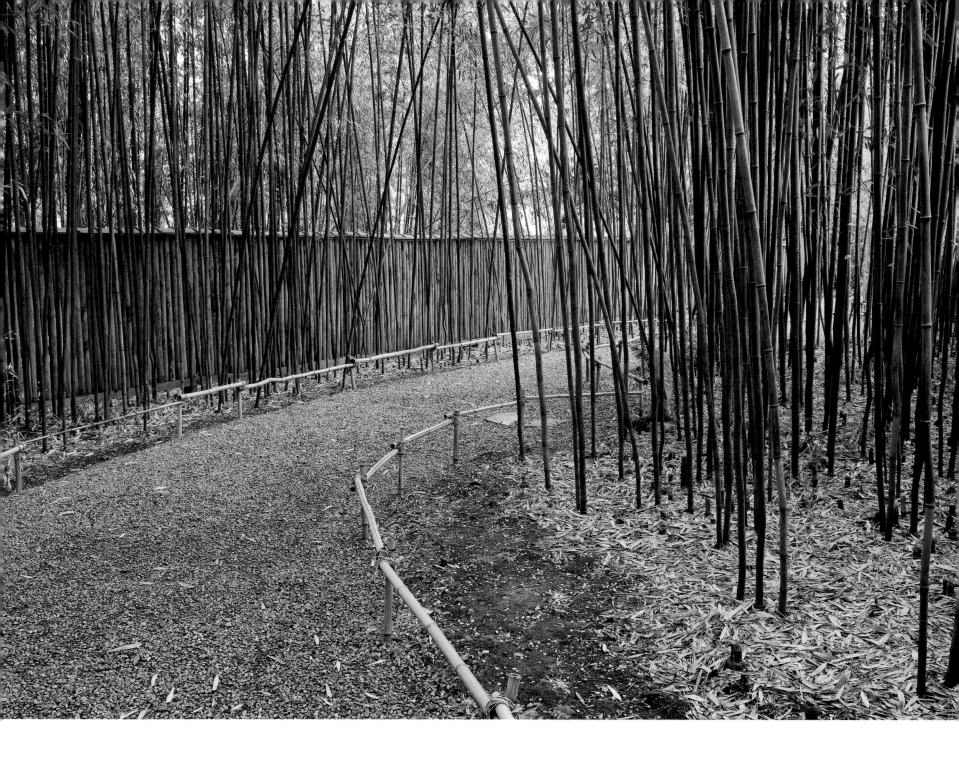

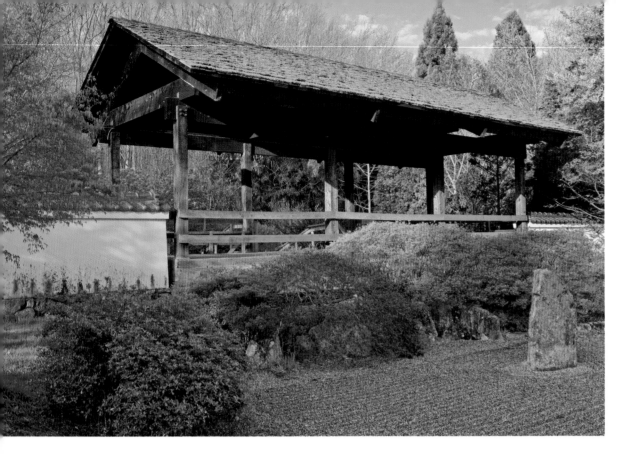

through the formal Entry Gate and comprised of a "crooked path" descending a hillside beneath mature trees. From the Japanese *roji*, Engel adapted the idea of a transitional space in which one travels through a mountain-like setting along stepping stones. After this preamble, the visitor passes through a simple gate to enter a bamboo grove along a flat gravel path. Borrowing ideas from stroll gardens, Engel evokes the sense of hide-and-reveal through strategic use of hedges, a tile-topped plaster wall, and the dense bamboo grove studded with a few lanterns and votive statues. Turning a corner and passing through another gate, the visitor arrives at the gabled viewing pavilion and its semi-formal entry courtyard.

From the pavilion, suggesting the experience of sitting on the verandah of a temple hall or aristocrat's pavilion, one gazes out at a "dry lake" composed of gravel brought from North Carolina and granite boulders trucked from northern Georgia, surrounded by hills. The view is severely framed by the pavilion's posts and beams. The subtle composition and variety of details invite prolonged and careful viewing. According to the official narrative that explains the garden's poetic name, the scene is supposed to "recreate in the mind an early morning mist rising between the distant hills, a scene often noted in Japan and Tennessee." In the garden, the "mist" is implied by the soft heads of the shrubs and trees pruned to emerge just over the silhouette of undulating hills. Black pines higher on the hill are pruned to maintain a small size and windswept appearance, creating the sense of a distant mountainside. Typical of Engel's other gardens, there is careful attention to colors, textures, and details. Engel meticulously drafted every part of the garden from the stone arrangements to the gates, even drawing patterns to be raked in the gravel and diagramming construction of the rake.

In 1991, Engel visited the garden and made detailed recommendations for the pruning of most every plant. In the subsequent two decades, Cheekwood's staff revised the viewing pavilion, built gates, and completed the gravel path leading up the hill, allowing a few filtered views back to the dry lake. As Shōmu'en has matured into one of the most original Japanese gardens in North America, Cheekwood faces the challenges of maintaining it at a high level as well as creating programs that will attract visitors to this unique environment.

1. David Engel, *Japanese Gardens for Today*, Rutland, VT: Charles E. Tuttle, 1959.

Opposite left The viewing pavilion provides an elevated view into the "dry lake" and surrounding slopes.

Opposite right Votive sculptures, including the Buddhist deity Sho Kannon, populate the bamboo forest.

Above The dry lake is edged with stones, conifers, and cherry trees.

Far left Dry waterfalls drop into the dry lake.

Left A Kasuga-style lantern provides a rustic backdrop for a red plum.

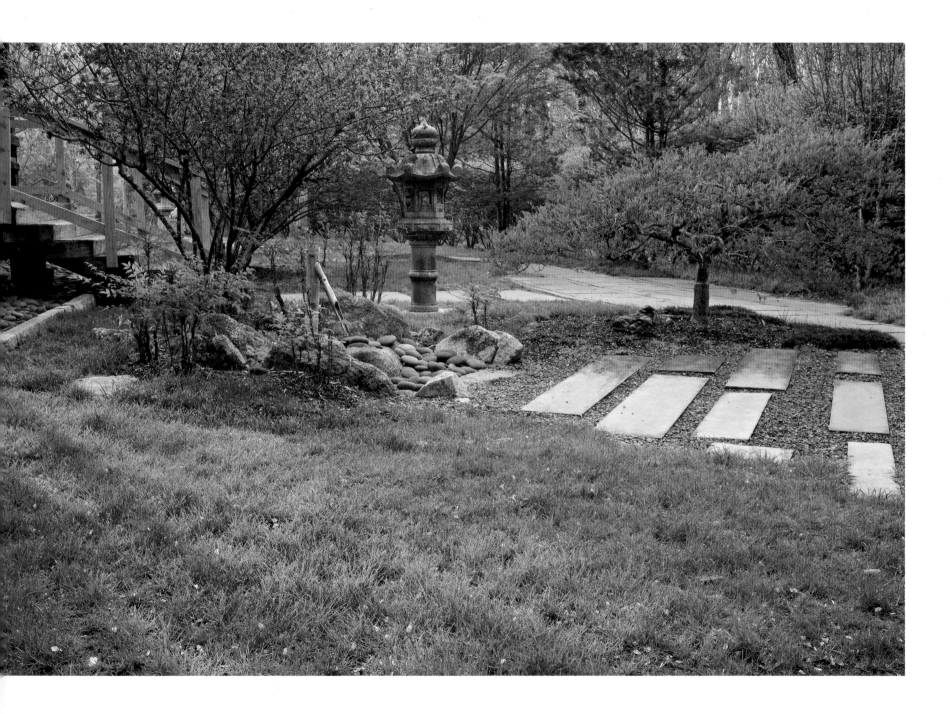

Opposite Paved stone slabs, a Kasuga lantern, a plum, and a maple comprise the courtyard.

Left An Enshū-style lantern and cherry flank the path as it leaves the viewing pavilion.

Below left A bench encourages visitors to rest on the descent through the transitional *roji* garden.

Below A ten-story stone pagoda stands amidst slender pines on the hill above the dry lake.

CHAPTER FOUR

EXPANSIVE VISIONS

Kōichi Kawana's Japanese Dreamscapes

In the 1970s and 1980s, Japanese gardens in North America reached new heights of popularity in terms of numbers of books published and gardens built. The largest and most spectacular examples were created by Kōichi Kawana at botanic gardens across the continent. These complex landscapes, full of references to famous gardens in Japan as well as creative combinations of new and conventional forms, combine intimacy and expansiveness. Kawana's most successful gardens, in Chicago, Los Angeles, and St. Louis, suggest the subtlety of Japanese design and the grandeur of North American space. To this potent mix Kawana's various writings suggest a strong symbolic program for his gardens. As such, his gardens have a spiritual dimension that appealed to patrons searching for antidotes to the seeming banality of modern culture.

Kawana's vision was the product of diverse experiences rather than any formal training in Japanese garden construction. Born, raised, and first educated (in economics) in Japan, Kawana later received masters' degrees in political science and in art from UCLA, where he long worked as an interior designer. His real passions, however, were Japanese arts, including pottery, flower arrangement, and ink painting, and teaching adult education classes in Japanese architecture and garden history. Kawana's best gardens reflect his rich personal history in dramatic form—they offer ample testimony to his imagination and the skill of the contractors who realized his ideas.

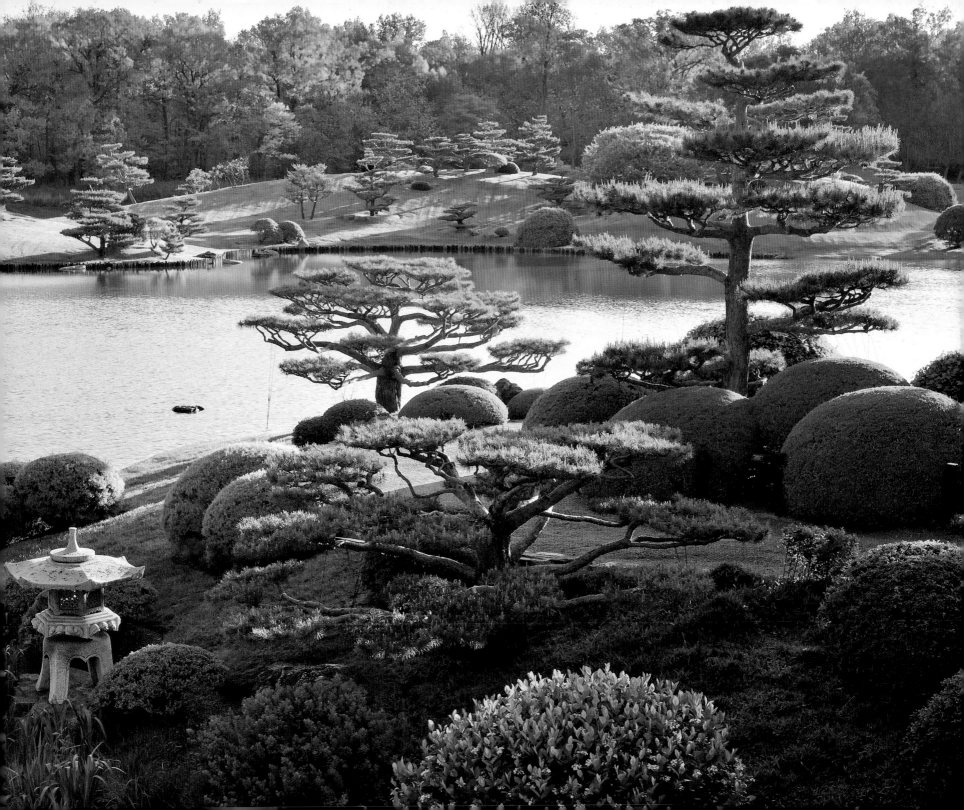

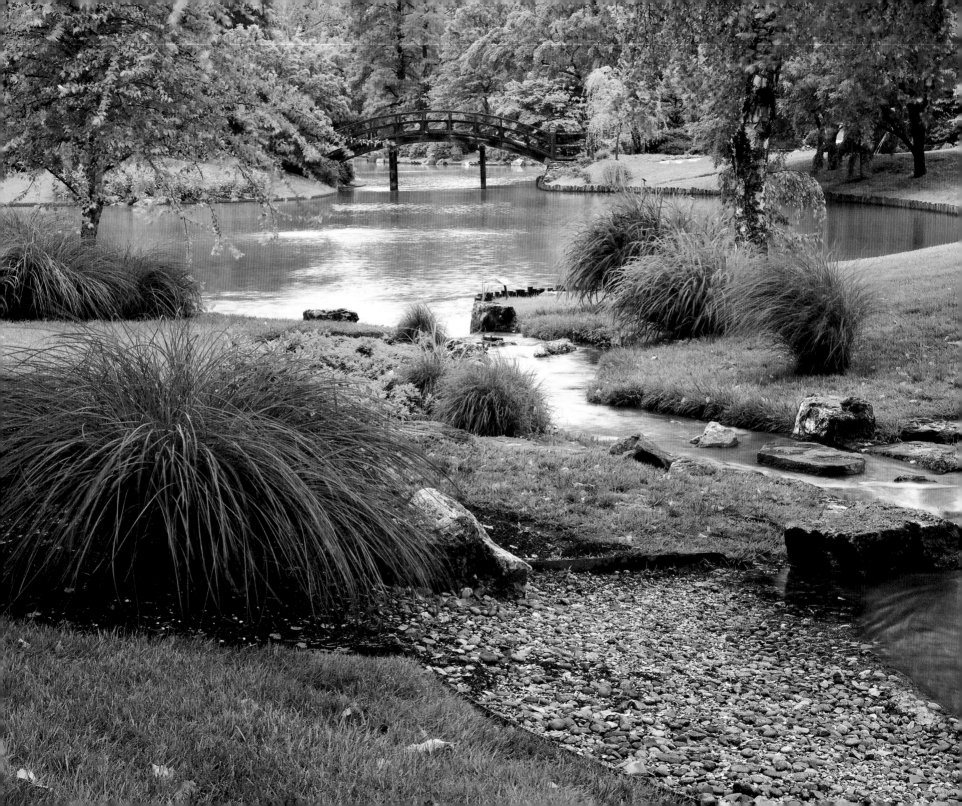

SEIWA'EN (GARDEN OF PURE, CLEAR HARMONY AND PEACE) AT THE MISSOURI BOTANICAL GARDEN

LOCATION ST. LOUIS, MISSOURI DESIGNED BY KŌICHI KAWANA OPENED 1977

In their characteristic creativity and massive scale, the gardens designed by Kōichi Kawana in the 1970s and 1980s expanded powerfully on the rich legacy of pond-style stroll gardens made in Edo-period Japan and in North America at both pre-war world fairs and post-war city parks. Though not formally educated in garden building nor in landscape architecture, Kawana drew on his experience as an interior designer and his knowledge of various Japanese arts as well as garden history to create three gardens of rare power. At the 14-acre Seiwa'en, Kawana not only designed the largest bounded Japanese garden in North America but evolved the *daimyō*-type stroll garden to fit the grand scale of an American botanic garden. In so doing, Kawana exploded the stereotypical idea of Japanese gardens as being dainty miniature landscapes. His best gardens, by contrast, evoke the impressive sweep of Japanese garden history as well as Japan's contemporary economic strength, even as they express the imagination of a designer unconstrained by conventional experience. In St. Louis, Kawana first explored the ideas that he would master in Chicago and Los Angeles.

In 1972, Sam Nakano, chairman of a Japanese Garden Committee formed by the Japanese American Citizens League of St. Louis, met with Dr Peter Raven, the new Director of the Missouri Botanical Garden. Raven approved of Nakano's idea for a garden, and the Garden Committee then chose Kawana as designer, though he had only recently started to make gardens. With $1.2 million gathered from individual donors and a fundraiser as well as from the NEA, the Missouri Department of Natural Resources, the Japan World Expo Commemorative Fund, and other foundations, ground was broken in September 1974. After excavation of the 4.5-acre pond, Kawana guided the rapid placement of 800 tons of stone, primarily Colorado green stone and Pennsylvania blue stone, around the pond area, with Missouri brown stone for stepping stones. Kawana then consulted with Raven on plant choices, shipping the Japanese black pines from California. Rather than making a blueprint, Kawana made brushed ink paintings of the various garden features and these were translated into formal plans by Mackey Mitchell Architects, who also oversaw much of the construction. On periodic visits, necessitated by his job on the design staff at UCLA, Kawana advised on construction until the garden was dedicated on May 5, 1977.

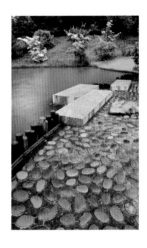

Above A pebble beach culminates in boat landing stones.

Opposite The 4.5 acre pond is fed by a gentle stream emanating from a waterfall.

Previous spread The Island of the Immortals beckons from the distance at the Chicago Botanic Garden.

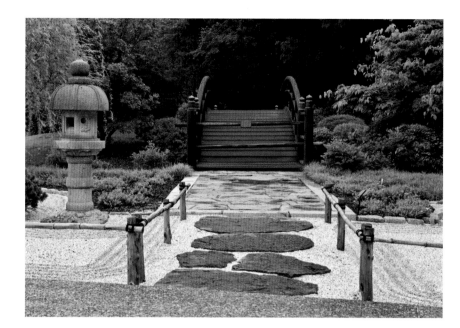

Right Typical of Kawana's innovation is the path to the tea house over a drum bridge accessed by stepping stones and aggregate *nobedan* stone pathways.

Below An undulating dry garden alongside the path is separated from the pond by a row of pines.

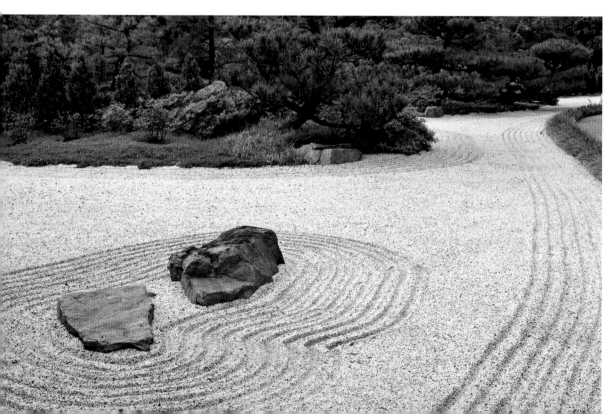

Seiwa'en utilizes the conventional hide-and-reveal scheme but on a grand scale, concealing and disclosing near and distant elements as the garden unfolds during the viewer's journey along a gently curving path. At the entrance, a large hedge blocks views of the massive pond. Instead, attention is diverted to the large lantern imported for the 1904 Louisiana Purchase Exposition, signaling the first great Japanese garden in St. Louis. Kawana frequently used symbolism to imbue the garden with cultural and spiritual meaning at a time when Americans were drawn to Buddhism and when Japanese gardens were usually "read" as expressions of a benevolent Eastern spiritualism. This recourse to symbolic meaning extended from the design of the garden itself to the content of the pamphlet. For example, in the original pamphlet, the three stages of the waterfall, encountered as one enters the garden, are said to represent heaven, earth, and man. Similarly, one of the three islands in the pond is named the Paradise Island, its three massive vertical stones standing for "where Buddha is said to have ascended to paradise." As the paved path meanders around the pond, Kawana arranges the stereotypical elements of stroll gardens: an eight-planked bridge in an iris garden, a drum bridge, a pebble beach, a rectilinear boat landing stone, lotus beds, a maple mountain, various types of lanterns, a stone pagoda, and other garden ornaments.

The most distinctive element of Kawana's design is the setting of sculptural elements against plantings, or even the juxtaposition of foreground "dry garden" elements with the distant scenery of the pond and islands. Though awkward in places, this bold concept would define Kawana's best later gardens. Another feature typical of Kawana's gardens is the raised hill with arbor pavilion offering a broad view. Here, in its first iteration, the Arbor of the Plum Wind nestles in a plum grove. Perhaps the most successful of Kawana's experiments is the placement of the Nagano'an tea house, a 1977 gift from Nagano Prefecture, on its own island so that visitors must cross over an arched bridge to enter the pure world of the tea house. From the "hidden" entry through thick

hedges to the patterns raked in the gravel around the tea house, the entire arrangement demonstrates subtleties in design and precision in execution. Unfortunately, the tea house and island are only open on select occasions.[1]

Although a limited staff at the garden makes maintenance a monumental challenge, the careful hand-pruning regimen of long-time curator Benjamin Chu has kept the myriad plants in proper scale and fine form. The garden, the scale of which dwarfs the handful of visitors there at most times, comes alive each year over the Labor Day weekend when it is decorated with lanterns and banners, enlivened by cultural demonstrations, and filled with hundreds of people for the Japanese Festival. The festival averages 42,000 visitors over three days.

1. Kōichi Kawana, "The Japanese Garden: A Reflection of Japanese Character," *Missouri Botanical Garden Bulletin*, 63: 17 & 18, 1975; Benjamin N. Chu, "Seiwan-en, Japanese Garden at Missouri Botanical Garden: A Brief Historical Description," unpublished manuscript.

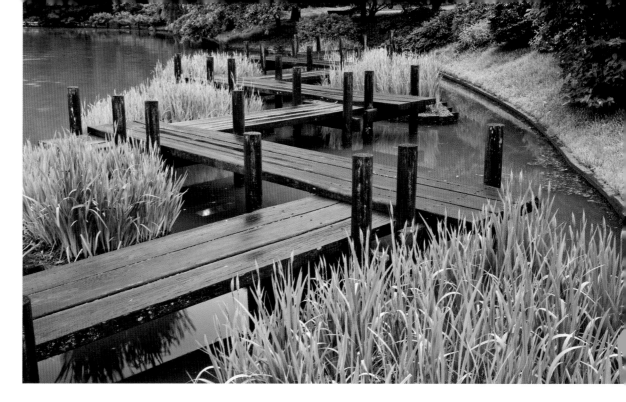

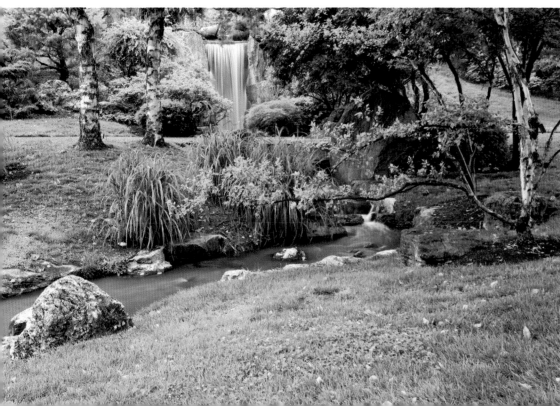

Above The familiar eight-planked zigzag bridge crosses an iris marsh.

Left The dramatic waterfall feeds the stream near the garden's entry.

Right This unusual double *zenigata* (coin-shaped) water basin, copying one at the Bōsen tea room at Kohōan, Daitokuji, Kyoto, is set among clipped shrubs, pines, and large stones.

Above A five-story stone pagoda provides another visual diversion along the lengthy path.

Right The more formal outer tea garden features two unique *nobedan* pathways of beach stones within bamboo borders.

Far left Guests purify themselves at this simple stone water basin, next to an Oribe-style lantern, before entering the tea house.

Left The rather literal boat-type water basin is one of the first ornaments confronted by visitors.

Below left The Nagano-an tea house is approached via stepping stones in raked gravel rather than the usual moss or ground cover.

Below The tea garden is divided into the outer and inner parts by a simple bamboo fence.

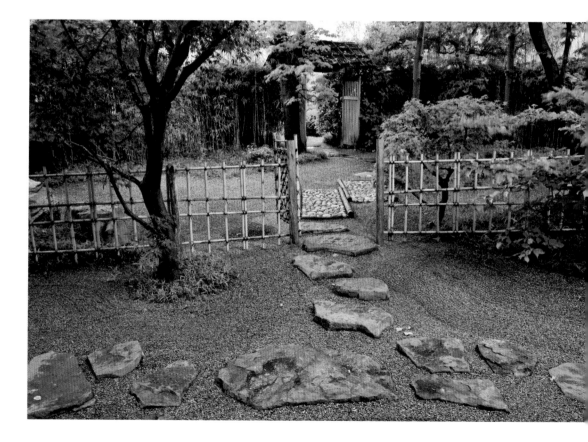

SANSHO'EN (GARDEN OF THE THREE ISLANDS)/ ELIZABETH HUBERT MALOTT JAPANESE GARDEN AT THE CHICAGO BOTANIC GARDEN

LOCATION **GLENCOE, ILLINOIS** DESIGNED BY **KŌICHI KAWANA** OPENED **1982**

Above Stepping stones through raked gravel distinguish the dry garden that leads to a viewing pavilion atop a hillock.

Opposite The Japanese garden is reached via an elegant bridge based on one at Ritsurin Park, Takamatsu, Japan.

The typical pond-style stroll garden, found in countless variations in Japan and in North America, features a path along the shore of a body of water, with views inward to islands in the pond. In the Garden of Three Islands at the Chicago Botanic Garden (CBG), self-taught garden designer Kōichi Kawana inverted the standard template. In this simple but revolutionary shift, visitors cross a bridge from the main garden to stroll around two islands, gaining changing views of the other islands and the surrounding shoreline. This plan radicalizes one part of the design in St. Louis, where a bridge leads to a tea house on the largest of three islands. In Chicago, the result is a mix of vistas and intimate spaces, winding paths, and points of contemplation in a hybrid Daoist-Buddhist paradise that is unlike any other Japanese garden. Against the backdrop of a dramatic Midwestern sky, Sansho'en is one of the most enthralling Japanese-style gardens in North America.

In 1976, when Seiwa'en at the Missouri Botanical Garden was nearing completion, Dr Francis de Vos, founding Director of the CBG, decided to create an Asian garden to balance his facility's dominant Western orientation. De Vos decided on a Japanese garden and chose Kawana, impressed by his work in St. Louis. With the CBG located on nine islands in a large lagoon on the Skokie River, de Vos gave Kawana three islands on the eastern side. Including the

surrounding water, the greater Japanese garden area comprises 17 acres. The island location and theme are well suited to a garden representing Japan, a mountainous island country where island imagery and symbolism play a major role in many garden styles. With $1 million raised from individuals, corporations, and foundations, construction took place over several years as Kawana made periodic trips to oversee the shaping of the islands, creation of paths, placement of stones and 12 stone lanterns, installation of the bridge and buildings, and planting of hearty plants (including 172 pines) carried out by CBG staff and local contractors. The garden was dedicated on September 19, 1982.

Sansho'en's central focus is Keiuntō, Island of the Auspicious Clouds, the first and largest of the three islands. Reached by an elegantly curving bridge, the island features a *shoin* building hugging the shoreline. Like the tea house in St. Louis, it is entered through a high hedge. Built by the Kumoi Construction Co., the bridge and *shoin* are closely based on similar structures at the famous Ritsurin Park in Takamatsu—the garden that was Kawana's point of departure. At the island's crown, Kawana adapted the typical hilltop *azumaya*, the umbrella-shaped pavilion approached by stepping stones set in a bed of raked gravel and surrounded by mounds of bush clover. This design adapts the basic juxtaposition of gravel, stones, and plants at St. Louis and

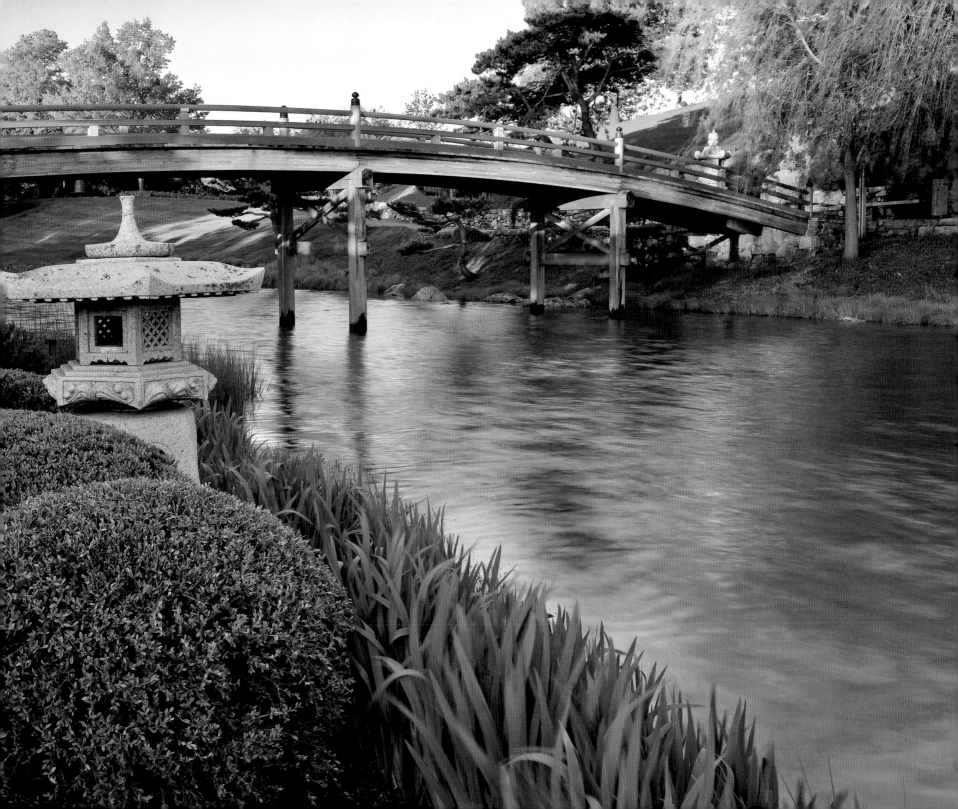

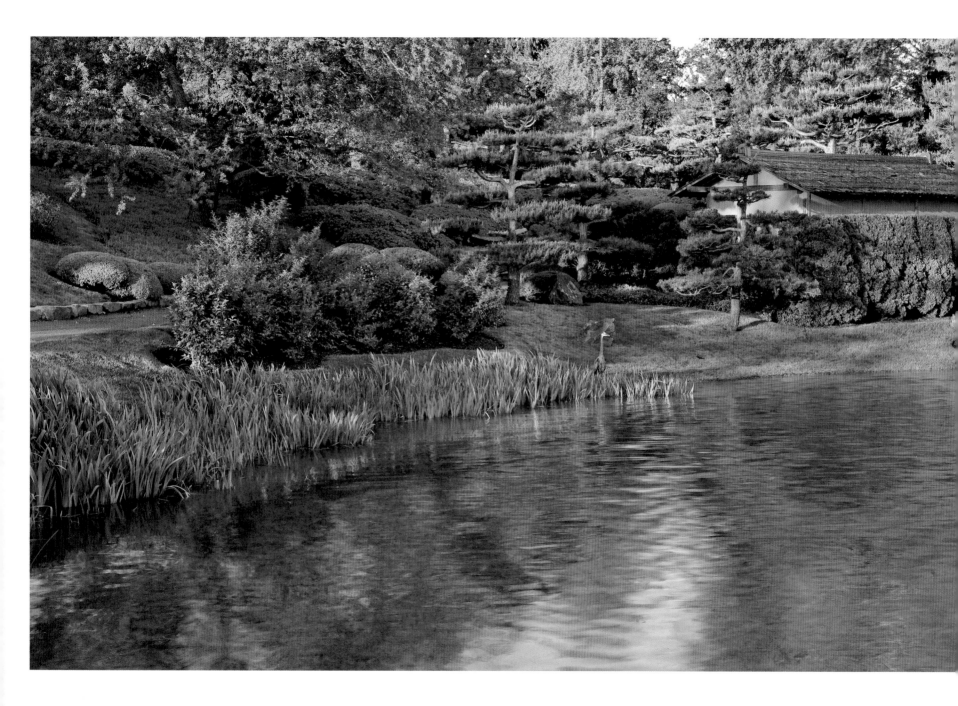

foreshadows the more sculptural dry garden at Suihōen in Los Angeles. Unfortunately, the difficulty of keeping visitors out of the raked gravel has led to the closure of the pavilion and entry garden.

The second island, Seifūtō, or Island of Pure, Clear Breezes, is reached via a bridge composed of two massive granite slabs. Relative to the more formal plantings and the azalea mounds on Keiuntō, the plants here are less aggressively pruned and more natural. At the far side of the island, a path leads to a small tea arbor in Kawana's adaptation of a *roji* or tea garden. Again, stepping stones traverse a bed of raked gravel. This arbor provides views over much of the garden, including the third island, Hōraijima (Ch. Penglai), the Island of Everlasting Happiness or Island of Immortality. The island cannot be reached by visitors—existing symbolically beyond human habitation—and is best seen from the shoreline north of Sanshoʻen. The pines and shrubs are kept small so that the island seems more distant.[1]

Filled with plants that flower in spring, summer, or autumn, and with its signature Scots pines vivid against the snow, the garden is spectacular in all seasons. Perhaps because the CBG has not developed a successful docent tour program, Sanshoʻen has become a sign-intensive environment, with dedication plaques, permanent signs, and even "ephemeral signs" that are rewritten periodically. After peaks and valleys in maintenance, the garden has recently received excellent care. For instance, in spring 2011, the small staff spent 570 hours candling pines. The power of Sanshoʻen within the CBG is evidenced by the fact that, decades after its dedication construction, a naturalistic Waterfall Garden was created on the slope facing its entrance. This new garden creates an appropriate context for the Japanese garden, although it could also be interpreted as extending the power of Japanese design into the rest of the garden.

1. "Sansho-En" booklet, Chicago: Chicago Botanic Garden, 1982; Kris Jarantoski, "Garden of Three Islands at the Chicago Botanic Garden," *Garden*, 1982.

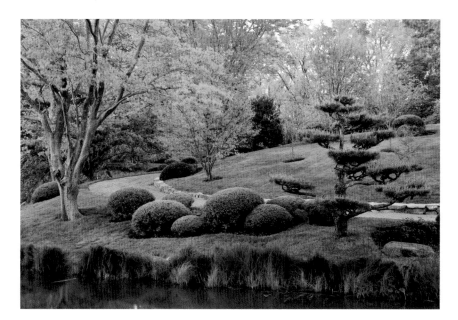

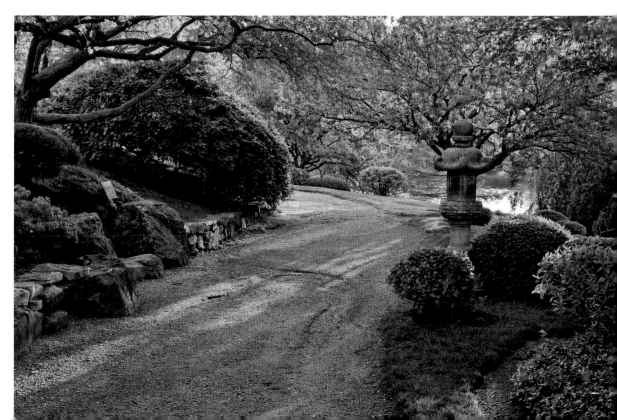

Opposite The garden's several structures are hidden from some angles, but emerge into view from others.

Left The paths provide a visual line between the shoreline and the side of the hills.

Below Curving path circle the islands, flanked by massed plants, stones, and garden ornaments.

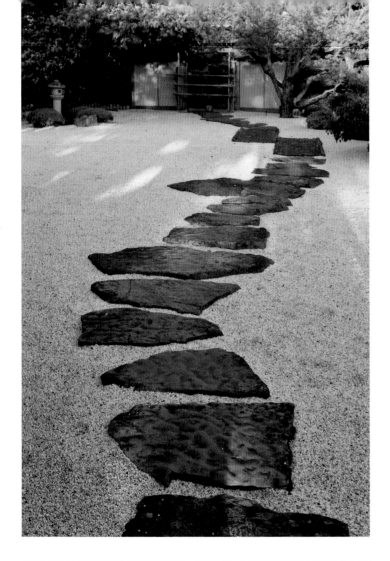

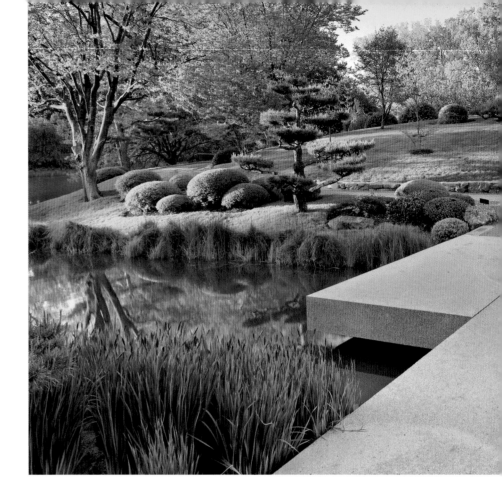

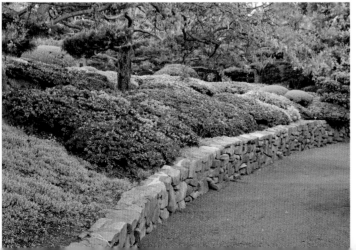

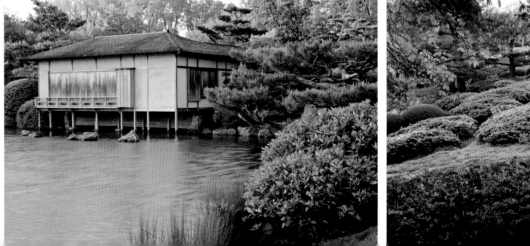

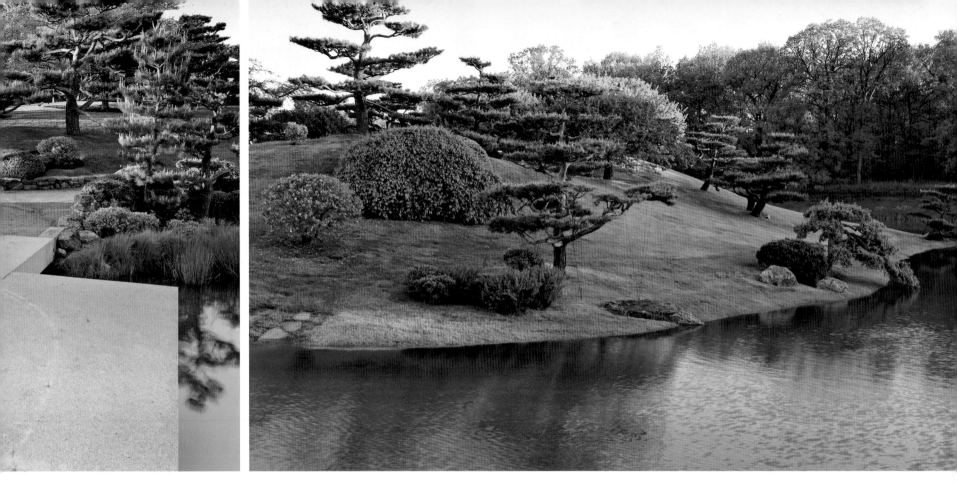

Far left above Kawana used his signature dry garden passage on the two islands that can be visited.

Far left below Masses of azaleas encircle a pine.

Center left The pondside *shoin* building is based on a building at Ritsurin Park, Takamatsu.

Left Large azalea hedges flank a hill crowned with a viewing pavilion.

Above left Two granite planks lead to a bank of irises on the Island of Pure, Clear Breezes.

Above right The distinctive pruning style on the many pines creates a challenge for the garden staff.

Right The garden successfully juxtaposes elements that are curvilinear and rectilinear, soft and hard, textured and smooth.

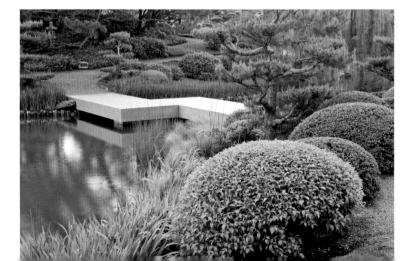

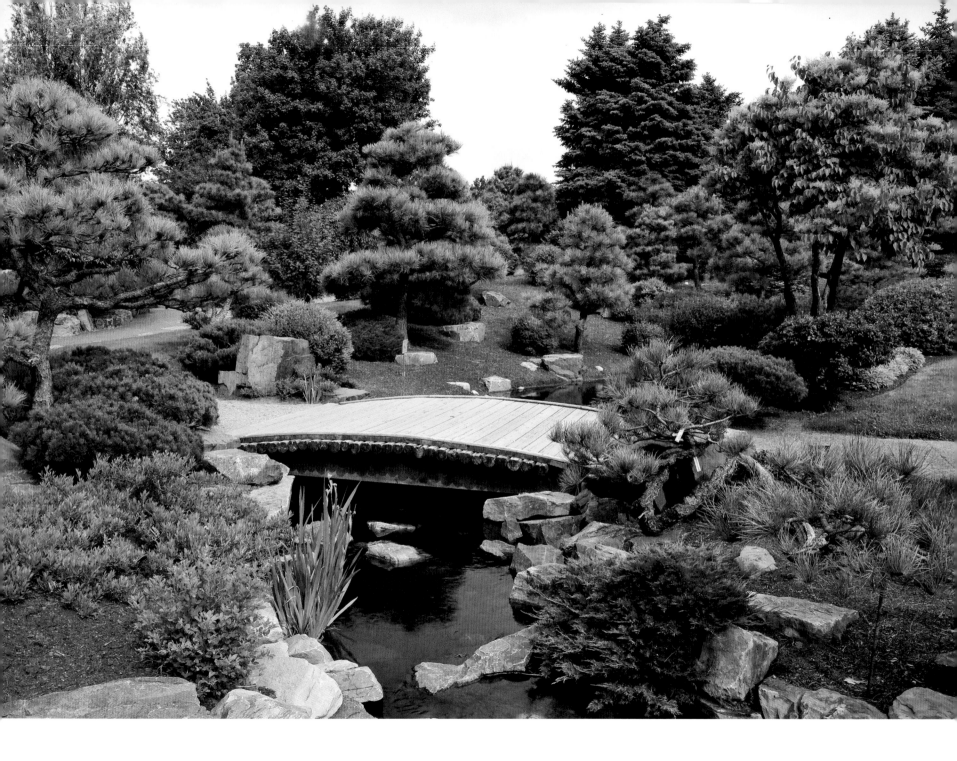

SHŌFŪ'EN (GARDEN OF THE PINE WINDS) AT THE DENVER BOTANIC GARDENS

LOCATION **DENVER, COLORADO** DESIGNED BY **KŌICHI KAWANA** OPENED **1979** MAJOR ADDITION **2012**

Opposite Ponderosa pines and stones gathered from the Front Range connect the garden with the local environment.

Below A *yukimi*-style lantern is at home in a garden that sees significant snowfall.

A central premise of Japanese garden design is sensitivity to the local environment. As a Japanese man who adapted himself to life in America, designer Kōichi Kawana was well suited to put this principle into practice. At the same time that he was creating grand water gardens in St. Louis and Chicago that adapt features of stroll gardens to the vast horizons of the American Midwest, for the Japanese garden at the Denver Botanic Gardens (DBG), Kawana sought to acclimatize a more intimate pond-type garden to the environment and spirit of the Rocky Mountains.

The DBG's 1969 Master Plan included a Japanese garden, advocated by Japanese-American members of local *bonsai* and *ikebana* groups after Denver's sister city Takayama donated a Kasuga-style lantern in 1964. The idea lay dormant until Kawana stopped in Denver on a trip between Los Angeles and St. Louis in 1977. Impressed by his vision and enthusiasm, the planning committee chose Kawana to design a 2.5-acre garden in the northwest corner of the 23-acre facility. Kawana presented his initial plan in August 1977, then helped with the $250,000 fundraising drive. During trips to Denver in 1978, made on weekends due to his regular job as "architectural associate" with the UCLA Campus

Architects and Engineers, Kawana led staff and volunteers as they gathered 300 tons of stones from Golden and Loveland, and accepted from local nurseries donations of Austrian pines, Japanese black pines, pinyon pines, blue spruce, and many other specimens. Most critical was the collection of Ponderosa pines, most around 400 years old, from the Roosevelt National Forest in the Front Range near Boulder. With a plant-collecting permit secured by DBG Vice President Edward P. Conners, volunteers from the Rocky Mountain Bonsai Society located and transplanted over 130 appropriately "tortured" Ponderosas. They are pruned in the "floating cloud" style to keep them like low, windswept mountain trees.

Kawana's design pairs a meandering stream with a pond, separating them by a low hill. Shōfū'en is traversed by meandering paths that, in the context of the Rockies, might be likened to mountain trails. In the northeast corner is a tea house approached through a tea garden. The tea house, funded by the Eleanor Muller Weckbaugh Foundation, was built in Nagano, Japan, and reassembled in Denver by the Kumoi Construction Co. early in 1979. It is used for tea ceremony demonstrations and, originally, housed a small

collection of *bonsai* in the outer area. Although the garden was dedicated on June 23, 1979 as part of Denver's "Japan Today" events, over the next few years it was completed with the creation of two entry gates and the addition of ground covers, including periwinkle, myrtle, moneywort, pearlwort, and bugleweed, to limit erosion from summer storms.[1]

Shōfū'en was long maintained by Kei Kawahara, then, after a period of decline it enjoyed a renaissance in the twenty-first century under new curator Ebi Kondō. In 2004, the DBG began planning a major renovation by Sadafumi Uchiyama to significantly improve the flow of the paths around the pond, create new viewing spots, including a Moon Viewing Platform at the pond's north edge, and redesign the tea garden. The expanded tea garden includes the new Bill Hosokawa Bonsai Pavilion, honoring the long-time Denver journalist and Japanese-American historian who garnered critical support for the garden during its initial creation. In 2012, to celebrate the completion of these important changes, the DBG hosted the annual conference of the American Bonsai Society/Bonsai Clubs International as well as the first conference of the North American Japanese Garden Association.

1. William Gambill Jr, "The Greening of Shōfū'en: Japanese Garden in the Shadow of the Rockies," *Green Thumb News*.

Opposite A raised viewing shelter provides both a viewpoint and a focal point.

Below left Irises add spots of color to a garden that is largely tan and green.

Below right An Oribe-style lantern occupies a quiet corner.

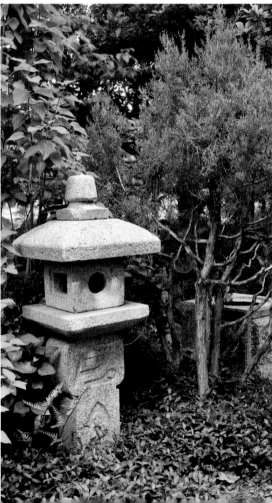

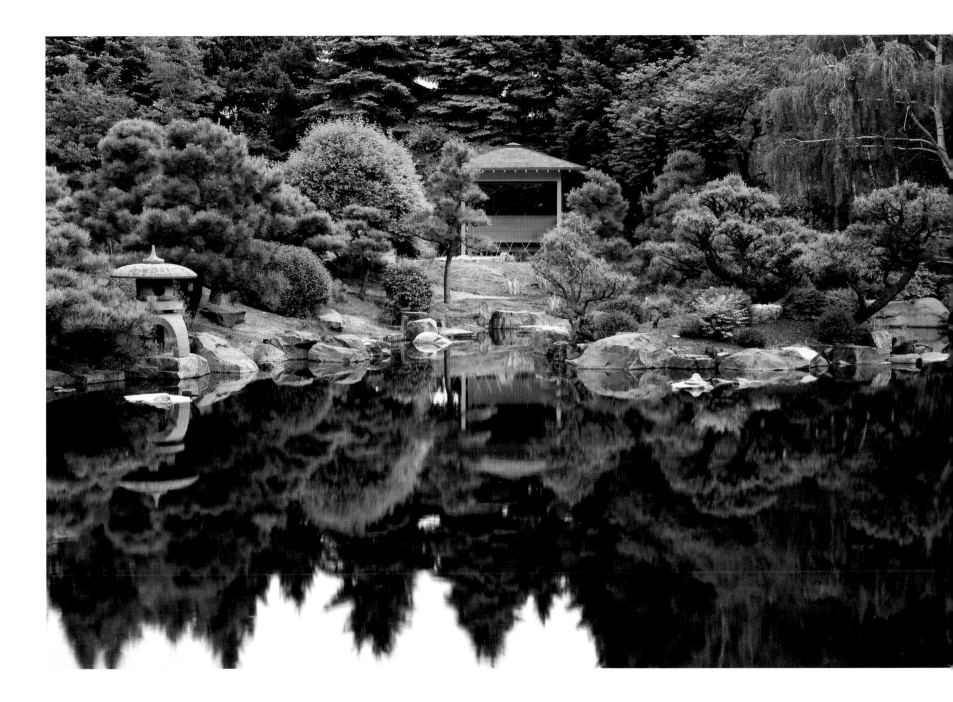

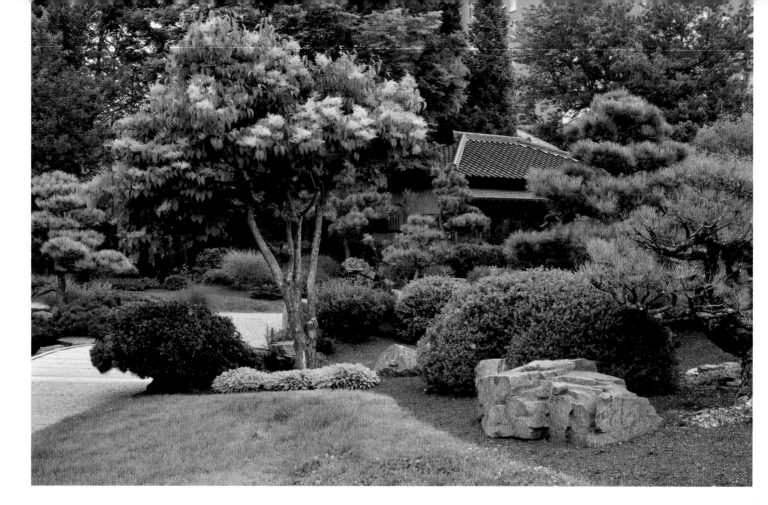

Right The tea house sits within a tea garden, renovated after this photo was taken.

Below The viewing shelter was part of the additions made by Sadafumi Uchiyama.

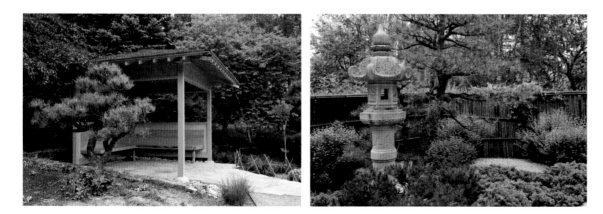

Left This Kasuga-style lantern, given by the city of Takayama in 1964, was the impetus for the garden.

Right The rectilinear quality of the newly added Moon Viewing Platform parallels the sharp lines of the boat landing area across the pond.

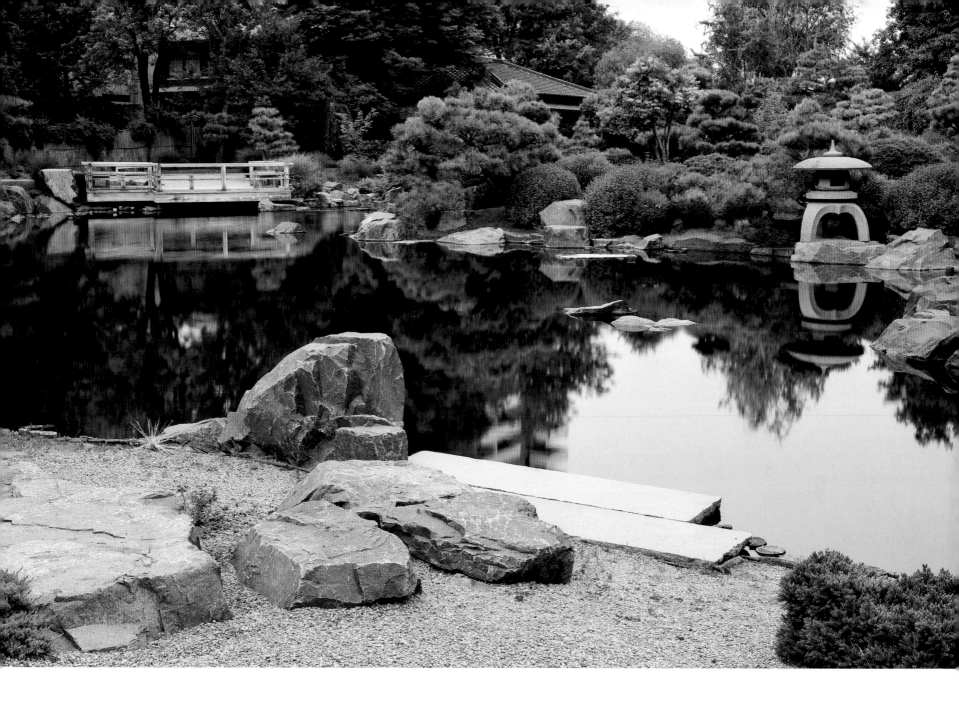

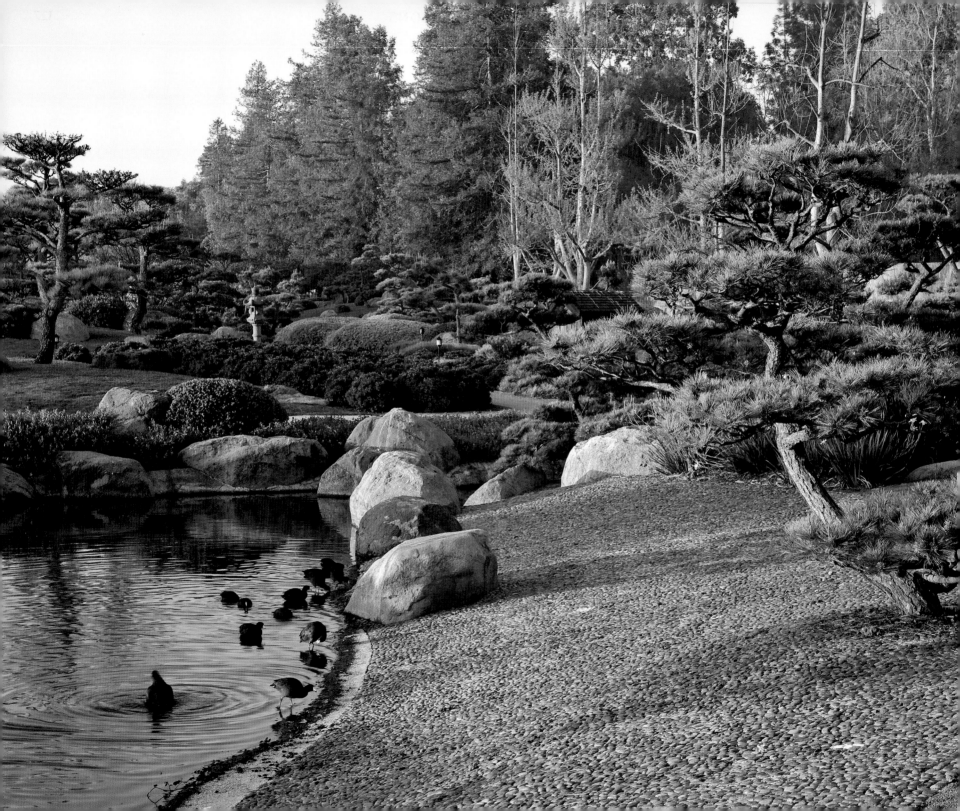

SUIHŌ'EN (GARDEN OF WATER AND FRAGRANCE) AT THE DONALD C. TILLMAN WATER RECLAMATION PLANT

LOCATION VAN NUYS, CALIFORNIA DESIGNED BY KŌICHI KAWANA OPENED 1984

The first major gardens designed by Kōichi Kawana adapted Japanese landscape styles to grand scales and to harsh weather conditions. In designing a 6.5-acre garden for the Donald C. Tillman Water Reclamation Plant in Los Angeles, Kawana was charged with accommodating the site's futuristic Administration Building and making the reuse of sewage effluent acceptable to the public. Encouraged by his experience creating colossal pond-style stroll gardens in St. Louis and Chicago, Kawana met this new challenge with the most imaginative garden of his career. Suihō'en is a bracing mix of diverse Japanese garden elements—dry garden, strolling garden, and tea garden—on a site flanked by architect Anthony Lumsden's massive administrative structure. Despite the latter's science fiction aura (it was the Starfleet Academy in the *Star Trek Next Generation* television series), the building has the grid-based modular construction, neutral color, and physical lightness characteristic of Japanese *shoin* buildings. The resulting mix of contemporary architecture and historically allusive garden creates an environment of intriguing beauty.

Opposite The garden, separated from the surrounding park by a screen of trees, effectively pulls the eye back through space.

Above right The large pond attracts many migrating birds.

Below Kawana's characteristic stepping stone path over gravel leads from the dry garden to the main path.

As Los Angeles's City Engineer from 1972 to 1980, Donald Tillman instituted progressive wastewater practices and his crowning achievement was a state-of-the-art water reclamation plant in the Sepulveda Flood Control Basin. Tillman desired a Japanese garden around the 4-acre pond to mitigate the negative associations of reclaimed water and homeowner opposition to a sewage treatment plant. Tillman was introduced to Japanese gardens in a Japanese art and architecture class that Kawana taught for UCLA Extension, an adult continuing education program. Kawana reportedly made sketches for the garden in the early 1970s, then re-designed it when hired in 1980. Built by city crews at a cost of several million dollars, the garden was dedicated in 1984 with the name Suihō'en or Garden of Water and Fragrance, literally "water scent garden". The poetic name fits the public relations' function of the complex, but, given the slightly pungent aroma when the breeze blows west from the treatment tanks, it also suggests Kawana's sense of humor.

Passing through the entry gate on a formal aggregate path, the visitor's initial view of the pond is partially hidden by plantings. After a few steps, the complexity of the

island-studded pond beckons. However, the immediate landscape is a dry garden, where the literal water in the pond is balanced by a symbolic "sea" of gravel that encloses the large Tortoise Island and is ringed by a shore of stones and shrubs. The dry garden is crossed on flat stepping stones in the same staggered *chidori* (plover) pattern used at Chicago's Sansho'en. The dry garden establishes the simple, even abstract tone of the entire complex, characterized by a monochromatic palette, subtle play of textures, and emphasis on the round shapes of stones and plants breaking the curving lines of paths and streams. Of all his gardens, Suihō'en best expresses Kawana's training in *ikebana*, *sumi-e* drawing and abstract painting.

From this bracing opening section, one broad path curves along the west side of the pond, reminiscent of the paths at Sentō Gosho in Kyoto. The other path, tucked behind a low mound, meanders between clipped hedges of pittosporum and a stream. When the paths merge toward the north end of the pond, visitors are offered tantalizing views of small islands in the pond and the *shoin* building at its far end. The shoreline, though generally edged in stones, stakes, and a curb of concrete grown over with ground cover or low shrubs, is punctuated here with the rectilinear boat landing stones and a broad pebble beach redolent of seventeenth-century Imperial gardens. A small hill culminates in a *sukiya*-style viewing arbor set in a grove of white alder.

The north end of the garden groups four distinct features in close proximity. In the northwest corner, Kawana designed an abstract version of the Amanohashidate stone and pine peninsula from Katsura Villa. This Floating Bridge of Heaven is represented by two stone-clad sections joined by a "bridge." Although ungainly, this element shows Kawana's desire to reimagine familiar garden features and his good sense in confining this experiment to a discreet corner. Just east of Amanohashidate, the main path crosses a gentle arched wooden bridge then leads to the small *roji* or tea garden with *machiai*, or waiting arbor, used for tea ceremonies. The 4.5 *tatami* mat tea room is located inside the adjacent *shoin* building. Although there is precedent for such combinations,

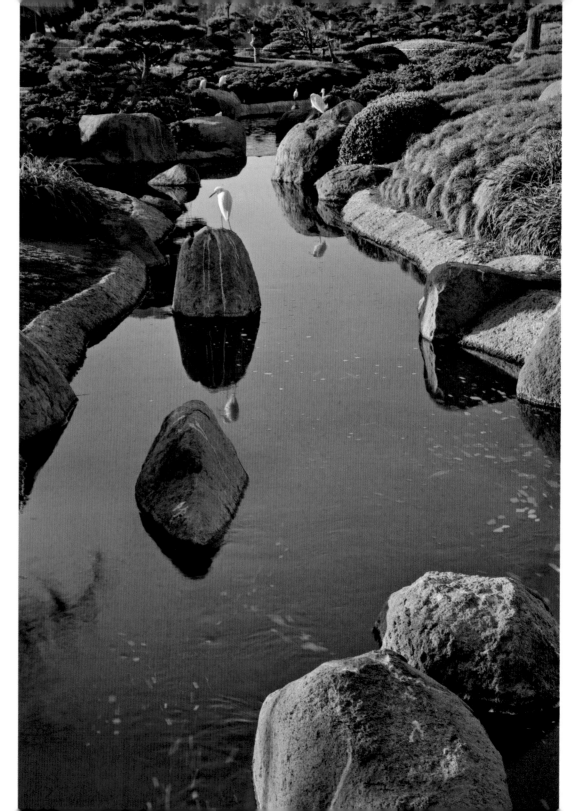

the authentic *chashitsu* contrasts awkwardly with the modern interior of the *shoin* building. In its waterside position and exterior design, Suihō'en's *shoin* resembles the *shoin* in Chicago—and both are based on the famous Kikugetsutei at Ritsurin Park in Takamatsu. From behind the *shoin*, the path climbs steeply to a viewing arbor. Both buildings provide pleasing vistas to the south, with the spacious, harmonious prospect of the pond garden echoed in the borrowed scenery of the Santa Monica Mountains.

Suihō'en's east shore evolves quickly from a waterfall in a steep ravine, through a plum grove, to an iris marsh traversed by an eight-planked bridge—the *yatsuhashi* common to Edo-period stroll gardens. Along the pond shoreline, Kawana adopts the millstone stepping stones from Kyoto's Heian Shrine. The path culminates in a grove of peach trees, their spring color balancing that of a cherry grove on the west shore of the pond. The garden circuit is completed through the Administration Building, where the views through glass panels recall the vistas through the rectangular frames of the *shoin* building.[1]

Suihō'en has been managed since its opening by Gene Greene. Greene designed the one major addition to the garden—a long, rectangular reflection pond set against the raised berm and wall installed on the garden's west flank to prevent flooding from the adjacent flood basin. Suihō'en appears in countless advertisements, television programs and films, playing roles ranging from the "Garden of Love" in Playboy's *Asian Exotica* to a Japanese corporate headquarters in Michael Crichton's *Rising Sun*. Filming fees help offset maintenance costs, as does money raised through weddings and other events. There are long-standing plans to create a Japanese pavilion at the entrance with a gift shop, community room, and staff offices.

1. *The Japanese Garden Guide Book*, pamphlet, Los Angeles: Department of Public Works, n.d. It is also discussed in Kendall H. Brown, *Japanese-style Gardens of the Pacific West Coast*, New York: Rizzoli, 1999, and David Newcomer, *Public Japanese Gardens in the USA, Southern California*, Mill Valley: Japanese Gardens USA, 2010.

Above Fortnight lilies, a favorite plant in Southern California yards, substitute for Japanese iris.

Above right The garden features most of the conventional features of a stroll garden, including a wisteria trellis.

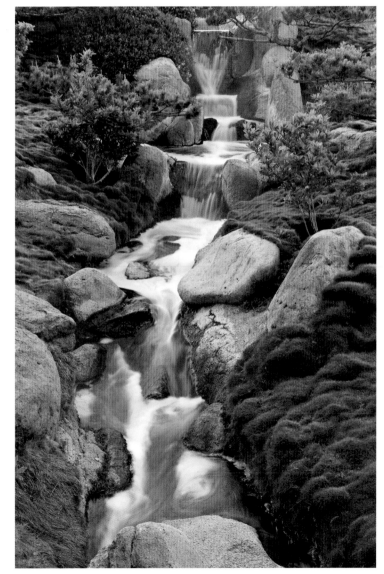

Right A stream cascades down a ravine at the garden's northeast corner.

Opposite Long, sinuous streams pull the eye into the distance, providing a watery parallel to the paths.

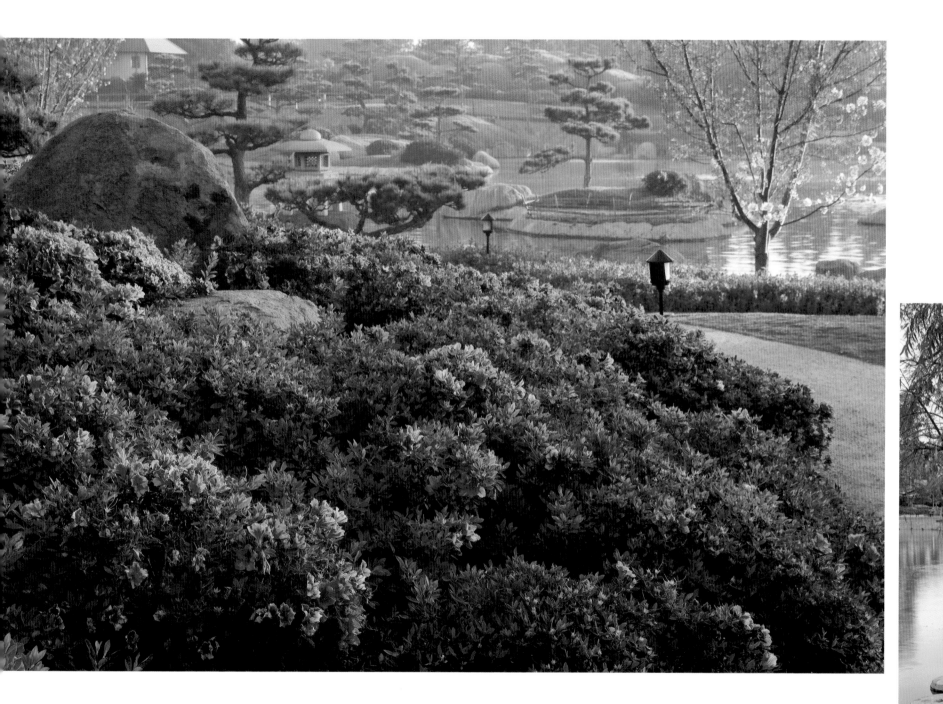

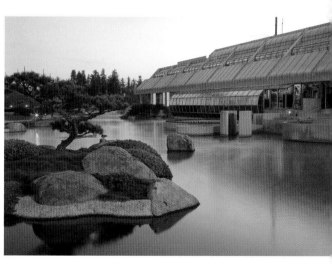

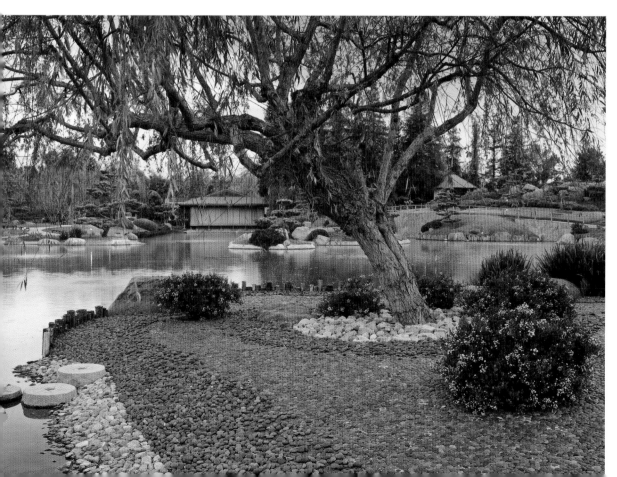

Far left Great hedges of pittosporum flank many paths and suggest a formal parallel to the large stones placed throughout the garden.

Left A viewing pavilion crowns a hill highlighted with cycads.

Below The garden surrounds the west side of Anthony Lumsden's futuristic Administration Building.

Left A willow foregrounds the view across the pond to the *shoin* building and viewing pavilion at the garden's northern end.

Opposite Mounds of azaleas connect the paths with the hillocks created with the earth excavated from the ponds.

SEISUITEI (PAVILION OF PURE WATER) AT THE MINNESOTA LANDSCAPE ARBORETUM

LOCATION **CHANHASSEN, MINNESOTA** DESIGNED BY **KŌICHI KAWANA** OPENED 1985 MAJOR ADDITION 1996

By the early 1980s, Japanese gardens were so ubiquitous, and gardens designed by Kōichi Kawana so noteworthy, that Francis de Vos, Director of the Minnesota Landscape Arboretum, invited Kawana to create a Japanese garden there. Funds were provided by long-time supporters Marge and John Ordway Jr, and Kawana was tasked with finding appropriate plants that would survive at a botanical garden intended to demonstrate specimens with a hardiness to -34 degrees. Moreover, the garden's size, a 75 x 75 foot space in the Home Demonstration Garden area, provided a major test for a landscape designer accustomed to working on a grand scale. A small space requires intimately scaled elements, the suggestion of space, and, arguably, simplification of themes. In a small garden there is no place to hide mistakes. These multiple challenges resulted in a garden that demonstrates the difficulty of successful design as well as the necessity of proper maintenance.

Created in 1984 and dedicated in 1985, Kawana named the garden after the water that is its main feature. Approached through a rustic cedar bark shingled gate, the sound of water is instantly apparent but the waterfall is screened by a grove

Above A five-story stone pagoda contrasts with the soft greens of a dogwood in flower.

Opposite The elegantly rustic viewing arbor affords vistas to the waterfall at the garden's heart.

of mugo pines and lilacs. Attention is shifted to a dramatic Kasuga lantern set in a bamboo grove to the right of the path. A few steps later, visitors get a partial view of the 10-foot waterfall, which is accessed through a small bamboo gate and a stepping stone path that leads to the small pond. For the cataract, Kawana employed blue-gray basalt from Dresser, Wisconsin. For the stepping stones, he recycled stones from the Arboretum grounds. The pond contains what Kawana called the Tortoise Island, another example of his deployment of classic design motives and symbolic explanations focused on good fortune and long life. The main path leads to a rustic arbor set among maples, redbuds, wild plum and euonymus. A seat in the pavilion provides clear views of the waterfall. Several other lanterns, a stone pagoda, and a water basin add visual highlights to the densely planted garden.[1]

In 1991, David Slawson was hired as consultant for Seisuitei, noting immediately the overgrown condition of the shrubs and trees. Slawson added rocks to both sides of the waterfall so it would appear more natural, replaced an asphalt path with a wider one of aggregate stone, and added stone benches. He also removed plants in areas that were cluttered,

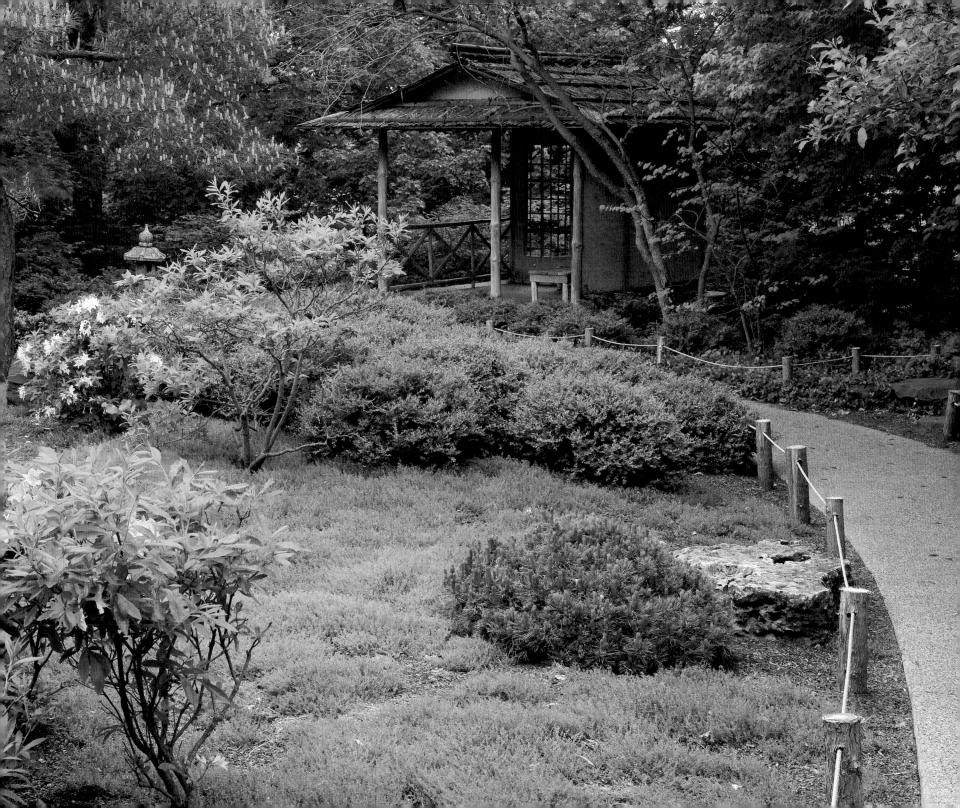

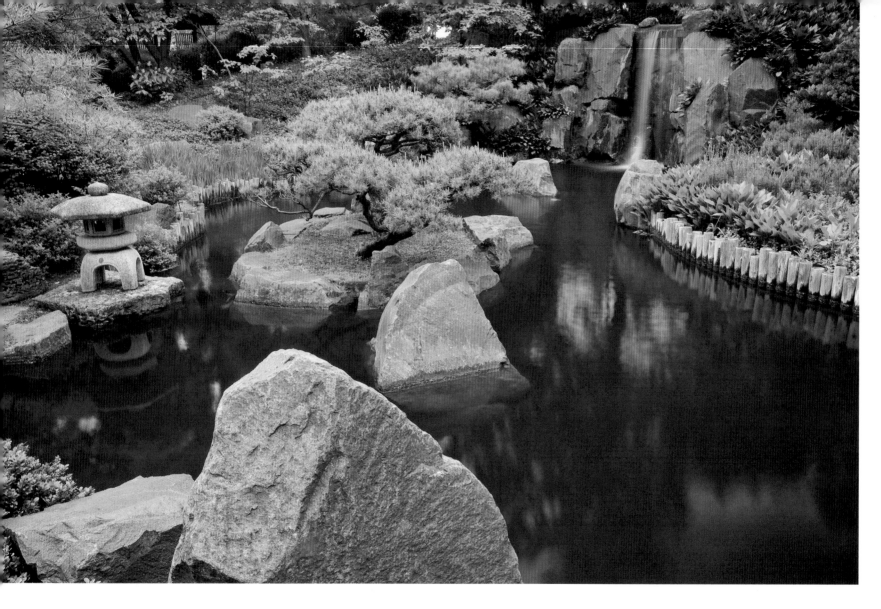

and added others in areas that were barren. As Slawson wrote in a guide for docents, "Continual improvement is part of the art of Japanese gardens. Most of the renowned garden in Japan have had changes made"

1. "Japanese Garden Expands Imagination," *Minnesota Landscape Arboretum News*, 5: 3, 1985; "A Garden for All Seasons," *Minnesota*, July/August 1985.

Above The Tortoise Island "floats" in front of the waterfall designed by Kōichi Kawana then made more natural by David Slawson.

Opposite below left This rustic gate marks the beginning of the path to the pond.

Opposite below right The pavilion provides a second focal point in the intimate garden.

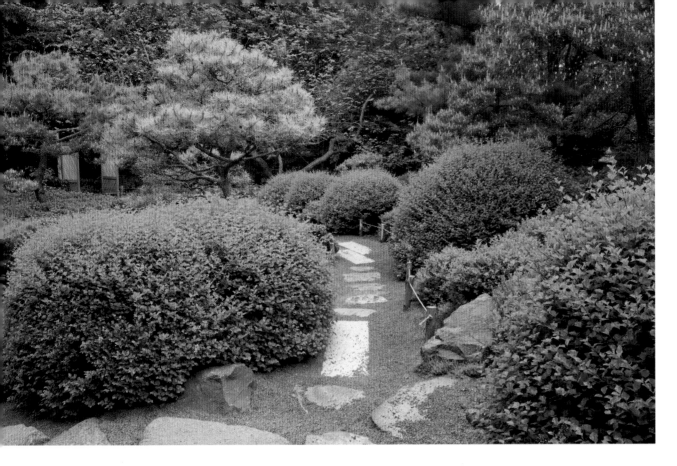

Above Stepping stones lead from the main path to the pond.

Above right The garden is entered through a humble cedar bark shingled gate.

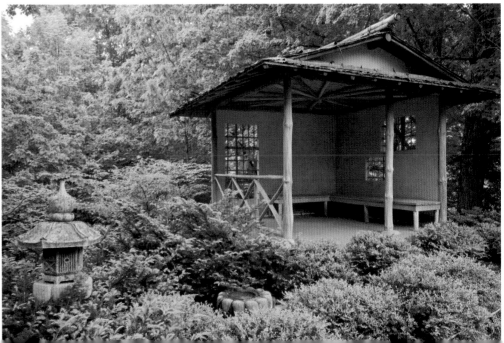

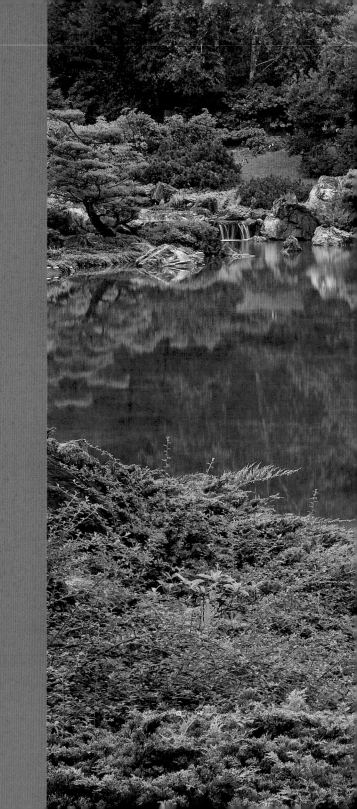

CHAPTER FIVE

TRADITIONS TRANSFORMED

Gardens for Changing Environments

Over their first century, most public Japanese-style gardens in North America served as overt manifestations of Japanese culture, authentic symbols of internationalism, and emblems of Japanese assimilation. At the turn of the twenty-first century, in places where such ambitions were still relevant, gardens that signaled them continued to be created, albeit with greater creativity in substituting native plants. However, in areas where these goals had been met, gardens strove to fulfill new missions and to satisfy elemental needs. Most basically, perceptive designers, liberated from the pretense of superficial authenticity and exoticizing elements, concentrated on the fundamental power of gardens to calm, to inspire, and even to heal. In essence, when, for many gardens, Japanese identity shifted from absolute to partial, from an end to a means, they had to evolve more refined functions.

By concentrating on fundamental precepts of Japanese garden design—sensitive integration with the specific locale, forced attention to areas of transition to impact ways of moving, gradual revelation of scenery as a metaphor for the nature of discernment— these gardens signal a shift in the understanding and deployment of Japanese culture. At the same time, the emphases on environmental and economic sustainability, and on providing compelling spaces for cultural activities, signal that these gardens are products of their own era—an age that celebrates multiculturalism, embraces hybridity, and accepts the idea of creative Japanese-style North American gardens.

ANDERSON JAPANESE GARDENS

LOCATION **ROCKFORD, ILLINOIS** DESIGNED BY **HŌICHI KURISU** OPENED **1978** MAJOR ADDITIONS **1985, 1991, 2005**

While most large Japanese gardens in North America were built quickly, and with limited visits by designers from Japan or Kōichi Kawana from Los Angeles, the creation of the Anderson Japanese Gardens was leisurely and organic. Fashioned section by section over more than three decades, the careful articulation of the natural site and attention to subtle movement through space is born of patient construction and an evolving vision. Though these qualities define many of the large gardens in Japan, in North America only the Japanese Garden in Portland is the product of such organic growth. Yet, where Portland expresses the ideas of various garden directors and changing board leadership, the Anderson Japanese Gardens stands as elegant testimony to the symbiotic relationship and reflexive learning curve between designer Hōichi Kurisu and patron John Anderson. Together the two men have adapted various Japanese garden features and concepts into a woodland environment that emphasizes stylish paths, subtle transitions, and the fusion of architecture with landscape imbued with a sensitivity to space in the service of deepening the visitor's consciousness or spiritual awareness.

In 1966, Rockford businessman John Anderson took his first trip to Japan, gaining immediate respect for the people, culture, and landscape design. Several years later, when

Above A stone basin fed by a *shishi-odoshi* ("deer-startling" pipe) is found in the quiet garden area near the Guest House.

Opposite The pond garden, with a bridge leading to Crane Island , began the successful collaboration between John Anderson and Hōichi Kurisu.

Previous spread Ken Nakajima's design at Montréal merges Japanese garden features with an idealized Eastern woodland.

Anderson and his wife Linda purchased a new home with extensive property along Spring Creek between their cliff-side residence and Spring Creek Road, Anderson thought the "backyard" had the potential to be a Japanese garden. Realizing that such an undertaking exceeded his own skills, in 1978 he hired Hōichi Kurisu, whom he had met during a trip to Portland, where Kurisu served as a garden director at the Japanese garden before opening a garden design, build and maintenance business. The initial project was the creation of the pond on the north side of the property. The pond is flanked on the south by the elegant waterside pavilion, which is reached after fording a stream fed by a waterfall. The path follows the hilly terrain around the pond, descending to cross an eight-planked bridge through an iris marsh, before coming to a stone beach and, eventually, a bridge leading to Crane Island.

Inspired by the success of this garden, Anderson and Kurisu visited Japan to look at examples of *sukiya* (tea taste) architecture and gardens. The result was the creation of the exquisite Guest House, built by Japanese carpenters in 1985. The Guest House is reached from the pond garden by several delicate paths leading through a wood. On these paths that bend to cross dainty steams, stone surfaces range from informal to semiformal to formal, and pass through

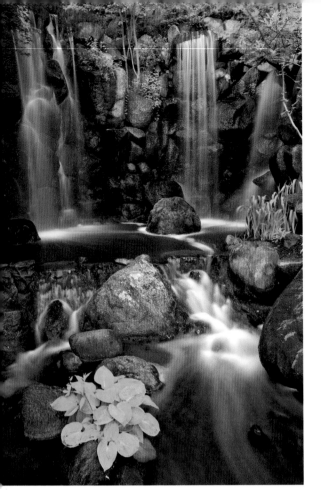

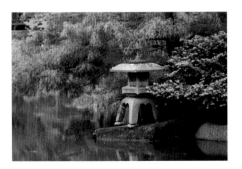

Left The 60-foot waterfall, which is activated with the flip of a switch, forms the center of the third garden area.

Below left A *yukimi*-style lantern stands on the shore of the pond garden.

Right The Garden of Reflection uses Japanese design principles but avoids any overt Japanese garden features.

Opposite The tea house sits on a rocky hillside above a quickly flowing stream.

rustic gates, one sees the exponential growth of designer and patron. Gone are the "postcard views" of the pond garden, reminiscent of countless North American Japanese gardens. Instead, attention is focused on subtleties of light filtering though branches, on the murmur and sparkle of water, and on the different textures as a stone path gives way to one of packed earth. Here, Kurisu's study of the delicate naturalistic gardens of Prof. Kenzō Ogata is most apparent, though one also senses his deepening sensitivity to the local landscape. In the flat garden, best viewed from inside the Guest House, Kurisu adapts elements of a sand garden with plants from the Midwestern prairie. The garden was opened to the public on completion of this section.

Between 1988 and 1991, Anderson and Kurisu, working with an experienced crew, created a third garden space, mixing the high drama (and engineering prowess) of an artificial but natural seeming 60-foot waterfall, with quiet contemplation experienced in the humble rest shelter and adjacent tea house nestled on the side of a hill beside a murmuring steam. The waterfall—created with 700 tons of boulders and 250 cubic yards of concrete over a 20-ton steel wall and, when turned on, pumping 1,600 gallons of water per minute—falls in four sections, with the lower level designed to magnify the water's sound. It is best viewed from a special platform over a reflecting pool, and can be crossed at its base on stepping stones.

In 1998, the Andersons donated their garden to a not-for-profit corporation, and simultaneously expedited construction on four acres southwest of Spring Creek. This new area includes the naturalistic yet ADA accessible Garden of Reflection, with the adjacent Outdoor Pavilion used for events, as well as a large Visitor Center with offices, gift shop, and restaurant. A dry stone garden occupies a walled section between the building and the adjacent lawn leading to the Garden of Reflection. In 2005, a new entry gate was constructed to create a more formal sense of arrival to the Japanese gardens area. The sense of entering into a sacred space is doubled as the garden is accessed by first crossing Spring Creek over an arched wooden bridge, then passing through the formal Main Gate.

The Anderson Japanese Gardens' "core values" include a commitment to the "highest standards" of maintenance, then conclude with the statement: "With grace, elegance, and gentle awareness we exemplify the Japanese cultural heritage

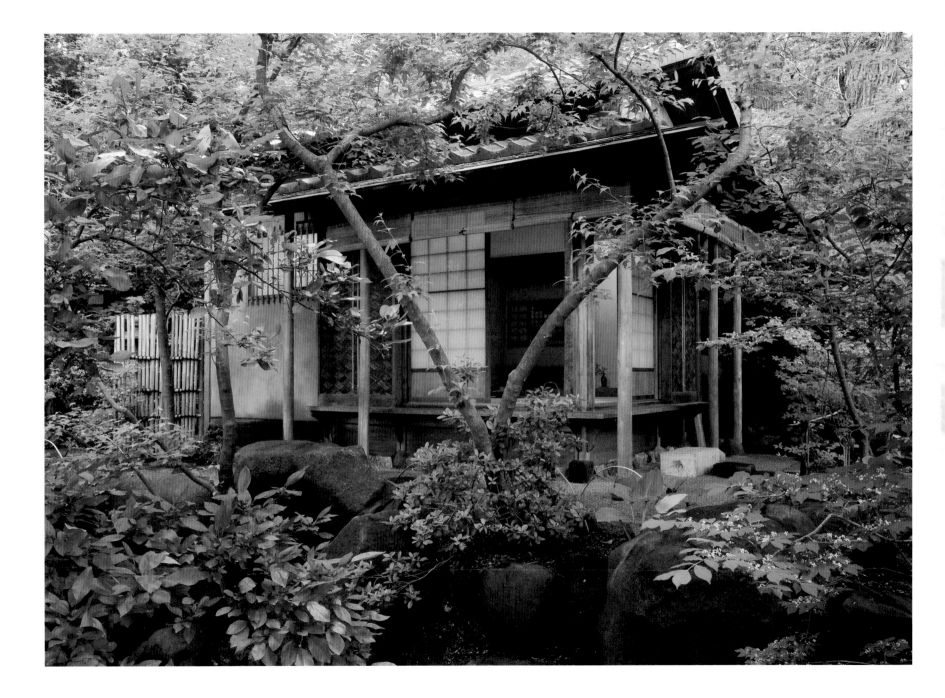

Above A Korean stone sculpture of an official highlights the area in front of the gate.

Left The large gate, approached by a broad arched bridge, provides the garden's point of formal entry.

of respectful humility in service to people of all cultures." The Rockford garden delivers on the promise of meticulous attention to the physical space and it rewards sensitive visitors with an experience of transcendent tranquility through the creation of real artistry on multiple levels. Kurisu's designs have been magnificently maintained by a staff of one gardener per 1.75 acres, under the guidance of Garden Curator Michael Elena then, from 1997, Tim Gruner. The Anderson Japanese Gardens offers weddings and corporate events in its Outdoor Pavilion, Guest House, Gallery or Dining Room, and various educational and cultural activities ranging from Japanese crafts to *tai-chi*. In addition to these events, John Anderson's commitment to the garden as a place of spiritual healing is evident in the garden's use for worship services held before regular visiting hours, and, beginning in 2011, a grief support program offered through Hospice Care of America.

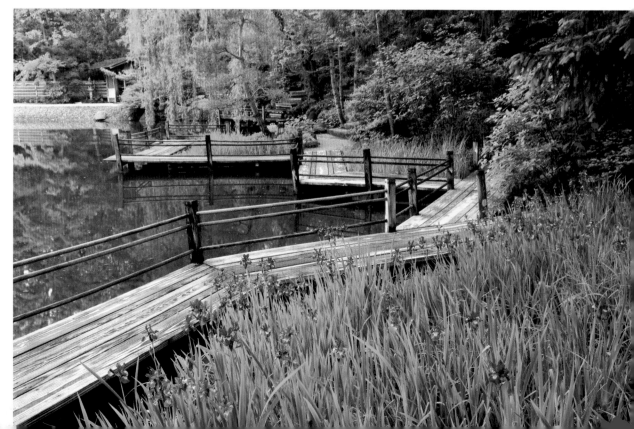

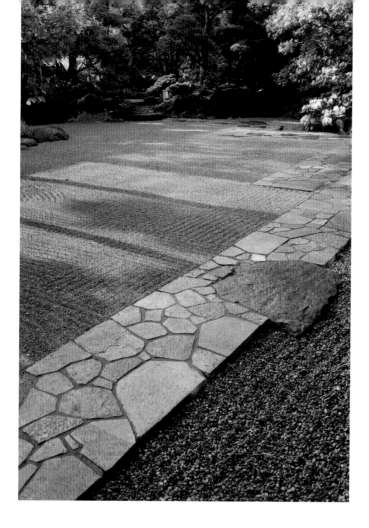

Left The pond edge includes a zigzag bridge through an iris marsh and a stone beach.

Above The flat garden of raked gravel and *nobedan* paths is best contemplated from the Guest House.

Right Intimate details, like this small water basin, contribute to the garden's subtle charm.

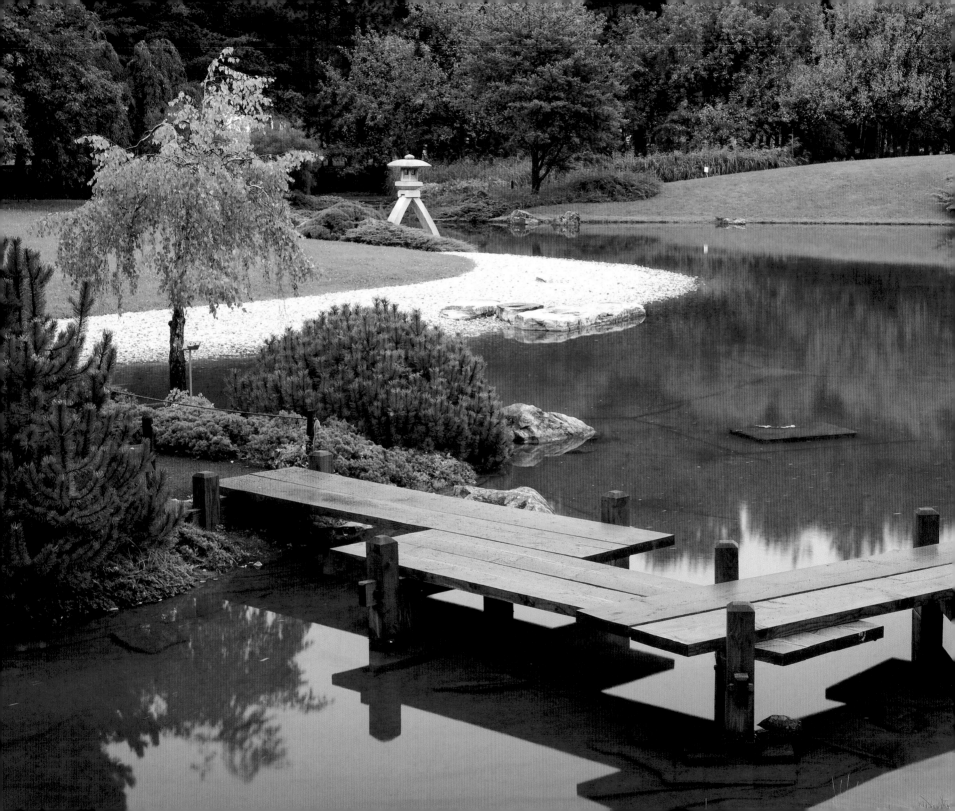

JAPANESE GARDEN AT THE MONTRÉAL BOTANICAL GARDEN

LOCATION **MONTRÉAL, QUÉBEC** DESIGNED BY **KEN NAKAJIMA** OPENED **1988** MAJOR ADDITION **2002**

In a long career spent designing modern gardens in Japan and adapting Japanese gardens to sites around the world, Ken Nakajima sought to convey the spirit rather than the superficial styles of Japanese arts. Using the term *fuzei* to indicate something like the elegance of nature imbued with human sentiment, Nakajima's gardens deploy water, stone, light, and plants to evoke the power of the local environment. In the Montréal Botanical Garden, Nakajima interpreted the *genius loci* as a gentle woodland of streams and groves, warmed with the bright colors of flowers.

The idea for a Japanese garden in Montréal started when the city's Japanese community proposed a Japanese garden to mark Canada's centennial in 1967. Nakajima, who was in Montreal designing the garden for the Japanese Pavilion at Expo '67, was asked to create a plan, and he made one for a garden in the Botanical Garden. The plan was never implemented, but, in 1986, the Reverend Takamichi Taka-hatake, head of a local Buddhist congregation, approached Pierre Bourque, Director of the Botanical Garden, and proposed a Japanese garden with a cultural pavilion as a lasting symbol of cultural accord between Japan and Montréal. Bourque agreed, and when Takahatake was able to secure much of the funding through political and corporate

connections in Japan (with other funding from Montréal and Québec), Nakajima was named as designer. He was a natural choice given his previous connection with the city and his experience creating Japanese gardens in Moscow, Rome, and especially, Cowra in Australia, where be designed one of the most successful Japanese-style gardens in the world.

During a walk around the Botanical Garden in November 1986, Bourque and Nakajima agreed that the garden should be built north of the rose garden on an untouched 5.5-acre plain, with marshes, maples, and a pine grove. Given

Left *Koi* add color in the pond just as flowers brighten the plantings around it.

Opposite The sharp lines of the zigzag bridge contrast with the sensuous curve of the stone beach.

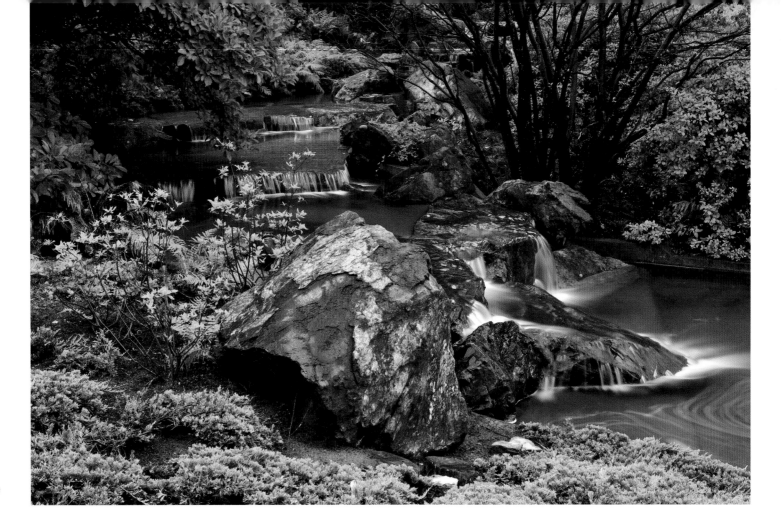

Right Water sparkles as it flows down the steep stream from the large waterfall.

Below right The bell tower, with a bell cast by National Treasure Masahiko Katori, sits between the garden and the pavilion.

Nakajima's disdain for modern copies of "classic" Kyoto gardens and his dismissal of foreigners' naïve desires for "authenticity," together with his practice of leaving intact all extant trees, this choice of location dictated that the garden would merge Japanese garden idioms with a North American woodland. Nakajima's primary concern was the location of appropriate stone. When, in May 1987, he found a greenish peridotite with black and white striations in an asbestos mine in Québec, he was able to commence work. A month later, on a study trip to Japan, Bourque chose the Fujiki Construction Co. in Osaka to design and build the pavilion, including a

bonsai gallery specified by Nakajima. Construction began in July 1987 with the grading of the pond and hillocks, and in the fall Nakajima oversaw construction of the waterfalls and placement of 500 tons of stones. He also selected plants from municipal greenhouses and made lists of other plants to be imported from Ontario, British Columbia, the United States, and Japan. These were planted the following spring, the same time that the two viewing shelters were constructed. The garden was dedicated on June 28, 1988, and the pavilion a year later. Its dry garden of 11 stones set on Shirakawa sand was designed by Nakajima, who had made his name with

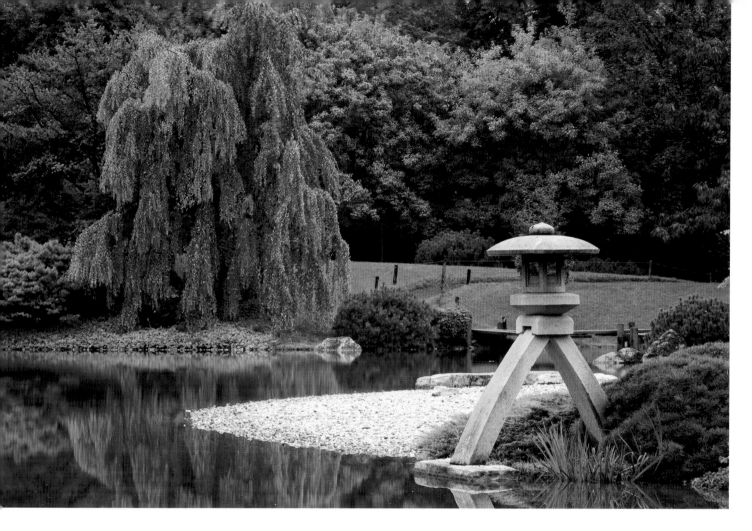

Above Visitors must be mindful of each step when crossing the zigzag bridge.

Left A *kotoji*-style lantern adds a note of drama to the woodland environment.

the stone garden at the Gyokudō Museum near Tokyo.

The design of the strolling garden is based on the flow of water, play of light, and visitor's movement through space in dynamic interplay. The water, falling over the cascade, coursing through the stream, and rippling in the pond, is most obvious. The viewer follows a similar course, gazing on the waterfall from above, then descending the hill and flowing around the pond edge to look back at the pond and falls from either of the two arbors or from the shore. Light was considered in the positioning of the waterfall to maximize the sparkle of the water, and in the planting of flowers that would be illuminated in the raking spring light.[1] Within this naturalistic garden, Nakajima inserted some effective contrasts in form. For instance, opposite the waterfall, the rectilinear form of a wooden zigzag bridge through iris marsh differs from the broad sweep of a stone beach nearby; a gently arched bridge mediates between them.

A peace bell, created by renowned metal artist Masahiko Katori and given by the sister city of Hiroshima, was added to the garden in 1998, and is rung each year on August 6 to commemorate the atomic bombing of Hiroshima. In 2002, a donation from Toyota Canada allowed for the creation of a *roji* leading into the tea room attached to the pavilion. Using plans sent from Hiroshima and overseen by Tom Torizuka, who has assisted Nakajima, the elegant garden, enclosed by Keninji-style and Kōetsu-style fences, was built by Louis Rinfret, Chief Horticulturist of the Japanese Garden. The entire complex is used for a variety of events, serving as a *de facto* Japanese culture center in Montréal.

1. The creation of the garden is thoroughly discussed in "Japanese Gardens," special bilingual issue of *Quatre-temps, Le Bulletin de la Societé d'animation du Jardin et de l'Institut bontaniques de Montréal*, 12: 2, 1988.

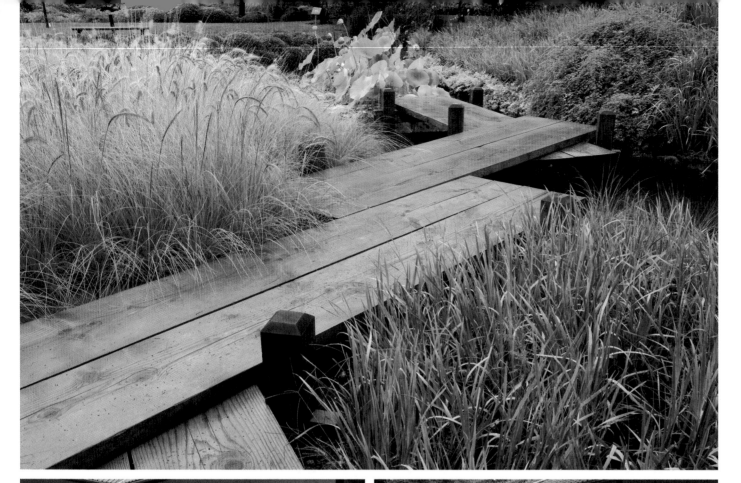

Left A second plank bridge runs across an iris marsh.

Right A viewing arbor looks over the garden.

Far left The *bonsai* court is appended to the large pavilion.

Left The area in front of the pavilion introduces the garden behind it with representative features, including manicured pines, stones, and a stone lantern.

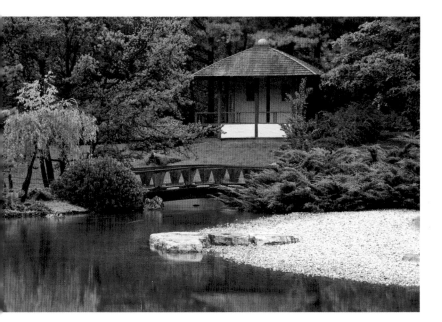

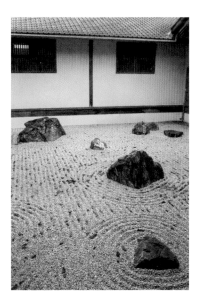

Left A stone garden fills a courtyard in the pavilion.

Right A stone path leads through the *roji* or tea garden.

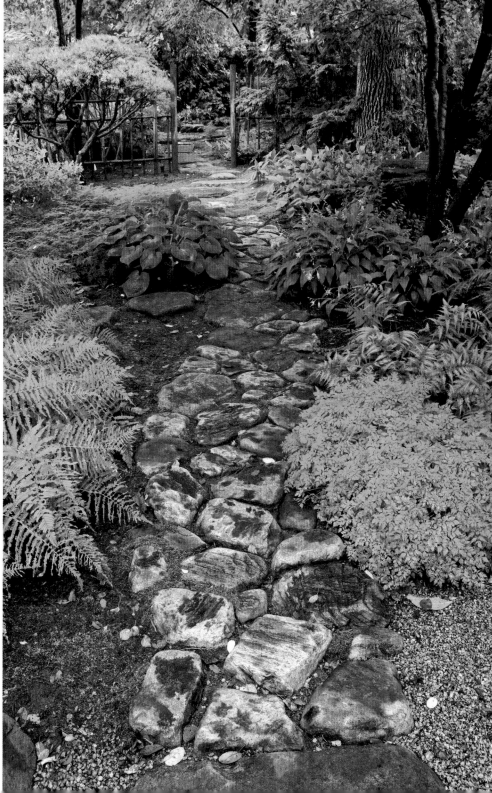

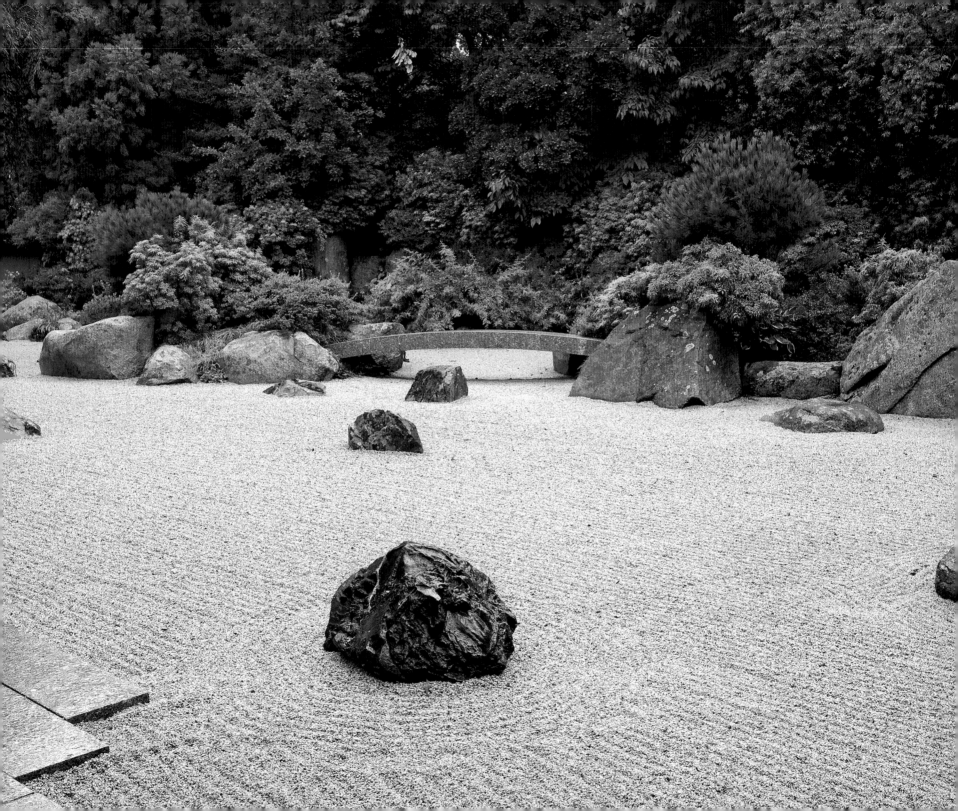

TENSHIN'EN (GARDEN OF THE HEART OF HEAVEN) AT THE BOSTON MUSEUM OF FINE ARTS

LOCATION **BOSTON, MASSACHUSETTS** DESIGNED BY **KINSAKU NAKANE** OPENED **1988**

Japanese gardens have often been called an art form, and thus it is fitting that they have been built at museums in Japan and the West beginning early in the twentieth century. When the current Museum of Fine Arts (MFA) was erected in Boston in 1909, the famous Japanese art collection was displayed around an indoor courtyard garden with stone ornaments and small trees. After that interior garden was destroyed to increase storage space, and, in 1978, the museum received a gift from the president of the Nippon Television Network to create a garden, Director Jan Fontein visited Japan to study modern gardens. He selected Kinsaku Nakane, a leading restorer of historic gardens and a creative designer of new ones in Japan and abroad. In Boston, Nakane adapted dry garden elements to suggest the rocky New England coastline, tying together the refined culture of Zen temples with the natural topography of the region.

Occupying about 10,000 square feet in an area north of the MFA's West Wing, the garden can be viewed from the second floor of the museum (from where it seems decidedly pictorial) and from a viewing terrace in the garden. Named after Kakuzō Okakura (otherwise known as Tenshin), the

Above A water basin suggests purity.

Opposite The pond edge is meant to evoke the New England coastline.

philosopher-art historian who served as Curator of Asiatic Art at the MFA from 1905 until his death in 1913, Tenshin'en includes a lantern collected by Okakura and a stone pagoda originally in the MFA's courtyard garden. It is entered through a formal gate flanked and surrounded on two sides by a plastered and tile-topped wall. Elegantly simply, the garden presents a sea of gravel set with a dozen stones and two islands connected to each other and the shoreline by stone bridges. The bed of white gravel is ringed by an undulating shore of stone and ground cover, and this symbolic body of water is "fed" by a dry waterfall.

The project was coordinated by Julie Messervy, a local landscape designer who had studied with Nakane in Kyoto. In the summer of 1987, Nakane and his son Shirō spent six weeks directing the setting of 178 stones brought from three sites in New England. Despite the large number of stones, their skillful placement and juxtaposition with the soft edges of the dry pond keep the garden dynamic and balanced. After the walls and viewing deck were created, the Nakane team returned in the spring of 1988 to direct the planting of trees and arrangement of ornaments, and to supervise the assembly

of the entry gate, which had been built in Kyoto by Suzuki Kōmuten Co. The garden is enclosed by a screen of trees, including Japanese cherry, maple, red pine, and cryptomeria, and by natives, including American holly and mountain ash. The garden features more than 1,000 shrubs, half of them varieties of azalea, the plant featured in Nakane's garden at the Taizō'in at Myōshinji in Kyoto, the garden which had most impressed Jan Fontein. About 600 perennials, including hostas, liriope, and ferns, further soften the impact of the rocks and the large bed of white gravel brought from Mount Airy in North Carolina.[1]

1. Julie Moir Messervy et al., *Tenshin-en: The Garden of the Heart of Heaven*, Boston: Museum of Fine Arts, Boston, 1993.

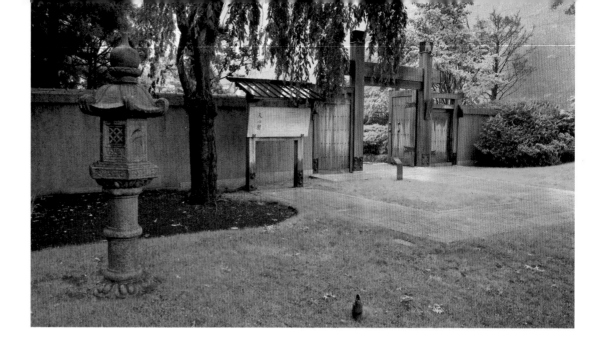

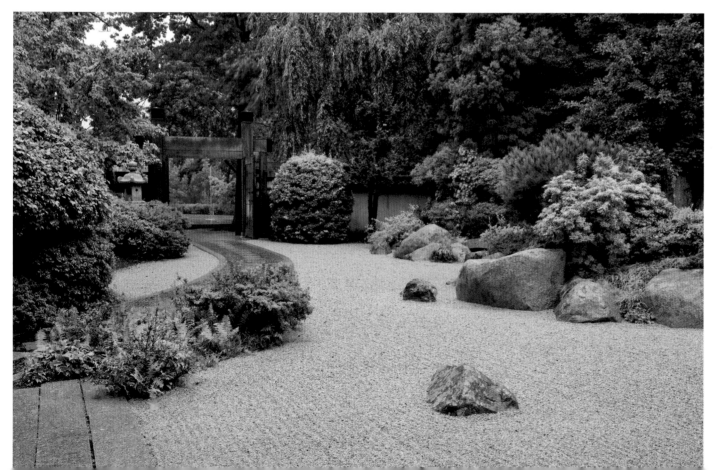

Above Located north of the museum's West Wing, the garden is accessed via a gate and signaled by a Kasuga-style lantern.

Left The tile-topped garden wall is largely hidden behind a screen of trees and shrubs.

Opposite above left The elegantly simple path leads from the gate to the main viewing area.

Opposite above right This stone is inscribed with the characters Tenshin'en, the "garden of (Okakura) Tenshin," the MFA's renowned curator of Asian art.

Opposite below left The path directs visitors to benches located near the museum's exterior wall.

Opposite below right The view through the gate allows only a tantalizing glimpse of the garden.

ROJI'EN (GARDEN OF DROPS OF DEW) AT THE GEORGE D. AND HARRIET W. CORNELL JAPANESE GARDENS IN THE MORIKAMI MUSEUM AND JAPANESE GARDENS

LOCATION **DELRAY BEACH, FLORIDA** DESIGNED BY **HŌICHI KURISU** OPENED **2001**

Below This simple South Gate marks the point of departure from the gardens and the midway point in the circuit around the lake.

Right This red powder puff (*Calliandra haematocephala*), a native of Malaysia, is one of the many plants in the garden not native to Japan.

Opposite The Yamato-kan or Founder's Hall sits on a promontory that makes it a focal point from several places in the garden.

The motto of Hōichi Kurisu's company is "Gardens of vision . . . for lives of insight." Kurisu evolved that belief during 20 years of work at the Anderson Japanese Gardens in Rockford, Illinois, in close consultation with patron John Anderson, and with little if any sense of following historic precedent. In contrast, at the Morikami Museum and Gardens, in just a few years Kurisu created a huge garden comprised of six diverse gardens inspired by different historical styles. Despite the historical allusions, Kurisu holds that creation is driven by ideas not by history, so that in these gardens familiar types became the launching points for exploration of a range of forms and meanings. At their core and taken in their impressive totality, the Morikami gardens encourage "therapeutic insights for today." Kurisu's desire to create "restorative gardens" is born out of his own experience growing up between Japan and America in a fractured family and during a time of intense nationalism and materialism. It also stems from his teacher Kenzō Ogata's emphasis on the visitor's experience of space as a way of creating joy.

Early in the twentieth century, George Morikami joined other Japanese immigrants farming at Florida's Yamato Colony. He became a successful land speculator, donating 200 acres to Palm Beach County in the early 1970s. In 1977, the Morikami Museum and Japanese Gardens opened on an artificial island, with small stroll gardens and dry gardens designed by Seishirō Tomioka of the Palm Beach County Parks and Recreation Department. In 1993, the new public–private partnership between the County and The Morikami Inc. raised funds from public and private sectors to create a new 32,000-square foot museum, cafe, office, and tea house on fill land created by excavating a large lake that connected with the old museum, now called the Yamato-kan. The master plan called for a garden in Morikami Park. Aware of the plan, Kurisu proposed a garden on the 7-acre lake and 17-acre grounds to Morikami Director Larry Rosensweig, board members, and Dennis Eshleman, head of the County Parks and Recreation Department. Sadafumi Uchiyama, then working with Kurisu and having just finished an MLA thesis at the University of Illinois on the history of Japanese

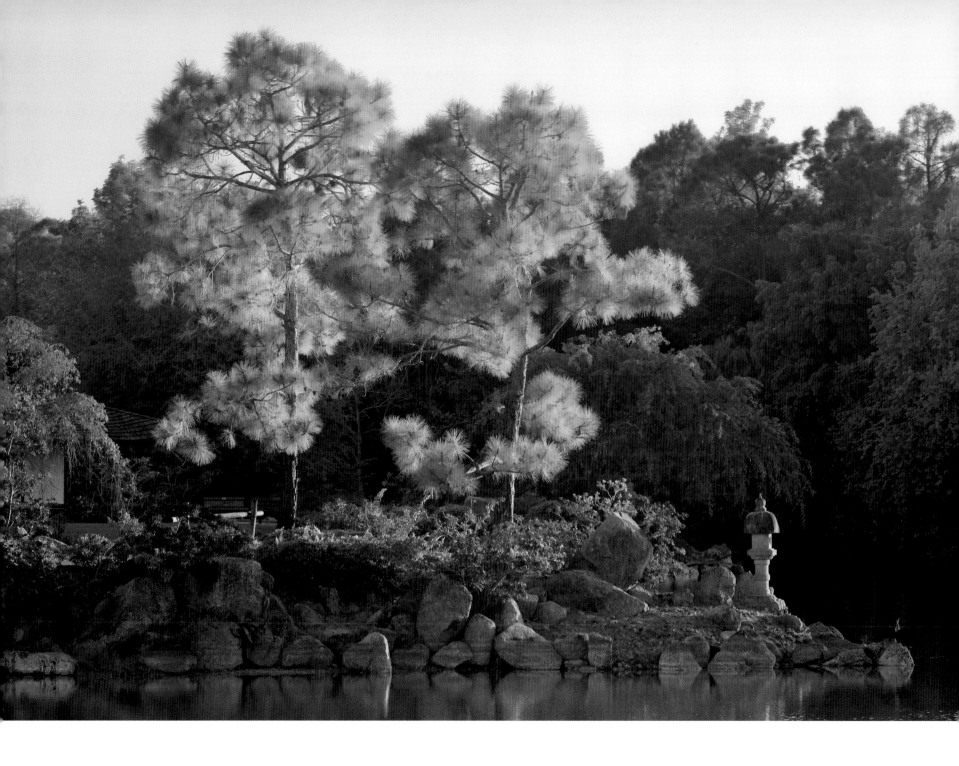

Above This *chie no wa* (wisdom ring) stone lantern reproduces the famous one placed at Amanohashidate in Miyazu, DelRay Beach's sister city in Japan.

Left The garden offers many benches where visitors can stop to take in the scenery or simply rest.

Opposite left This gate, with attached waiting bench on its other side, stands between the Nelson Memorial Garden and the Founder's Hall.

Opposite right The Late Rock Garden features huge stones enclosed by a plaster wall and a dramatic clipped hedge.

gardens, developed the concept of a series of period gardens—an idea that appealed to Rosensweig because it deepened the Morikami's mission to educate about Japanese culture. Eshleman's department provided nearly $4 million to construct the garden, and the Morikami Inc. found donors to contribute a million dollar maintenance endowment in exchange for naming rights.

Construction started in 1998, with the east side opening in January 2000, and the west side dedicated on January 9, 2001. For this massive project in a region devoid of rock, 17 train carloads of pale peach granite were shipped from Texas. Given a climate too hot and wet for most Japanese plants, Kurisu primarily used natives, choosing plants for their sculptural qualities. Kurisu faced so many challenges— from legal restrictions (ADA and state regulations dictated path widths, grades, and construction techniques, and required 18 percent minority contractors) to the natural environment (alligators under 14 feet cannot be removed from the lake)—that he published an article explaining how he adapted to some requirements and created new systems to work around others.[1]

The garden unfolds along a one-mile strolling path that takes visitors through six distinct gardens before visiting the older gardens on the east shore. Leaving the museum, visitors first encounter the Shinden Garden. Adapting the aristocratic residential style of the early ninth-century Heian period, the path traverses two stately low bridges to tour two islands, then crosses a third bridge and through a gate to return to the mainland. Views to the northeast show the waterfall that feeds the lake. The path passes through a bamboo grove and leads to the Paradise Garden. Based on Pureland temple gardens from the thirteenth and fourteenth-century Kamakura and early Muromachi periods, it recalls Saihōji in Kyoto where a pond shaped like the character *shin* 心 (heart/mind) is surrounded by a thicket of trees. The adjacent Early Rock Garden further reimagines the design of Saihōji with its dry waterfall, dry steam, and dry pond, all showing the evolution from a conventional and symbolic

landscape to a conceptual one based on Zen Buddhism's mistrust of sensory experience. The Late Rock Garden, approached along a corridor of hedges and enclosed by a tile-topped plaster wall and a hedge, takes this idea to its logical extreme. The bed of gravel set with large stones borrows its idea from the famous Ryōanji temple, where nature and design are distilled to their barest essence.

A long path leads to the Flat Garden, also concealed by walls and hedges. Across a flat table of raked gravel, low hills and shrubs allow a "borrowed view" across the lake to the museum. Next is the Modern (Romantic) Garden, where the light, naturalistic style of nineteenth-century gardens is created in plants of South Florida. From this suite of garden rooms, the path leads to the older Nelson Memorial Garden then passes through the South Gate. Following the shoreline, visitors cross the bridge leading to the Founder's Hall on Yamato Island and the Morikami *bonsai* collection. Returning to the mainland, the circuit around the lake is completed by visiting the Rocky Point then reaching the museum, which is flanked by Morikami Falls.

Both planned and spontaneous changes have marked the garden's first decade. After some large trees were felled by Hurricane Wilma in 2005, cherry trees were donated in 2006. In 2010, a rock garden was added to the Nelson Memorial Garden. Following Kurisu's vision, the gardens

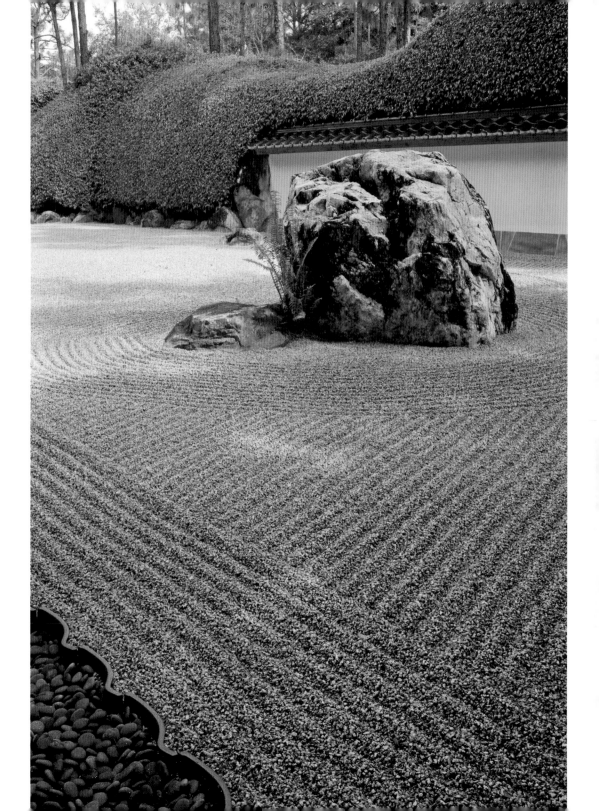

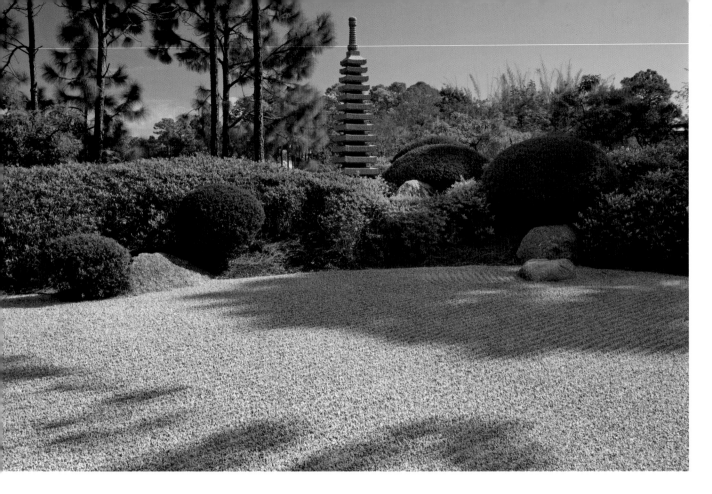

Left The Flat Garden contrasts a horizontal plane of gravel with vertical elements, including pines and a large stone pagoda.

Below The small lantern, set beneath a single pine in the bed of gravel of the Flat Garden, mediates between the horizontal and vertical axes.

Right The Nelson Memorial Garden combines various garden ornaments within a walled enclosure.

Opposite below left This gate marks the return to the mainland after the island of the Shinden Garden.

Opposite below right The Founder's Hall is surrounded by plantings and the Morikami *bonsai* collection.

have been used for therapeutic purposes. In 2007, the Morikami and College of Nursing at Florida Atlantic University studied the impact of garden visits relative to art therapy in mitigating mild depression in older adults. Based on that positive result, in 2008 they used a federal grant to develop "Stroll for Well-Being" garden walks. The Morikami gardens also host a full range of cultural events. The most spectacular is the mid-August Bon festival, when lanterns to guide the returning souls of the deceased are floated on the large central lake.

1. Makoto Suzuki and Hōichi Kurisu, "The Morikami Museum and the George D. and Harriet W. Cornell Japanese Gardens," *Landscape Design*, 24, 2001.

Above A massive lantern, much weathered and covered with moss, brings a note of age into the garden.

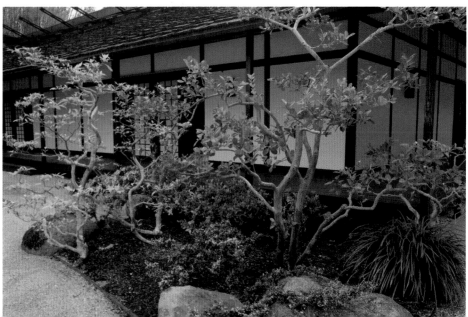

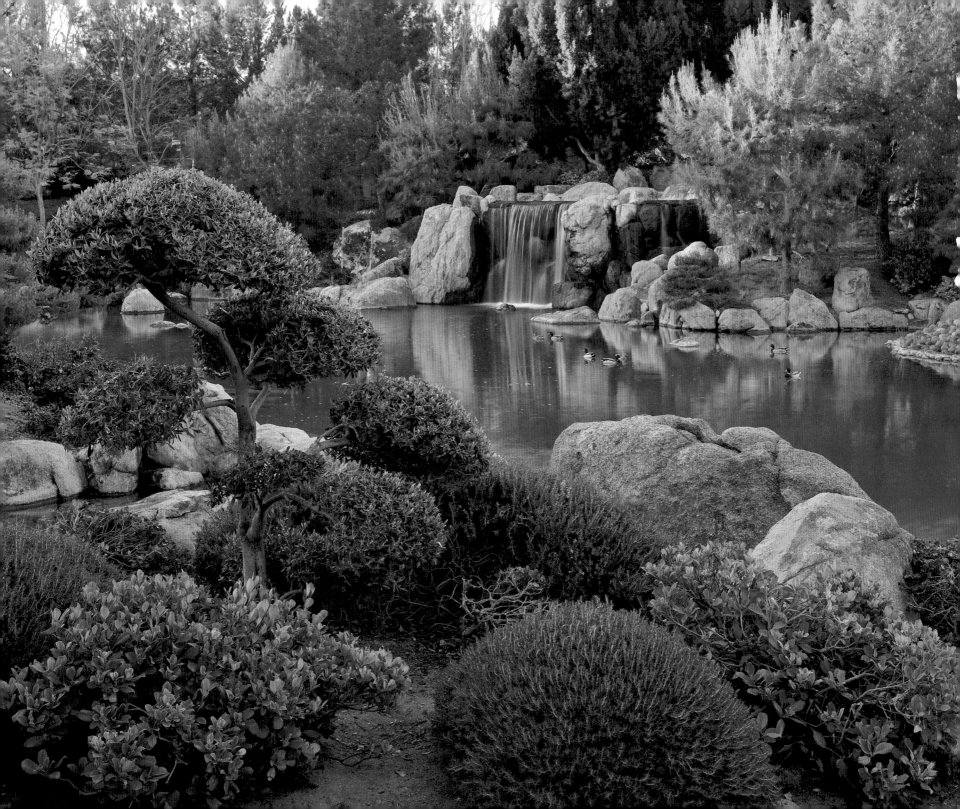

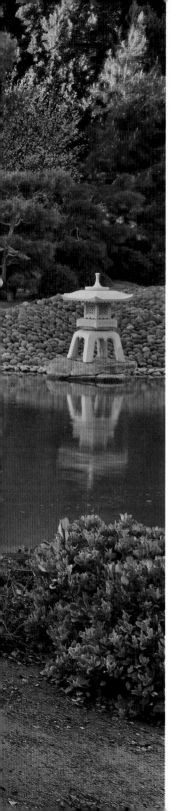

ROHŌ'EN, JAPANESE FRIENDSHIP GARDEN OF PHOENIX IN MARGARET T. HANCE PARK

LOCATION **PHOENIX, ARIZONA** DESIGNED BY **NOZOMU OKITA** OPENED 1996 MAJOR ADDITION 2002

Opposite In its desert environment, this 0.5-acre pond fed by a 12-foot waterfall seems like a mirage.

Left The first stage of the project, the Musōan tea house and surrounding garden, were constructed in 1996.

The notion of building a Japanese garden in the Sonora Desert, where temperatures average over 100 degrees from June through September, is remarkable. That a sensitively designed, 3.5-acre stroll garden with a 0.5-acre pond was built in a park situated over an interstate highway in a city with few Japanese-Americans is even more audacious. But, with its elegant tea house and 12-foot-high waterfall, the Japanese Friendship Garden of Phoenix is a monument to the power of Japanese gardens to represent beauty and friendship under the most challenging circumstances. In the context of Japanese gardens in North America, Rohō'en is also important as a laboratory for creative plant substitution.

Rohō'en (Ro Ho En in the garden's writing) means "Heron Phoenix Garden," and refers to the heron symbol of Himeji and the mythical bird after which Phoenix is named. This compound name reflects long cooperation between the cities. Eleven years after Phoenix and Himeji signed a sister city relationship in 1976, Himeji's mayor proposed a friendship garden. In 1978, Phoenix citizens passed a bond for the garden, with $1 million later raised privately. In 1990,

Above The 12-story stone pagoda includes four relief sculptures of seated buddhas at its base.

Himeji submitted a large pond-style stroll garden plan. The first phase, the construction of the Musōan tea house and tea garden, was finished in 1996. The second phase, including the pond, waterfall, and several pavilions, was dedicated on November 23, 2002. Nozomu Okita of Himeji designed the garden, using input from other garden specialists there and in Phoenix. Okita made numerous trips to Phoenix to oversee the construction carried out by local contractors.

The garden is accessed from two sides. The Central Avenue entrance leads to a view circle featuring a statue of the *shachi*, the auspicious roof ornament from Himeji Castle that is the garden's symbol. There is also a direct vista of the impressive waterfall that dominates the eastern end of the pond. In the opposite direction, a path leads through the tea garden to the tea house. The formal entrance from Third Avenue passes through the main gate/ticket booth, then provides a view of the pond's western section with its large island reached by an impressive stone bridge. The pond's middle section contrasts a rectilinear concrete viewing deck and a boat landing stone on the north shore with a curved

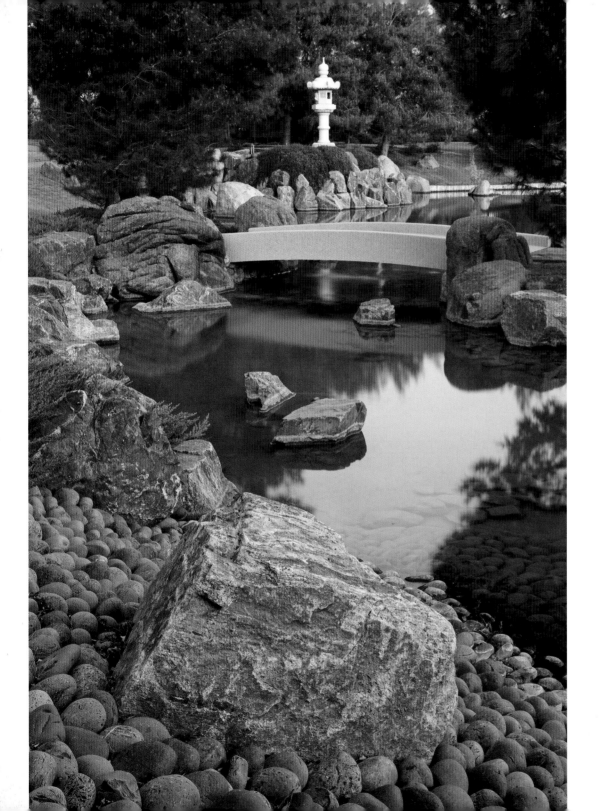

stone beach promontory on the facing shore. Some 1,500 tons of stone were brought from several quarries in central Arizona, resulting in a wide range of rock colors and types around the garden.

The garden is particularly successful in finding plants that not only can withstand dry desert heat as well as a few sub-freezing nights each winter but that have colors, textures, and shapes suitable for a Japanese-style garden. Most notable are Aleppo and elderica pines in place of black pines, rosemary and the Arizona native dodonea for clipped hedges, Korean grass (zoysia) as ground cover in the tea garden, jacaranda and flaxleaf paperbark as substitutes for flowering plum and cherry in the spring, and purple leaf plum for fall color. Heritage oak and olive trees create the shade necessary for some shrubs and ground covers.

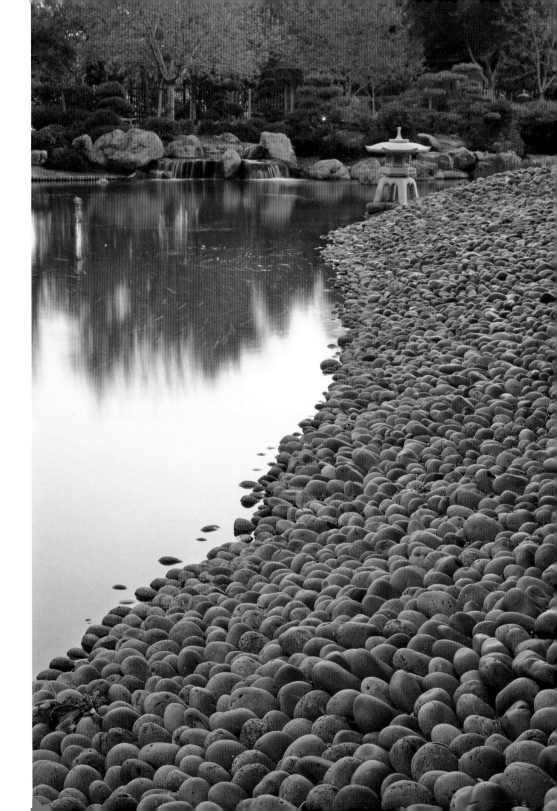

Far left Brought from several quarries, the rocks exhibit a variety of colors.

Left This statue of Himeji's animal symbol, a *shachi*, stands just inside the Central Avenue gate.

Above One crosses the "double bridge" to a small island then traverses a gently arched bridge to reach the far shore.

Right A shoreline of beach stones culminating in a *yukimi*-style lantern extends nearly from the central island to the waterfall.

Right The garden includes familiar Japanese garden plants, like cherry, as well as native substitutes.

Far right *Koi* add color to the pond, and the garden.

Below A hexagonal *yukimi*-style lantern stands in front of the stone beach.

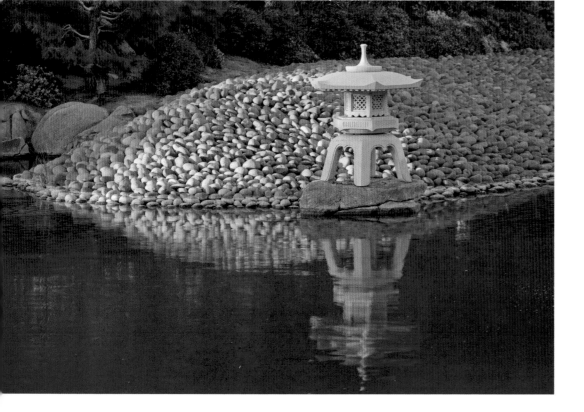

Right The tea garden is comprised almost exclusively of plants that substitute for those used in Japan.

Below A paper crane testifies to the garden's many cultural activities.

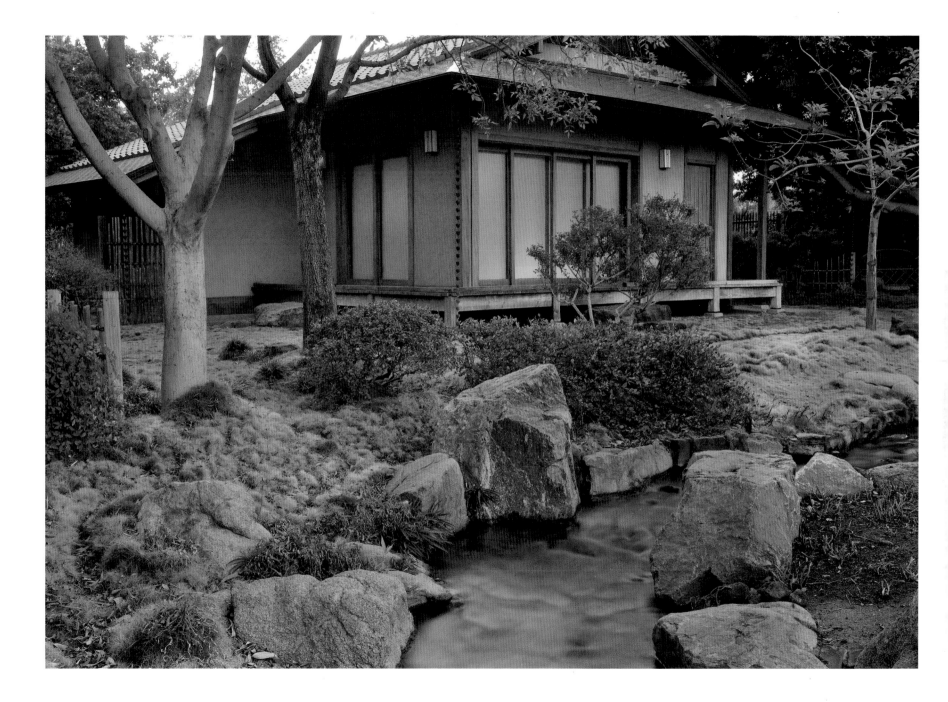

GARDEN OF THE PINE WIND AT GARVEN WOODLAND GARDENS

LOCATION HOT SPRINGS, ARKANSAS DESIGNED BY DAVID SLAWSON OPENED 2001 MAJOR ADDITION 2005

Right The wholly artificial stream, created at a crease in the hillside, feeds the pond at the bottom of the garden.

Below The reflection in the placid stream justifies the name of the Bridge of the Full Moon.

Inspired by native landscape and the idealization of nature in East Asian landscape paintings and prints, in Hot Springs, Arkansas, David Slawson created a garden that adapts some of the underlying concepts of Japanese stroll gardens while avoiding overt symbols. In the last half century, other garden builders have professed this goal, but few have better realized it than does Slawson at the Garden of the Pine Wind. In fact, most visitors to this 4-acre hillside garden assume that the streams, waterfalls, and rock outcroppings are simply a beautiful section of natural terrain. Trained under noted Japanese garden designer Kinsaku Nakane, who often invokes the surface elements of a local place through visual metaphor, Slawson goes a step further to evoke Nature writ large.

In 1934, Verna Cook inherited from her father a large parcel of land used by the Wisconsin-Arkansas Lumber Co. and the Malvern Brick and Tile Co. After the death of her husband Patrick Garven in the 1970s, Verna Cook Garven sold much of the property but preserved the remaining 210 acres, planting trees and shrubs that accorded with her love of Arkansas's scenery. In 1985, she transferred the land to the School of Architecture at the University of Arkansas for a botanical garden, hiring architect E. Fay Jones to design the

structures and, eventually, landscape architect Robert Byers to serve as garden curator/designer. Because of Mrs Garven's love of Japanese gardens and her planting of Japanese maples on the site, the 1999 master plan, by Behnke and Associates of Cleveland, specified that the first landscape should be a Japanese garden. Through a private garden he designed in Fayetteville, Slawson came to the attention of the Garven leadership. They found his approach such a natural fit with their woodland garden that no other bids were solicited.

Bestowed with a $1.2 million budget provided from state real estate tax, and working with a curving path designed by a local landscape architect, Slawson laid out the garden along an artificial stream that pumps 800 gallons of water per minute from Lake Hamilton at the foot of the Garven site. Slawson first determined where folds in the land would provide a natural site for his watercourse and the waterfalls built over concrete weirs. Working with a local stone purveyor, he found good Ozark and Ouachita sandstone, and had 750 tons transported to the site. On three subsequent trips, Slawson oversaw the choice and placement of rocks for the three waterfalls. In consultation with Slawson, Byers and the talented construction supervisor Mike Brown planted the site with maple and cherry trees as well as fern, azalea, hydrangea, and holly.

Right The Garden of the Pine Winds is approached from the Bonsai Garden, which unfolds in small glens connected by an undulating path.

Below The garden is composed around a path that curves down a hillside, crossing the man-made stream several times.

weighing 17 tons. The "clouds" are suggested by cherry trees.

As if seduced by the "natural landscape" that they had created, Garven did not initially plan any specialized maintenance. After several years, however, it became clear that a skilled arborist was required, and one is contracted twice each year. The Garden of the Pine Wind hosts intimate weddings around the *koi* pond, and each Christmas it is filled with thousands of blue and white lights during the Lights on the Landscape event that attracts about 50,000 visitors.

1. Slawson's ideas are articulated in the first part of his book, *Secret Teachings in the Art of Japanese Gardens*, Tokyo: Kodansha International, 1987.

Left The forest hillside explodes in color each spring.

Below The garden succeeds in suggesting an ideal version of an Arkansas woodland.

The Garden of the Pine Wind features two bridges, the wooden Sunrise Bridge (named after a bridge across the beautiful Kitakami River in Iwate Prefecture) spanning a narrow ravine, and the arched, stone-clad Full Moon Bridge crossing a placid lower part of the stream. The garden culminates in a meadow and *koi* pond, which drains via a dramatic waterfall. Slawson designed it with a protruding lip so that brave visitors can walk behind the cataract. His inspiration was Hiroshige's 1853 woodblock print *Rearview Waterfall in the Nikkō Mountains in Shimotsuke*.

So successful was the Garden of the Pine Wind that Slawson was hired to build subsequent landscapes, beginning with the elegant rock outcrop and stream by the Welcome Center, and including parts of the Children's Adventure Garden and the Celebration Garden around the beautiful Anthony Chapel. To create an Asian garden zone around the Garden of the Pine Wind, in 2005 Slawson created a Bonsai Garden in a series of elegant glens, each featuring several *bonsai* placed on a natural stone and set in front of a thin slab of Oklahoma sandstone. Beginning in 2010, he created the dramatic Floating Cloud Bridge across a drainage ravine along the trail leading to the Rose Garden. Designed to suggest a bridge floating above mountains and clouds, the stone pinnacles include one rock that is 12 feet high and

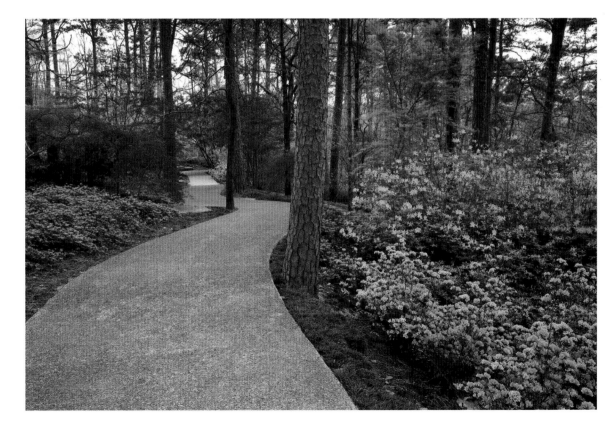

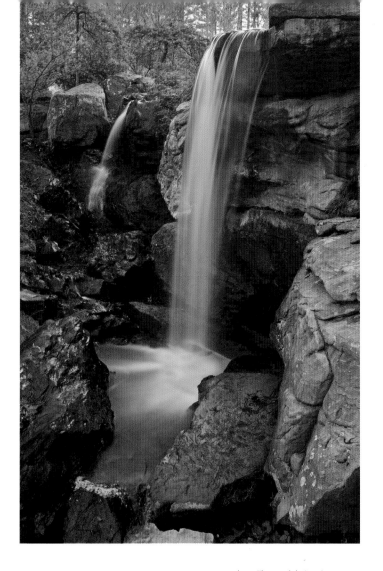

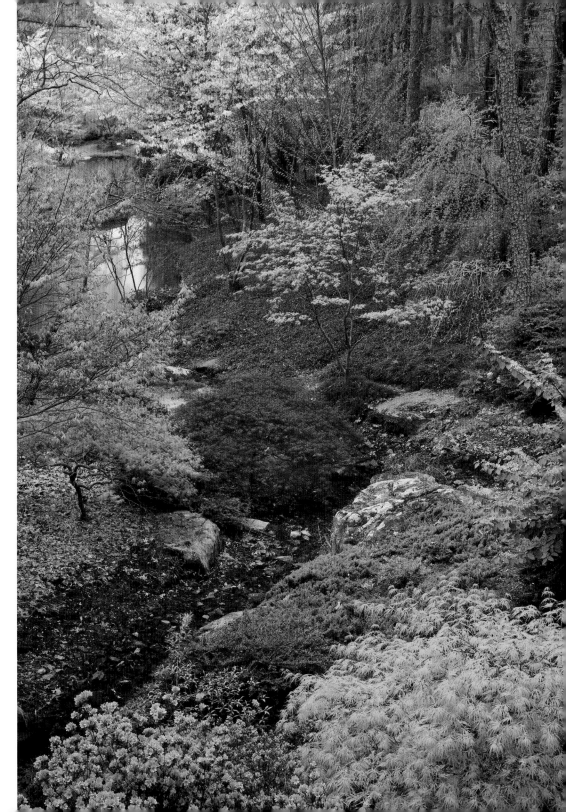

Above The pond drains via a dramatic waterfall inspired by a waterfall in Nikkō, Japan, as shown in a print by Hiroshige.

Right Views extend up and down the steep hillside.

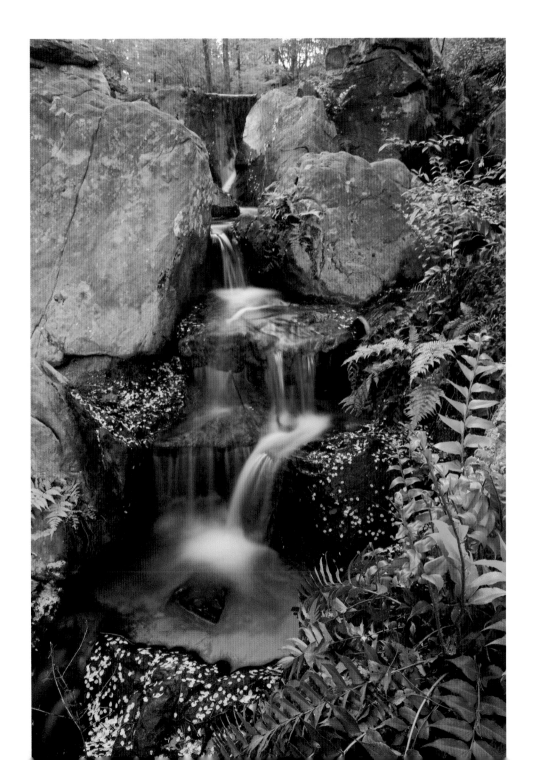

Left At Garven, garden builder David Slawson created waterfalls with an uncanny feeling of natural cataracts.

Below The wooden Sunrise Bridge (Asahibashi), associated with hope, is the first bridge crossed by visitors.

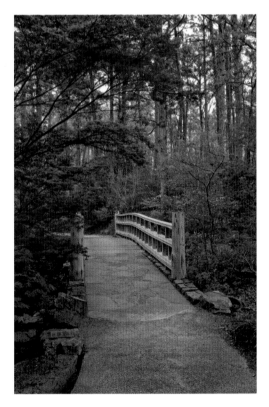

APPENDIX 1

Contact Information

(p. 20) **Golden Gate Park** 7 Hagiwara Tea Garden Drive, San Francisco, CA 94118 japaneseteagardensf.com/

(p. 26) **Huntington Botanic Garden** 1151 Oxford Road, San Marino, CA 91108 huntington.org/

(p. 32) **Maymont Japanese Garden** 1700 Hampton Street, Richmond, VA 23220 www.maymont.org/

(p. 36) **Brooklyn Botanic Garden** 1000 Washington Avenue, Brooklyn, NY 11225 www.bbg.org/

(p. 40) **Hakone Estate and Garden** 1000 Big Basin Way, Saratoga, CA 95070 www.hakone.com

(p. 48) **Shōfūsō Japanese House and Garden** Horticultural and Lansdowne Drives, Philadelphia, PA 19131 www.shofuso.com/

(p. 52) **Washington Park Arboretum** 9817 55th Ave. S, Seattle, WA 98178 www.seattle.gov/parks/park_detail.asp?ID=415

(p. 58) **Nitobe Memorial Garden** UBC Botanical Garden and Centre for Plant research, 6804 SW Marine Drive, Vancouver, BC V6T 1Z4 www.botanicalgarden.ubc.ca/nitobe

(p. 64) **Bloedel Reserve** 7571 NE Dolphin Drive, Bainbridge Island, WA 98110 www.bloedelreserve.org/

(p. 70) **Portland Japanese Garden** 611 SW Kingston Avenue, Portland, OR 97205 www.japanesegarden.com/

(p. 78) **Japanese Garden, San Mateo Central Park** El Camino Real and 5th Avenue, San Mateo, CA 94402 www.ci.sanmateo.ca.us/index.aspx?NID=718

(p. 94) **Nikka-Yūkō Japanese Garden** 9th Ave and Mayor Magrath Drive, Lethbridge, AB TIJ 3Z6 www.nikkayuko.com/

(p. 90) **Nishinomiya Garden, Manito Park** 1702 S. Grand Blvd., Spokane, WA 99203 www.manitogardens.com

(p. 94) **Fort Worth Botanic Garden** 3220 Botanic Garden Boulevard, Fort Worth, TX 76107 fwbg.org/

(p. 100) **Shōmu'en, Cheekwood** 1200 Forrest Park Drive, Nashville, TN 37205 www.cheekwood.org/

(p. 108) **Missouri Botanical Garden** 4344 Shaw Boulevard, St. Louis, MO 63110 www.mobot.org/

(p. 114) **Chicago Botanic Garden** 1000 Lake Cook Road, Glencoe, IL 60022 www.chicagobotanic.org/

(p. 120) **Denver Botanic Gardens** 1007 York Street, Denver, CO 80206 www.botanicgardens.org/

(p. 126) **Tillman Water Reclamation Plant** 6100 Woodley Avenue, Van Nuys, CA 91406 www.thejapanesegarden.com/

(p. 132) **Minnesota Landscape Arboretum** 3675 Arboretum Drive, Chaska, MN 55318 www.arboretum.umn.edu/

(p. 138) **Anderson Japanese Gardens** 318 Spring Creek Road, Rockford, IL 61107 www.andersongardens.org/

(p. 144) **Montréal Botanical Garden** 4101, Rue Sherbrooke Est, Montéal, QC, H1X 2B2 www.2.ville.montreal.qc.ca/jardin/en/japonais/japonais.htm

(p. 150) **Boston Museum of Fine Arts** 465 Huntington Avenue, Boston, MA 02115 www.mfa.org/

(p. 154) **Morikami Museum and Japanese Gardens** 4000 Morikami Park Road, Delray Beach, FL 33446 www.morikami.org/

(p. 160) **Japanese Friendship Garden of Phoenix** 1125 North 3rd Avenue, Phoenix, AZ 85003 www.japanesefriendshipgarden.org/

(p. 166) **Garven Woodland Gardens** 498 Arkridge Rd., Hot Springs, AR 71913 www.garvangardens.org/

APPENDIX 2

75 Important Japanese Gardens in North America

This appendix lists, with brief descriptions, 15 important gardens in each of five regions across North America. These gardens were selected primarily for their quality, but also taking into account historical importance and geographic distribution. The creation date for each garden is the year major construction was completed. In each region, the gardens are arranged along an imaginary driving tour that can be filled out with the gardens in the front of this book and other gardens found on the websites listed in the Select Bibliography. Armchair travelers can visit these gardens online, touring via the official website, Google Maps, You Tube videos, and photos on various sites.

THE SOUTH

Ichimura-Miami Japanese Garden, Watson Park, Florida
www.friendsofjapanesegarden.com/
The old San-Ai-En stroll garden, built in 1960 by industrialist Kiyoshi Ichimura, was converted in 2002 into a modernist interpretation of a Japanese garden in a circular walled enclosure. Landscape architect Lester Pancoast's garden is more important for what it tries to achieve than for what it actually accomplishes.

Japan Pavilion, World Showcase at EPCOT, Lake Buena Vista, Florida
disneyworld.disney.go.com/parks/epcot/
Befitting its location and function, this Disneyfied version of Japan features a well-made pastiche of various Japanese buildings—castle, palace, pagoda—surrounded by elegant waterfalls, pools, paths, and even a dry garden, designed by Shoji Kanaoka and Disney's Imagineers in 1982.

Grand Hyatt (formerly Hotel Nikko), Atlanta, Georgia
www.grandhyattatlanta.com/
Though incongruous at a huge neo-Georgian style hotel, this garden features a dramatic 30-foot waterfall that cascades to a pond flanked by an outdoor terrace and a quiet tea garden (now called the Zen Garden), both designed by Takeo Uesugi in 1994.

Japanese Garden, Carter Presidential Center, Atlanta, Georgia
www.jimmycarterlibrary.gov/
A gift from the YKK Co., the 2-acre garden by Kinsaku Nakane features two waterfalls—the larger "dignified" one symbolizing President Carter and the smaller "beautiful" one his wife Rosalynn—flowing through a "mountain valley" of clipped azaleas and emptying into a large lake on the 37-acre retreat.

Japanese Gardens, Birmingham Botanical Gardens, Alabama
www.bbgardens.org/
Designed by Buffy Murai in 1967, this impressive 7.5-acre garden, entered via a *torii* gate, features the delicate Toshin'an tea house and *roji*, dry garden, hill-and-steam garden, Japanese Cultural Pavilion (from the 1965 NY Expo), and stroll garden. Though now overgrown, if it realizes a proposed renovation, it will surpass its former glory.

Asian American Gardens, Bellingrath Gardens, Theodore, Alabama
www.bellingrath.org/
Reminiscent of pre-war Oriental gardens in Jacksonville and Clearwater, Florida, with its playfully exotic architecture set among lushly planted lawns and sinuous ponds, this garden designed by John Brown and Harry Ryan in 1967 conveys a unique "Southern charm." It is one feature at a lovely botanical garden and home.

Japanese Garden, Hermann Park, Houston, Texas www.hermannpark.org/
In 1991, noted garden designer Ken Nakajima fused a Japanese pond-style stroll garden with the scenery of southeast Texas on a 5-acre site, with arbors and pavilions under a canopy of native trees set around a large lake. The Houston Parks and Recreation Department faces the challenge of maintaining the large, diverse garden.

Isamu Taniguchi Oriental Garden, Zilker Botanical Garden, Austin, Texas
www.zilker-garden.org/
This rustic garden was dedicated in 1969 and named after the Japanese immigrant who spent nearly two years creating a series of pools, paths, and glades along a steep hillside in a park run by the City of Austin and the University of Texas. A stone "tea house" and lanterns add to the Japanesque effect.

Japanese Tea Garden, Brackenridge Park, San Antonio, Texas
en.wikipedia.org/wiki/San_Antonio_Japanese_Tea_Garden
In 1917, a stone quarry was transformed, with prison labor, into a lush lily pond garden, and run as the "Japanese Tea Garden" by the Jingu family until World War II. When the garden was listed on the National Register of Historic Places, San Antonio restored the name in 1983, though locals call it the Sunken Gardens.

Japanese Garden of Peace, Admiral Nimitz Museum, Fredericksburg, Texas
www.pacificwarmuseum.org/
Composed of planted mound "islands" in a sea of gravel standing for the Pacific Ocean, this symbolic garden designed by Taketori Saita in 1976 is outside a museum dedicated to the US Navy's war against Japan. A replica of Admiral Togo's study in Tsuruoka, Japan, overlooks the garden.

Kyoto Meditation Garden, Omniplex, Oklahoma City, Oklahoma
www.omniplex.org/
Located in a corner inside this multipurpose facility, this "pocket garden" was a 1985 gift from Oklahoma's sister state, Kyoto Prefecture and its Landscape Gardening Cooperative. Symbolizing the friendship between the two regions, a bridge connects one grass island to another island amid a sea of gravel.

Seijaku'en, Memphis Botanic Garden, Tennessee
www.memphisbotanicgarden.com/
Begun by Takuma Tono in 1965 and sponsored by the Ikebana International chapter, this sprawling stroll garden was expanded by Kōichi Kawana and J. Ritchie Smith in 1989. Highlights are the views across the serpentine pond from the more confined areas around the arched bridge and *yatsuhashi*.

Culberson Asiatic Arboretum, Sarah P. Duke Gardens, Durham, North Carolina
www.hr.duke.edu/dukegardens/
In this large botanical garden, the Asian section, entered through a tile-roofed gate and created from 1982, includes a Japan-derived tea house, arched bridge, eight-planked bridge, beautiful new Japanese pavilion set along steams, large pond, and collection of Japanese camellias and maples.

Kitakyushu Garden, Norfolk Botanical Gardens, Virginia

www.norfolkbotanicalgarden.org/
At this unique seaside botanical garden, a Japanese pond garden was created in 1962 to honor the sister city Moji. The garden was renovated in 1995, and the name changed to reflect Moji's new name, adding an entry area with paths through forests of clipped black pines and Japanese maples as well as a dry steam and pond.

Morven Farm, University of Virginia, Charlottesville, Virginia

www.uvafoundation.com/
Created by Iwaki zōen in 1993 for John Kluge on a maple-filled ravine on a huge estate, the property was donated to the University of Virginia in 2001. This steam-and-pond garden is overlooked by a beautiful *sukiya*-style residence, approached via an elegant tea garden built on a hillside set with huge stones.

THE EAST

Japanese Garden, Hillwood Museum and Gardens, Washington DC

www.hillwoodmuseum.org/
In 2002, Zen Associates restored the series of rocky hillside ponds linked by waterfalls built originally in 1958 by Shogo Myaida for heiress Marjorie Post. In this important project, Hillwood fulfilled its preservation mission and helped illuminate a chapter in the history of post-war residential Japanese gardens.

Gude Garden, Brookside Botanical Garden, Wheaton, Maryland

www.brooksidegardens.org/
From 1972, Hans Hanses created this free interpretation of a Japanese garden, with paths leading around a large pond to an island pavilion elegantly built over the water. Called the Gude Garden, it commemorates nurseryman Adolph Gude whose family donated the many specimen trees and shrubs that beautify the garden.

Morris Arboretum, University of Pennsylvania, Philadelphia, Pennsylvania

www.business-services.upenn.edu/arboretum/
During 1905–12, the still mysterious Y. Muto created the Hill and Cloud Garden, then the Overlook Garden, on the estate of John and Lydia Morris. Now part of the Morris Arboretum, Muto's dramatically vertical stone arrangements, waterfall, and specimen plants are still beautiful a century after their creation.

Swiss Pines, Malvern, Pennsylvania

en.wikipedia.org/wiki/Swiss_Pines
In 1957, Arnold Bartschi hired David Engel to redesign remnants of an old Japanese garden on part of his 19-acre property. A decade later, Bartschi had Katsuo Saitō add new features. Though overgrown and dilapidated, the gardens still show why they were one of the finest residential gardens in the 1960s.

Serenity Garden, Bethlehem, Pennsylvania

www.bethlehem-pa.gov/about/sisterCities/japan/serenity.htm
Of the many small "plaque, pine and (dry) pond" sister city gardenettes tucked beside libraries and city halls across North America, this one from Tondabayashi is among the very best. Nicely built by Sakon Yoshinaga in 1971, and with a small tea pavilion, it was refurbished in 1996 with a useful explanatory sign added.

Japanese Garden, Georgian Court College, Lakewood, New Jersey

www.georgian.edu/arboretum/bi_arbjp.htm
This intimate flat garden, a birthday gift to Lucy Gould from her husband George in around 1910, contrasts starkly with the palatial estate on which it stands. The only intact residential garden by Takeo Shiota, it features a teahouse made for the 1908 Japan-Britain Exposition.

James Rose House, Ridgewood, New Jersey

www.jamesrosecenter.org/
The area west of Manhattan features various Japanese gardens, from pre-war estates in the Catskills to one at Prentice-Hall Publishers, but none is as imaginative as landscape architect James Rose's outdoor/indoor house and garden, which internalize Japanese design aesthetics in ways both deadly serious and extremely whimsical.

Japanese Garden, Kykuit, Pocantico Hills, New York

www.rbf.org/
In 1910, J. D. Rockefeller Jr commissioned a Japanese pavilion and garden on the family's estate. In 1960, Nelson Rockefeller hired David Engel to redesign the garden and add a walled stone garden along the path to a tea house by Junzō Yoshimura. The subtle creativity of the garden comes alive as one moves slowly through it.

Hammond Museum Japanese Stroll Garden, North Salem, New York

hammondmuseum.org/
This woodsy Japanese garden, featuring a waterfall, pond, bamboo grove, cherry and maple groves, and dry garden, was designed by Natalie Hammond around her home in 1957. It is similar to several gardens in the greater area, including the Humes Stroll Garden in Mill Neck, NY, and the Mytoi Garden on Martha's Vineyard.

Innisfree Garden, Millbrook, New York

www.innisfreegarden.org/
Although reportedly inspired by the ideas of Chinese poet Wang Wei (699–559), many Japanese garden concepts are used in this series of marvelous "cup gardens" and borrowed views across a scenic lake. The garden was created between 1930 and 1960 by the property's owner Walter Beck and landscape architect Lester Collins.

Japanese Garden, Sonnenberg, Canandaigua, New York

www.sonnenberg.org/
Among the nine gardens commissioned by Mr. and Mrs. Frederick Thompson around their summerhouse, the Japanese garden of c. 1910 was Mary Thompson's favorite. Though needing restoration, among the many early 20th century residential gardens, it is the one of few in its original form and open to the public.

Tiger Glen Garden, Johnson Museum of Art, Ithaca, New York

www.mpkeane.com/tigerglen.html
Of the small campus gardens in New England (at Yale, Wesleyan, Mt. Holyoke, Smith, and Amherst), Marc Keane's garden at Cornell is the most enchanting. Through an intimate distillation of a rocky ravine, Keane invokes local scenery and Sino-Japanese lore with his reference to the ecumenical story of the "Three Laughters of the Tiger Glen."

Japanese Garden, Roger Williams Park, Providence, Rhode Island

en.wikipedia.org/wiki/Roger_Williams_Park
This understated pond-style stroll garden is the rare civic Japanese garden made in the 1930s. Built as part of a WPA project in this urban park and originally featuring floral planted islands, it was rebuilt in the 1990s in a more restrained style, dominated by stones and pines grouped on rolling hills.

Fuller Gardens, North Hampton, New Hampshire

www.fullergardens.org/
In 1927, Massachusetts Governor Alvan Fuller hired Arthur Shurtleff to build gardens around his seaside home. However, the intimate Japanese garden, with rustic *torii*, curving rock-lined paths, and red bridge across a waterfall-fed pond, may have been built by previous owners as it suggests the fashion of around 1910.

Asticou Azalea Garden, Northeast Harbor, Maine

gardenpreserve.org/asticou-azalea-thuya/azalea-garden.html
Charles Savage, owner of a local inn, bought the plants from the property of landscape designer Beatrix Farrand and, in 1956, used many of them in this tranquil, 2.3-acre Japanese-inspired garden on the Asticou Terraces created by Joseph Curtis. Paths meander along streams and pass a stone garden before reaching a Great Pond.

THE MIDWEST

Japanese Courtyard Garden, Phipps Conservatory, Pittsburgh, Pennsylvania

www.phipps.conservatory.org/
This small pocket garden shows how stereotypical elements of a Japanese garden—waterfall, *koi* pond, and bridge—can be condensed effectively into a small space without feeling crowded. The Phipps Conservatory also displays a strong *bonsai* collection.

Japanese Garden, Stan Hywet Hall, Akron, Ohio

www.stanhywet.org/
Among the dozen major estate gardens built by Tarō Ōtsuka in the Midwest in the 1910s, this is one of two that are open to the public. Commissioned in 1916 by Gertrude Seiberling, wife of the founder of Goodyear, it features Ōtsuka's favorite Mt Fuji and *torii* motifs as well as a waterfall, arched bridge, and viewing pavilion.

Japanese Garden, Dawes Arboretum, Newark, Ohio

www.dawesarb.org/
In one of the most creative Japanese-inspired gardens in North America, in 1964 Prof. Makoto Nakamura of Kyoto University reinterpreted the dry garden as stone outcrops and rocky ravines on an undulating grass meadow, then adapted the pond-style stroll

garden into a low windswept landscape, emphasizing the horizon.

Saginaw Japanese Cultural Center and Tea House, Saginaw, Michigan

www.japaneseculturalcenter.org/welcome0.aspx
In 1970, a 3-acre park-like garden was built to honor the Saginaw-Tokushima sister city relationship, and in 1986 the Awa Saginaw-An tea house, designed by Tsutomu Takenaka, and an attached *roji* garden were added. The Cultural Center brings Japanese culture into Michigan's industrial belt.

Takasaki Park, Battle Creek, Michigan

www.battlecreekvisitors.org/
This small well-designed sister city garden, created in 1999, curves along the edge of a small lake in Irving Park. As such, it recalls Buffalo's sister city garden on Mirror Lake in Delaware Park, although that older garden (1974, renovated 1996) has the added beauty of small islands that include the lake in the composition.

Osaka Garden, Jackson Park, Chicago, Illinois

www.hydepark.org/parks/osaka2.html
The first Japanese garden on Jackson Park's Wooded Isle was built as part of the 1893 Columbian Exposition, with a tea garden added when it became a civic Japanese garden in 1934. A new sister city garden, built in 1981, refurbished in 1993, and redesigned in 2002 by Sadafumi Uchiyama, effectively uses this attractive site.

Japanese Garden, Fabyan Villa, Geneva, Illinois

www.ppfv.org/fabyan.html
Nelle Fabyan commissioned Tarō Ōtsuka to create this garden in 1914. While her husband was engrossed in science, commerce, and politics, Mrs Fabyan sought a garden that would counter Western blindness to nature and "delight the eye" even as it ministered to the soul.

Japanese Garden, Dubuque Arboretum, Iowa

www.dbq.com/arboretum/index.html
This series of pond gardens connected by dramatic waterfalls was created by Hōichi Kurisu in 2003. Together with gardens being built in Fargo in North Dakota and Omaha in Nebraska, it is one of a new wave of Japanese gardens at Midwestern arboreta and botanic gardens.

Japanese Garden, Janesville Rotary Garden, Wisconsin

rotarybotanicalgardens.org/gardens/japanese-garden

This volunteer-made garden, created largely in 1991, is entered through an attractive gate and includes the world's longest eight-planked bridge as well as an arched bridge along the edge of an old quarry fed by springs. It also features a large flat garden with a dry sea of gravel.

Jōryō'en, Carleton College, Northfield, Minnesota

apps.carleton.edu/campus japanesegarden/

David Slawson's "Garden of Quiet Listening" is a 3-D landscape painting—a sea of gravel and beds of shrubs create a dry landscape meant to evoke a lake fed by a stream. Located next to a dormitory, it was created in 1976 in conjunction with Asian Studies professor Bardwell Smith, and can be seen from a small arbor.

Japanese Garden, Normandale Community College, Bloomington, Minnesota

www.normandale.edu/japanesegarden/

A vibrant 2-acre mélange of bridges and pavilions around a lake set in a verdant valley, this garden is a popular wedding spot at this commuter college. Designed by Takao Watanabe and dedicated in 1976, it commemorates the Japanese-Americans who trained for Military Intelligence Service during WW II at nearby Fort Snelling.

Como-Ordway Memorial Garden, St. Paul, Minnesota

www.comozooconservatory.org/

Como Park featured a large, elegant pondside stroll garden in 1904, and though the new garden, designed by Masami Masuda in 1979, then restored c. 1992, is a smaller hill-and-pond garden, it is no less beautiful. Funded by the Ordway family, its highlights are the many beautiful stones and pines, and the tea house built in 1987.

Shoto Teien, Terrace Park, Sioux Falls, South Dakota

www.siouxfallsparks.org/ContactUs/wedding_locations/Terrace_Japanese_Gardens.aspx

From 1928 to 1936, Joseph Maddox designed and built a Japanesque garden along the shore of Covell Lake, winning commendation from *Better Homes and Gardens* for the Women's

Club that supported it. From 1986 to 1991, Kōichi Kawana redesigned the garden, adding a walled entry gate and viewing arbors, plus new plants and stones.

Kurimoto Japanese Garden, University of Alberta, Edmonton

www.devonian.ualberta.ca/DisplayGardens/KurimotoJapaneseGarden.aspx

This spacious, attractive 5-acre pond-style stroll garden, built in the Devonian Botanic Garden in 1990, is the northernmost Japanese garden in North America. Like his garden in Lethbridge, Prof. Tadashi Kubo adapted Japanese principles and features to the garden parkland of central Alberta. The Ozawa Pavilion was added in 1993.

Japanese Stroll Garden, Nathanael Greene Park, Springfield, Missouri

www.botanicalsociety.net/japanesegarden.html

This 7.5-acre stroll garden in the rear of a large park was begun in 1985 with the impetus of Yuriko Mizumoto Scott, and created with carpenters from the sister city Isesaki. Paths lead past three ponds, over the requisite eight-planked and arched bridges, viewing arbor, tea house, and dry garden. A Fall Festival is held annually.

SOUTHWEST AND CALIFORNIA

Sasebo Japanese Garden, Albuquerque Biological Park, New Mexico

www.cabq.gov/biopark/garden/exhibits/japanese-garden

This 4-acre garden designed by Tōru Tanaka in 2007 has two areas: a xeriscapic dry garden courtyard around a bell tower and entry gate, and a stroll garden comprised primarily of native plants around a pond fed by a large waterfall. More attractive than the pond garden are the intimate streams and paths on its north side.

Sankei'en San Diego Friendship Garden, Balboa Park, California

www.niwa.org/

This garden began with a dry garden and pavilion by Ken Nakajima in 1990, added a revenue-generating café, pond, and patio in 1999, and in 2010 broke ground in the adjacent canyon. Designed by Takeo Uesugi, the large new garden adds a waterfall and stream, camellia and azalea areas, cherry grove, tea houses, and culture center.

San Diego Tech Center, California

www.mpgoffice.com/SanDiegoTechCenter/

Takeo Uesugi created a large garden for the Bannockburn Lake Office Plaza north of Chicago in 1989 and, in 1982, this garden of elegant paths through forested hillocks and a pondside pavilion restaurant. Though now removed, Uesugi had fashioned creative dry gardens where the landscape met the modern office buildings.

California Scenario, Costa Mesa California

en.wikipedia.org/wiki/Isamu_Noguchi

Isamu Noguchi's design for a 1.6-acre rectangle between two office towers and the back walls of a parking garage, abstracts various aspects of California's topography. Recalling his early stage sets for Martha Graham and a Japanese stroll garden reimagined as a dry garden, the space is special by day and magical at night.

Earl Burns Miller Japanese Garden, CSU Long Beach, California

www.csulb.edu/~jgarden/main.html

With funds donated to create a tranquil space on a large campus, in 1981 Edward Lovell created a 1.3-acre pond-style stroll garden with bridges, tea house, and dry garden. The garden hosts many social, educational, and cultural events. Japanese gardens grace the CSU campuses at Pomona, Dominguez Hills, and San Francisco.

Seiryū'en, James Irvine Garden, JACCC, Los Angeles, California

www.jaccc.org/jaccc/irvine_garden.html

In 1979, in a triangular space next to the Japanese American Community and Culture Center, Takeo Uesugi designed a garden of forked steams, inspired by the Murin'an garden in Kyoto, and meant to symbolize three generations of Japanese-American experience. A master plan calls for substantial renovation to facilitate greater use.

Japanese Garden, Descanso Gardens, La Canada Flintridge, California

www.descansogardens.org/

The Descanso Garden Guild, a ladies auxiliary, donated funds for the Japanese garden that was built in 1966 with donations of materials and labor by local Japanese-Americans. The steam and *koi* pond, designed by Kōichi Kawana, flow past Whitney

Smith's distinctive and controversial Full Moon Tea House and deck.

Hannah Carter Japanese Garden, UCLA, Los Angeles, California

www.japanesegarden.ucla.edu/

Created in 1959 as "The Garden That Reminds One of Kyoto" by Nagao Sakurai for Gordon Guiberson, and renovated in 1968 by Kōichi Kawana after it was given to UCLA, this hill-and-pond garden is entered by an elegant gate and contains a tea house. In 2011, UCLA began plans to sell off this beautiful visit-by-reservation garden.

Japanese Garden, Ganna Walska Lotusland, Montecito, California

www.lotusland.org/gardens/japanese-garden

In 1967, Ganna Walska decided to add one more garden on her large estate by turning a pond into a Japanese stroll garden. Second-generation garden builder Frank Fujii and stonemason Oswald da Ros built a waterfall and stream, and set dozens of stone lanterns and other garden ornaments along a meandering path.

Manzanar National Historic Site, Independence, California

www.nps.gov/manz/

Between 1942 and 1944, this internment camp in the Owens Valley saw the creation of dozens of pond gardens as internees turned this dusty instant city of 12,000 into a temporary home. The best gardens—at Merritt Park, the Hospital, and Block 34—feature sophisticated waterfalls, ponds, and streams using Sierra Nevada granite.

Shinzen Japanese Friendship Garden, Woodward Park, Fresno, California

www.shinzenjapanesegarden.org/

The Japanese garden built in Fresno's Roeding Park in 1932 was largely destroyed by 1942. The 3.5-acre lakeside stroll garden made in Woodward Park in 1981 by Paul Saito and the Japanese-American community has fared far better, adding a tea house by Shirō Nakagawa in 1989, and receiving a major renovation in 2002.

Japanese Garden, Micke Grove Regional Park, Lodi, California

Designed by Nagao Sakurai, this 3-acre pond-style stroll garden with a large pavilion was the project of Duke Yoshimura,

sponsored by the Japanese American Citizens League, and created in 1965 by the Japan Garden Club and other groups, including prisoners. Though facing maintenance challenges, the garden has "good bones."

Lakeside Japanese Garden, Lakeside Park Garden Center, Oakland, California

www.gardensatlakemerritt.org/welcome-to-japanese/

This courtyard garden, designed by Harry Tsugawa from 1959, is the first public Japanese garden built after WW II in California. Comprised of a small pond, waterfall, and hill, it features 15 large, dramatically set stones amid lush plantings, and a viewing shelter. A large *bonsai* garden was added nearby in 2002.

Japanese Garden, Hayward, California

www.haywardrec.org/facilities.html

Bay Area landscape architect Kimio Kimura and Hayward Park Superintendent Wesley Sakamoto produced this garden in 1980. The "dynamic balance" of the stones, shrubs and trees reflects Kimura's design ideas, as does the balance of the "fast moving" dry waterfalls and the placid pond, overlooked by a pavilion.

Japanese Friendship Garden, Kelly Park, San Jose, California

www.sjparks.org/regional/japanesefriendship.asp

In 1958, Edna Anthony led a broad public/private coalition to create a Japanese garden inspired by the famous Kōrakuen garden in San Jose's sister city Okayama. The 6-acre garden, featuring three large ponds connected by waterfalls and meandering streams, was dedicated in 1965, with a restaurant-shop added in 1970.

NORTHWEST AND HAWAI'I

Donald Garrity Japanese Garden, Central Washington University, Ellensburg, Washington

www.cwu.edu/garden.html

Masa Mizuno designed this fenced campus garden—with a steam flowing through a landscape of primarily native pines, shrubs, and stones—to reflect the nearby Cascade Mountains. A dry stone garden, surrounded by a low hedge, offers an abstract counterpart to the naturalistic orientation of the majority of the garden.

Yashiro Japanese Garden, Olympia, Washington

www.olympiawa.gov/Default.aspx?sc_itemid={3181FD9F-0E67-433D-90BD-76F9C288228E}

Landscape architect Robert Murase designed several Japanese gardens in the Pacific Northwest (Beaverton, OR, Bellevue, WA, Burnaby, BC) that translate Japanese design into a more modern idiom. This sister city garden, dedicated in 1990, is the most successful, creating intimacy and mystery in a small space.

Pt. Defiance Park, Tacoma, Washington

www.metroparkstacoma.org/page.php?id=28

After a quasi-Japanese style trolley station was erected at this large urban park in 1911, a Japanese garden was built in front of it. In 1982, the small pond garden was refurbished as a sister city garden, adding a *torii* and small shrine given to Tacoma by Kokura in 1961.

Kubota Garden, Seattle, Washington

www.kubota.org/

Fujitarō Kubota built this 20-acre nursery and Japanese-Cascade hybrid garden from 1927. It was given to Seattle by his family in 1987. As the site of a 2004 conference on Japanese gardens, the garden got a new entry area, and it has evolved since then under the thoughtful care of Seattle Parks and Recreation.

Nishiyama Japanese Garden, Everett Community College, Washington

www.everettcc.edu/programs/socsci/nbi/index.cfm?id=5040

Created in 2003 as part of the Nippon Business Institute, this mini sampler garden joins tea, dry, and stream gardens in a small area enclosed by an elegant fence and gate. Part of a Japanese garden renaissance in Washington, it joins recent gardens in Bow, Burien, Moses Lake, Longview, Sequim, Tukwila, and Yakima.

Momiji Garden, Hastings Park, Vancouver, British Columbia

www.hastingspark.ca/momiji-japanese-garden/

Following UBC's Nitobe Garden, Japanese gardens were created near Vancouver. In contrast to New Westminster's stroll garden, North Vancouver's stream garden, and Stevenson's dry garden, this lovely garden designed by Ken Nakajima in 1993 focuses on a pond, though a path leads through a delicate maple grove to a waterfall.

Japanese Gardens, Royal Roads University, Victoria, British Columbia

www.hatleygardens.com/japanese_garden.html

In the first decade of the twentieth century, the elderly Isaburō Kishida created Japanese gardens around Victoria in Gorge Park (now Takata Japanese Garden), Butchert Gardens, and for James Dunsmuir at his Hatley Park estate (now a college). The triple-arch bridge and waterside pavilions are highlights of this large pond garden.

Japanese Friendship Garden, Memorial Park, Hope, British Columbia

en.wikipedia.org/wiki/Hope,_British_Columbia

In 1991, the Japanese Gardeners Cooperative of British Columbia completed this lovely pond garden to remember the Japanese-Canadians interned in the nearby Tashme Camp, and "to demonstrate Japanese culture to the general public." The garden has a sophisticated entry area and makes excellent use of borrowed scenery.

Kasugai Japanese Garden, Kelowna, British Columbia

www.kelownakasugai-sistercity.com/kelowna/kasugaigardens.html

This 3-acre sister city garden, dedicated in 1984, includes a pond garden with a waterfall (optimally seen from the viewing pavilion), an iris marsh with an eight-planked bridge, a stone garden, and a meandering stream. Roy Tanaka, a local farmer, created the garden as a gift to the city.

Japanese Garden, Powlson Park, Vernon, British Columbia

www.greatervernonrecreation.ca/index.php/parks-trails

This steam-and-pond garden, featuring a small viewing arbor, was built in 1967 as a Canadian Centennial project. Like many gardens from the era, the ambitions of the garden's creators have not been matched with the requisite maintenance, and the garden is ready for restoration or renovation.

Cultural Gardens, Honolulu International Airport, Oahu, Hawai'i

www.hawaii.gov/hnl/customer-service/cultural-gardens

In 1967, Richard Tongg designed Chinese, Hawaiian, and Japanese gardens for the large areas between the airport's terminals. Made to be seen from the terminal and a viewing deck, rather than entered, a pavilion, zigzag bridge, and stone ornaments enliven this waterfall-fed pond garden.

Imin (East West) Center, University of Hawaii, Oahu, Hawai'i

www.eastwestcenter.org/

During a workshop for landscape architects, Kenzō Ōgata created this garden featuring a sinuous stream set between mounds of turf. Stone pagodas and lanterns punctuate the tranquil landscape, best seen from the balcony of the adjacent building. Urasenke donated the Jakuan tea house and tea garden in 1972.

Byōdō'in Gardens, Kaneohe, Oahu, Hawai'i

www.byodo-in.com/

Kyoto's famous eleventh-century Byōdō'in (Temple of Equality) was reproduced in concrete in 1968 as part of a cemetery. Like the original, the Hawaiian version faces a large pond but it adds *koi*, some delicate streams, and a tea house. In Kaneohe, the backdrop of jagged peaks far surpasses the low hills of Uji and southern Kyoto.

Japanese Garden and Teahouse, Kepaniwai Heritage Garden, Maui, Hawai'i

www.hawaiiweb.com/maui/html/sites/kepaniwai_park_heritage_gardens.html

The Hawaiian Islands are full of imaginative and hybrid Japanese gardens at temples, cemeteries, hotels, restaurants, museums, and old estates. One of the most picturesque is this pond-and-hill garden designed by Richard Tongg, with a Japanese temple-style "tea house." The setting near the famous Iao Needle is spectacular.

Liliuokalani Gardens Park, Hilo, Hawai'i

www.vthawaii.com/BIGISLAND/Liliuokalani/Liliuokalani.html

This large garden around Waihono Pond, and featuring multiple bridges, pavilions, and lanterns, was first constructed in 1914. After being largely destroyed by tsunami in 1946 and 1960, it was rebuilt with contributions by Kinsaku Nakane, a dry garden by Nagao Sakurai, and an Urasenke-sponsored tea house.

SELECT BIBLIOGRAPHY

Books About Japanese Gardens in North America

Brown, Kendall H., *Japanese-Style Gardens of the Pacific West Coast*, New York: Rizzoli International, 1999.

Gong, Chadine Flood and Lisa Parramore, *Living with Japanese Gardens*, Salt Lake City: Gibbs Smith, 2006.

Lancaster, Clay, *The Japanese Influence in America*, New York: Abbeville, 1983; 1st edition Walton Rawls, 1963.

Makoto Suzuki et al., *Japanese Gardens Outside of Japan/Kaigai no Nihon teien*, Tokyo: Japanese Institute of Landscape Architecture/Nihon zōen gakkai, 2007.

McFadden, Dorothy Loa, *Oriental Gardens in America: A Visitor's Guide*, Los Angeles: Douglas-West, 1976.

Newcomer, David M., *Public Japanese Gardens in the USA, Present and Past: Northern California*, Mill Valley, California: Japanese Gardens USA, 2007.

_____, *Public Japanese Gardens in the USA, Present and Past: Southern California*, Mill Valley, California: Japanese Gardens USA, 2010.

Oster, Maggie, *Reflections of the Spirit: Japanese Gardens in America*, New York: Dutton Studio Books, 1993.

Rao, Peggy and Jean Mahony, *Nature on View, Homes and Gardens Inspired by Japan*, Tokyo: Shufunotomo/Weatherhill, 1993.

Books That Impacted the Creation of Japanese Gardens

Conder, Josiah, *Landscape Gardening in Japan*, Tokyo: Kodansha International, 1990; 1st edition Yokohama: Kelly and Walsh, 1893; revised 1912.

Engel, David, *Japanese Gardens for Today*, Rutland, Vermont: Charles E. Tuttle, 1959.

Isamu Kashikie, *The ABC of Japanese Gardening*, Tokyo: Japan Publishing, 1964.

Katsuo Saito, *Japanese Gardening Hints*: *The Romance of Gleaning Sand, Rugged Stones, and Shady Trees in Your Own Garden*, Tokyo: Japan Publications, 1969.

Katsuo Saito and Sadaji Wada, *Magic of Trees and Stones: Secrets of Japanese Gardening*, Tokyo: Japan Publishing, 1964.

Kiyoshi Seiki, Masanobu Kudō, and David Engel, *A Japanese Touch for Your Garden*, Tokyo: Kodansha International, 1993.

McDowell, Jack (ed.), *Sunset Ideas for Japanese Gardens*, Menlo Park, California: Lane Books, 1968.

Murphy, Wendy B. and the Editors of TIME-LIFE BOOKS, *Japanese Gardens*, from the series *The Time-Life Encyclopedia of Gardening*, Alexandria, Virginia: Time-Life Books, 1979.

Newsom, Samuel, *A Thousand Years of Japanese Gardens*, Tokyo: Tokyo News Service Ltd, 1953.

Ortho Books (ed.), *Creating Japanese Gardens*, Des Moines: Meredith Books, 1989.

Journals and Journal Articles

The Journal of Japanese Gardening, Sukiya Living Magazine, published six times per year since Jan/Feb 1998.

Yukiko Yanagida McCarty, "Japanese Architecture and Gardens in America," 12 articles in *The East*, Tokyo, Vol. 40, No. 1 May/June 2004–Vol. 42, No. 1 May/June 2006.

Websites

en.wikipedia.org/wiki/Japanese_garden
www.a-japanese-garden.com/
www.jgarden.org/
japanesegardening.org/
www.najga.org/ (North American Japanese Garden Association)
www.rothteien.com/

DVD

Japanese American National Museum, *Beyond the Japanese Garden: Short Films & Documentaries*, 2007.

ACKNOWLEDGMENTS

I would like to thank Calvin Barksdale, formerly of Tuttle Publishing, for supporting this book, June Chong for guiding it, and David Cobb for his boundless enthusiasm and generosity, qualities matched only by his skill as a photographer and his stamina as a traveler.

I am deeply indebted to the many garden professionals who have provided research materials and patiently answered questions. In North America, I was greatly helped by garden designers who shared their ideas and memories, notably Hōichi Kurisu, David Engel, David Slawson, Barry Starke, Ken Sakurai, Takeo Uesugi, Masayuki Mizuno, and Tōru Tanaka. I have been equally fortunate to receive much information from public garden directors, curators, horticulturalists, and board members, including Diana LaRowe of the Phoenix Japanese Friendship Garden, James Folsom and David MacLaren of the Huntington Botanic Garden, Gene Greene of Suihō'en, Lon Saavedra of Hakone Estate and Garden, Sam Fukudome of San Mateo, Stephen Bloom and Sadafumi Uchiyama of the Portland Japanese Garden, Lisa Chen of the Seattle Department of Parks and Recreation, Richard Brown of the Bloedel Reserve, Patrick Lewis of the University of British Columbia, Jim Flott and Steve Gustafson in Spokane, Robert Hironaka of the Nikka-Yūkō Japanese Garden in Lethbridge, Edward Conners and Ebi Kondō of the Denver Botanic Gardens, Henry Painter of the Fort Worth Botanic Garden, Bob Byers, Marla Crider, and Mike Brown of Garvan Woodland Gardens, Ben Chu of the Missouri Botanical Garden, Benjamin Carroll and Chris Jarantoski of the Chicago Botanic Garden, John Anderson and Tim Gruner of the Anderson Japanese Gardens, Louis Rinfret of the Jardin Botanique du Montréal, Brian Funk and Scott Medbury of the Brooklyn Botanic Garden, Frank Chance and Kim Andrews of Shōfūsō in Philadelphia, Leigh Ann Lomax of Cheekwood, Dale Wheary and Peggy Singleman of the Maymont Japanese Garden, and Larry Rosensweig of the Morikami Japanese Gardens. I must also extend my gratitude to Douglas Roth, publisher of *Sukiya Living* magazine, and Prof. Seiko Gotō of Rutgers University for their assistance and insight. My experience of Japanese gardens in North America is much indebted to many other professionals and enthusiasts.

In Japan, I would like to acknowledge the assistance of Prof. Makoto Suzuki of Tokyo University of Agriculture and Prof. Miyuki Manabe-Katahira of Momoyama Gakuin University, as well as garden designers Ken Nakajima, Shirō Nakane, Shunmyō Masuno, and Takao Donuma.

Finally, it is an honor to thank Ron Herman and Marc Treib, who, 30 years ago, introduced me to Japanese gardens in their class at the University of California Berkeley. Most of all, this book would not have been possible without the constant research assistance, in English and Japanese, of my wife Kuniko. She has been an indefatigable internet explorer and a steady navigator during our research travels in 47 American states and 4 Canadian provinces over 20 years.

Kendall H. Brown
Los Angeles, September 2012

THE TUTTLE STORY
"Books to Span the East and West"

Most people are surprised to learn that the world's largest publisher of books on Asia had its humble beginnings in the tiny American state of Vermont. The company's founder, Charles Tuttle, came from a New England family steeped in publishing, and his first love was books—especially old and rare editions. Tuttle's father was a noted antiquarian dealer in Rutland, Vermont. Young Charles honed his knowledge of the trade working in the family bookstore, and later in the rare books section of Columbia University Library. His passion for beautiful books—old and new—never wavered throughout his long career as a bookseller and publisher.

After graduating from Harvard, Tuttle enlisted in the military and in 1945 was sent to Tokyo to work on General Douglas MacArthur's staff. He was tasked with helping to revive the Japanese publishing industry, which had been utterly devastated by the war. When his tour of duty was completed, he left the military, married a talented and beautiful singer, Reiko Chiba, and in 1948 began several successful business ventures.

To his astonishment, Tuttle discovered that post-war Tokyo was actually a book lover's paradise. He befriended dealers in the Kanda district and began supplying rare Japanese editions to American libraries. He also imported American books to sell to the thousands of GIs stationed in Japan. By 1949, Tuttle's business was thriving, and he opened Tokyo's very first English-language bookstore in the Takashimaya Department Store in Ginza, to great success. Two years later, he began publishing books to fulfill the growing interest of foreigners in all things Asian.

Though a Westerner, Tuttle was hugely instrumental in bringing a knowledge of Japan and Asia to a world hungry for information about the East. By the time of his death in 1993, he had published over 6,000 books on Asian culture, history and art—a legacy honored by Emperor Hirohito in 1983 with the "Order of the Sacred Treasure," the highest honor Japan bestows upon non-Japanese.

The Tuttle company today maintains an active backlist of some 1,500 titles, many of which have been continuously in print since the 1950s and 1960s—a great testament to Charles Tuttle's skill as a publisher. More than 60 years after its founding, Tuttle Publishing is more active today than at any time in its history, still inspired by Charles Tuttle's core mission—to publish fine books to span the East and West and provide a greater understanding of each.